BRITAIN

YESTERDAY & TODAY

CARLTON
BOOKS

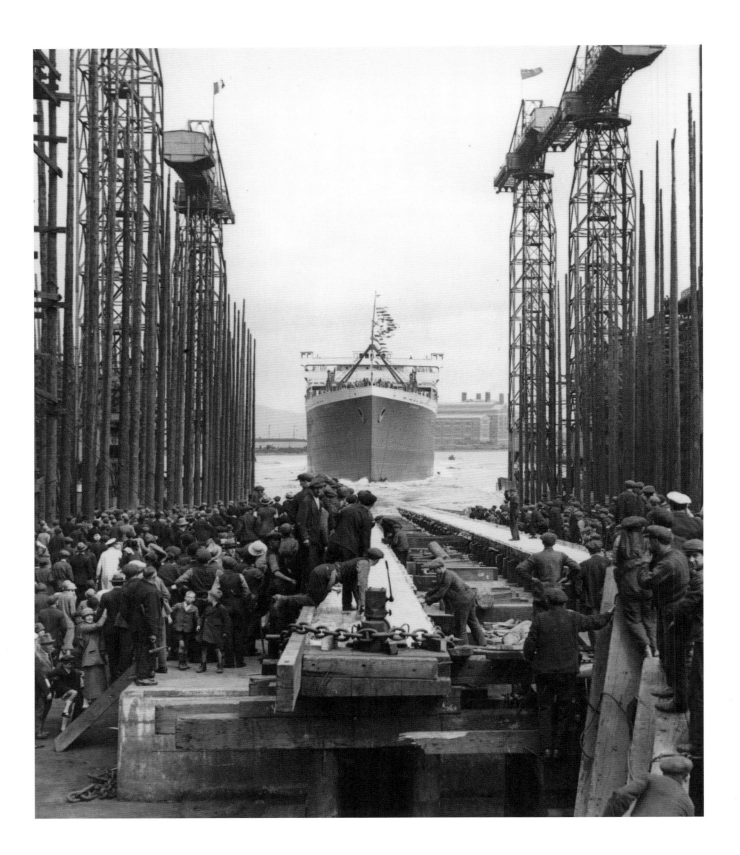

BRITAIN

YESTERDAY & TODAY

JANICE ANDERSON &
EDMUND SWINGLEHURST

CARLTON
BOOKS

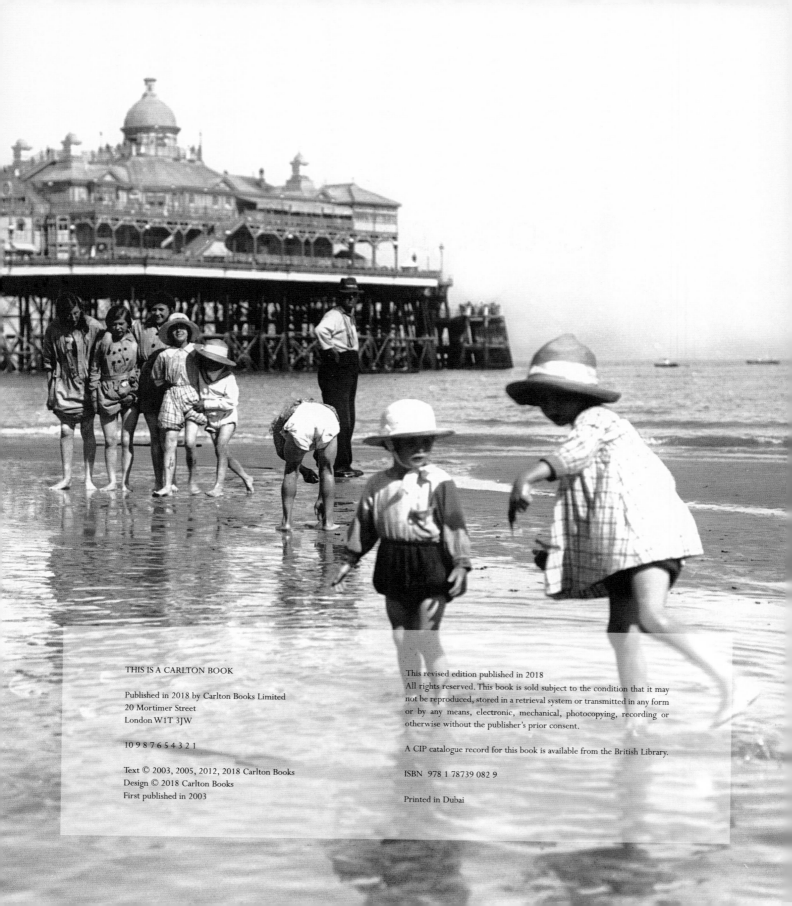

THIS IS A CARLTON BOOK

Published in 2018 by Carlton Books Limited
20 Mortimer Street
London W1T 3JW

10 9 8 7 6 5 4 3 2 1

Text © 2003, 2005, 2012, 2018 Carlton Books
Design © 2018 Carlton Books
First published in 2003

This revised edition published in 2018
A CIP catalogue record for this book is available from the British Library.

ISBN 978 1 78739 082 9

Printed in Dubai

CONTENTS

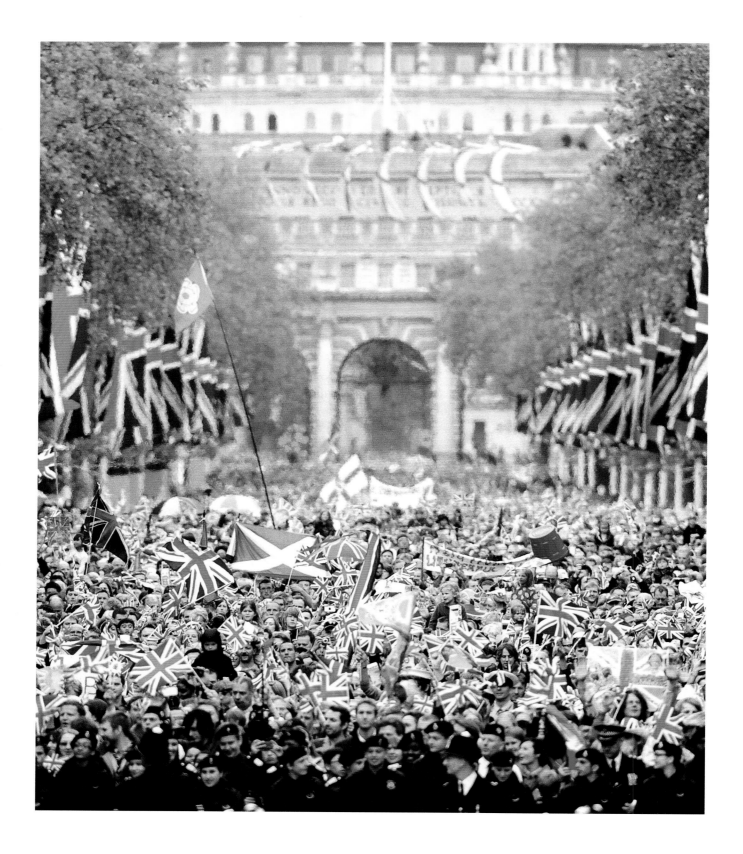

FOREWORD BY PETER SNOW

Pictures bring history to life. The Bayeux tapestry helps us to imagine the great clash between Harold and William in 1066. William Hogarth's mischievous paintings give us a glimpse of the realities of life in seventeenth century London. Artists did their best to illustrate their times. But in the last century or so, photography has opened our eyes to history with more immediacy than ever before. This beautiful book is a treasure house of photographs that describe this passage of time. They highlight the contrasts in our life and environment past and present — and also the similarities.

The evocative pictures of Paddington Station then and now (pp.156–57) reveal the revolution in railway train technology: streamlined locomotives and posh coaches have replaced the old steam trains. But the permanent backdrop of Brunel's magnificent roof remains and the people who will soon pour onto the platforms to catch today's trains will have much the same to chatter and worry about as the crowd on Platform 1 in 1935. The street markets of the East End of London (pp.126–27) are as busy as ever they were and still sell everything under the sun.

I have spent a lifetime as a television journalist telling stories about Britain — and to me pictures play a vital role in bringing events alive and revealing the personalities of people in the news. Words add information and explanation but the pictures are what we remember. When you delve back into history and the work photographers did to record what the world was like, the past opens up for us with all its triumph and tragedy. And this book is a magnificent testament to the power of pictures in allowing us to take that voyage through time.

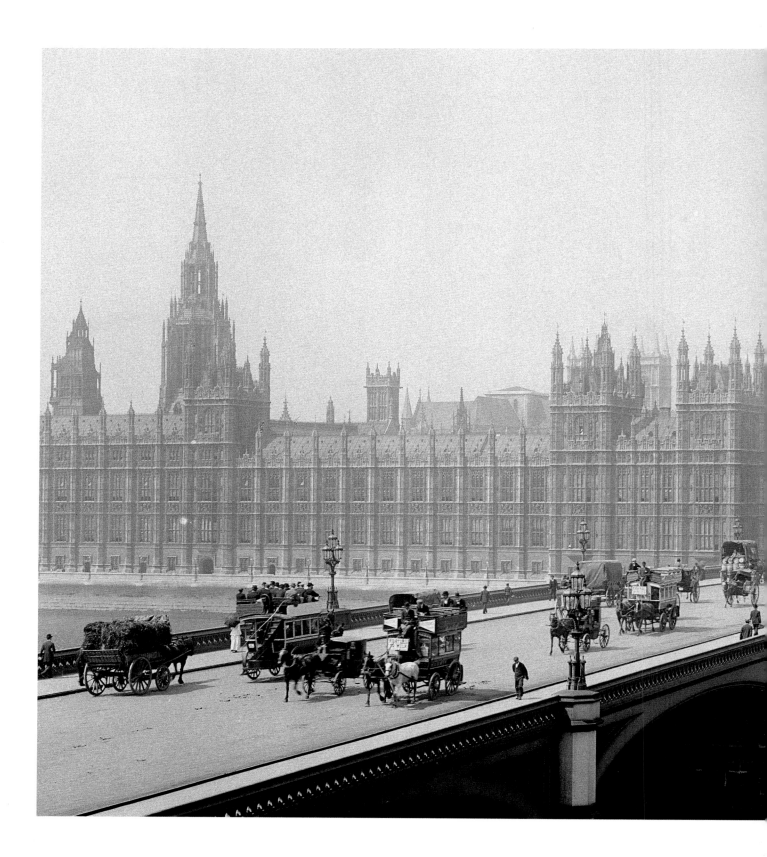

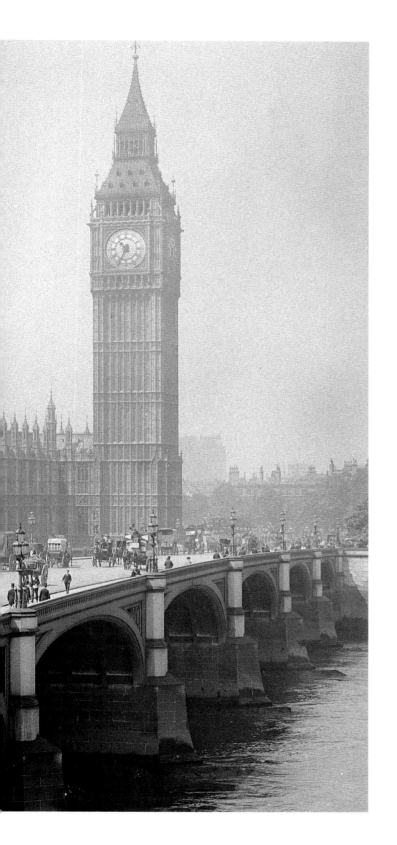

INTRODUCTION

The United Kingdom of Great Britain and Northern Ireland has much to be proud of and much to celebrate. We pack into a comparatively small space some of the world's most beautiful countryside, where rolling green and gold farmland and 'blue remembered hills' are studded with lakes, lochs and tarns and watered by great rivers and sparkling streams. Our towns and cities include some that are among the most architecturally handsome and innovative in the world. Our society is essentially peaceful and well ordered, set on a firmly democratic base in which we all have a say, through the ballot box, in what goes on nationally and at a local level.

Things are not like this for many other countries in the world, and they were not always like this for us. Britain yesterday – in the nineteenth and early twentieth centuries – was an imperial power and a nation that relied on its industries, most of them in the Midlands and the north of England, for much of its great wealth and for the income of the bulk of its people. Today, sociologists and historians tell us, we are a post-industrial society, whose once-mighty industrial base has dwindled to a shadow of its former might and in which an entirely different kind of economy, based on 'invisible earnings' and the finance and service industries, directs the way in which we live our lives and choose the ways by which we earn our living.

During the move from an industrial world to a post-industrial one, our standards of living improved dramatically, though not without many difficulties. Today, the welfare of the individual is an essential concern, primary and secondary education is a universal right, adult men and women all have the vote, and many kinds of leisure can be enjoyed by everyone in the free time that shorter working hours and longer paid holidays have given us.

All this has happened during a time when science and technology have progressed at breathtaking speed. On the way, they have given us steam propulsion of many kinds – including railways and ships – the telegraph, electric light, sewage systems, paved roads, the internal combustion engine, powered flight, radio communications and many, many more benefits, most of which were little more than a gleam in scientists' eyes when Prince Albert opened the Great Exhibition in London's Hyde Park in 1851.

Today, Britain is again one of the world's most prosperous nations. It is a country where the bulk of the population, who once rarely saw foreign faces, now lives in a multicultural society where many races and religions live together in, largely, peace and harmony. It is a country whose people, once eating mostly roast beef or boiled mutton, are now connoisseurs of pasta, pizza, Peking duck, noodles, curry, sushi and tacos. And it is a country where people still happily celebrate centuries-old traditions and customs in the midst of twenty-first-century technology and wizardry.

This book is a celebration of all these aspects of life in Britain today, and of the adaptability, ingenuity and tolerance of the British people.

FREE

TIME

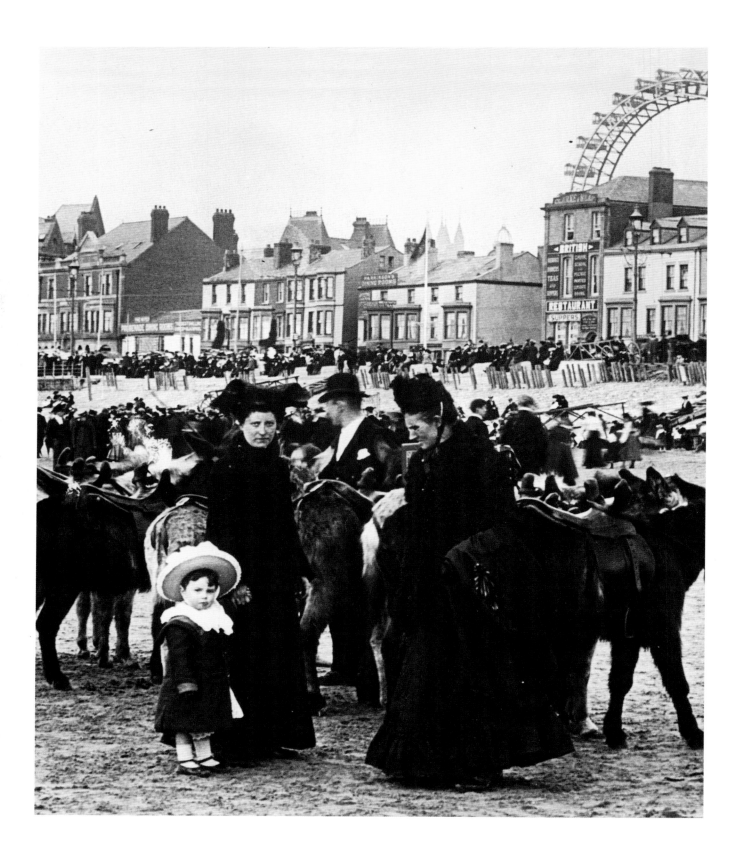

GREAT DAYS OUT

Before the railway age, days off were spent locally for most Britons, if they took them at all. The train enabled people to get away quickly to the countryside and the seaside. The 1871 Bank Holidays Act, which established the Easter, Whitsun, August and Christmas bank holidays, gave another fillip to the idea of taking a short break from home and work.

The seaside was the most popular destination for days out in Britain and all the big resorts catered as much for the day visitor as for the longer-term holidaymaker. Margate and Southend, downriver from London, Brighton on the south coast and Blackpool in the north were among the most popular resort towns.

While a trip to the seaside is still a great day out, more sophisticated day trippers have their search for excitement met by all the fun of the theme park. The great theme parks, such as Alton Towers in Staffordshire and Thorpe Park in Surrey, offer a dazzling array of rides, entertainment and other attractions that quieter suppliers of great days out, such as the National Trust, cannot match.

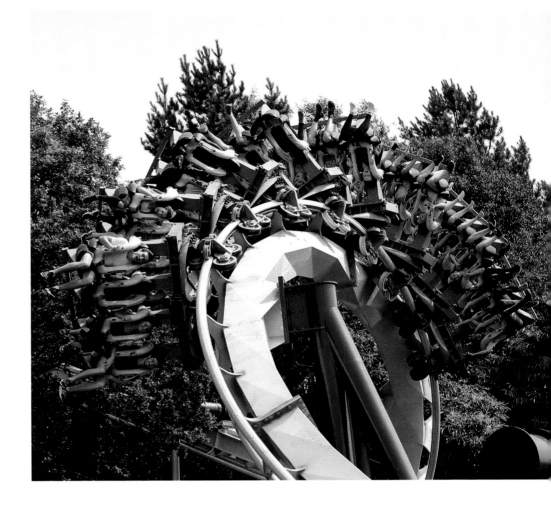

1890
Donkey rides on the sands were a popular feature of days by the sea. These donkeys are on the main beach at Blackpool.

TODAY
Theme parks provide today's great days out. Intrepid visitors are turned upside down when they ride on the 'Nemesis' rollercoaster at Alton Towers.

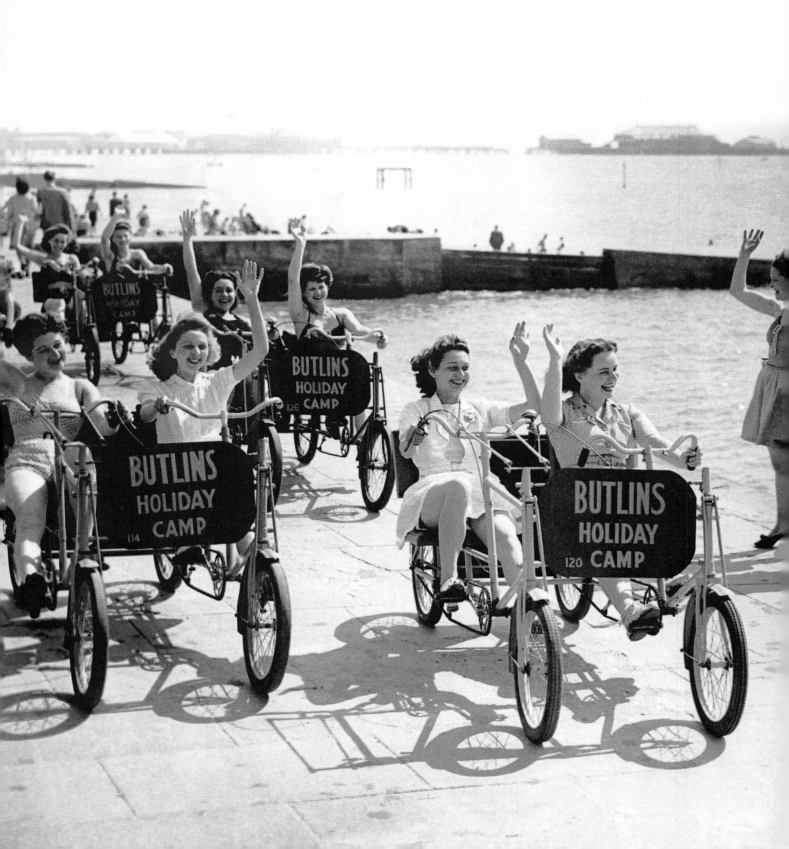

HOLIDAY CAMPS

Billy Butlin launched the first of his many holiday camps at Skegness in 1936 and one at Clacton-on-Sea two years later. His camps and those people who followed him, such as the holiday giant Thomas Cook, provided clean, simple holiday accommodation in wood cabins at a time when life was hard for many.

After World War II was over in 1945, holiday camps were hugely popular, offering all kinds of entertainments and fun for all ages, from knobbly-knees competitions and bathing-beauty pageants to ballroom dancing and light entertainment, day and night.

The advent of the cheap package holiday abroad in the 1960s meant the end of the old-style Butlins camp. People wanted freedom, not the constant attention of regiments of blazered hosts making everyone 'join in'.

Today's holiday camp is a very different being. It is called a 'holiday leisure resort' and it is built with the British weather in mind. At Center Parcs, for instance, visitors can indulge in water sports and games in a sub-tropical climate, oblivious to any snow or rain outside. Butlin's now offer themed party weekend packages for adults too.

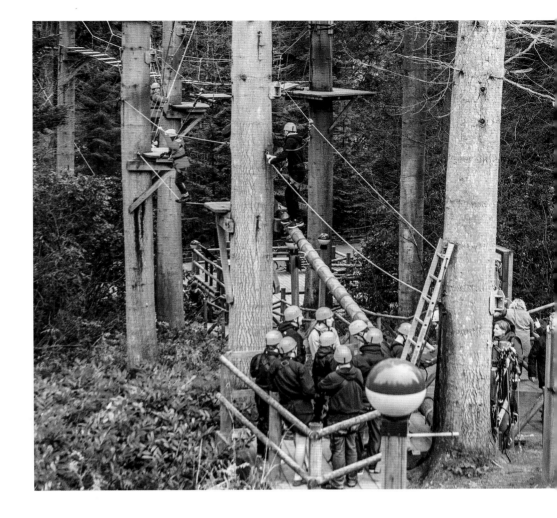

1939
Holidaymakers on two-seater bicycles carry out a friendly invasion of Clacton-on-Sea's Marine Parade from Butlins Holiday Camp in the town.

TODAY
Climbing ropes and tree platforms provide entertainment at the Center Parcs holiday resort in Longleat, Wiltshire.

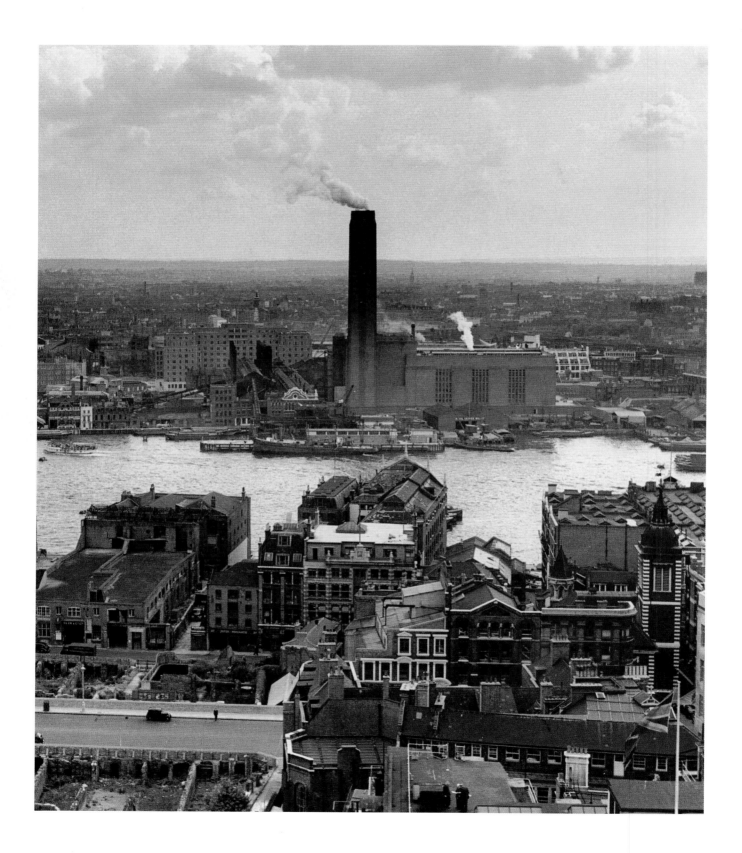

TATE MODERN

The transformation of Bankside Power Station on the south bank of the Thames into Tate Modern began in 1995. The art gallery was opened in the millennium year, 2000, but the footbridge that was meant to link it to the north bank near St Paul's Cathedral had to be closed because it wobbled. It opened to the public in 2002, since when it has been a hugely popular way of reaching the gallery.

The Bankside Power Station, designed by architect Sir Giles Gilbert Scott, was built in two phases between 1947 and 1963. It is a brick-clad steel structure, with some 4.2 million bricks used in its construction. The main chimney was kept down to a height of 99 metres (325 feet) so that it would be lower than Christopher Wren's dome on St Paul's.

The building was transformed into a truly exciting gallery of modern art by world-famous Swiss architects Herzog & de Meuron, who also designed the new Tanks and Switch House extensions, which opened in 2016, increasing the size of Tate Modern by 60 per cent.

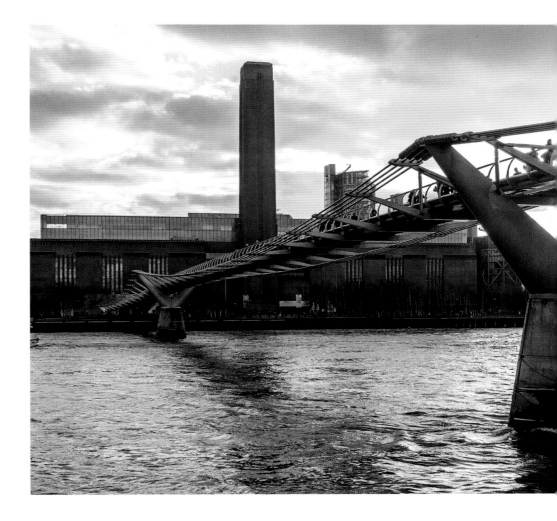

1953
Bankside Power Station 10 years from completion. It was powered by oil rather than coal, a controversial system in the 1950s.

TODAY
Tate Modern seen from the St Paul's Cathedral end of the Millennium Bridge. The gallery has welcomed over 60 million visitors since it opened.

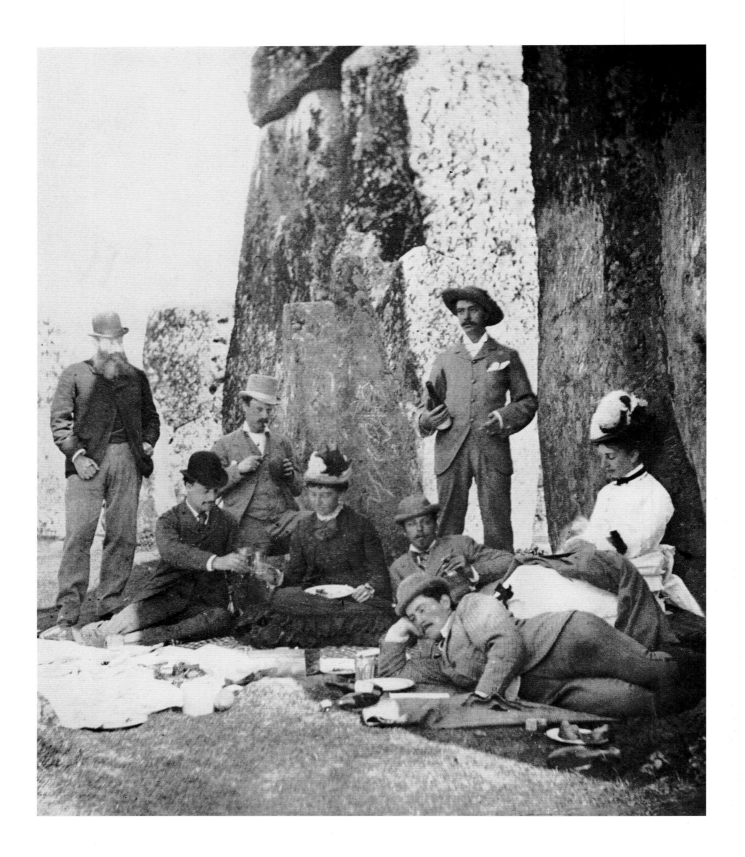

1877

The elegant party picnicking at Stonehenge includes Queen Victoria's son, Prince Leopold, Duke of Albany (reclining on his elbow, cigar in hand).

TODAY

Every year, revellers gather at Stonehenge to recreate the ancient Druids' way of celebrating the Winter Solstice at Stonehenge.

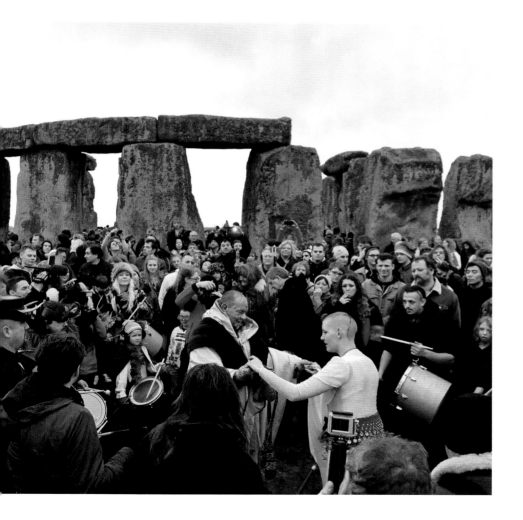

MYSTERIOUS STONEHENGE

The great circle of stones called Stonehenge that stands in a field on the Salisbury Plain in Wiltshire is one of the most important survivals from pre-historic times in Britain. It has long attracted thousands of visitors every year, not least those seeking some remnant of the sun-worshipping Druids.

Druids held sun-worshipping ceremonies at Stonehenge nearly four thousand years ago. Today, Companions of the Most Ancient Order of Druids keep vigil at Stonehenge every 21 June, the day of the Summer Solstice.

Wear and tear caused by the huge numbers of visitors to the site led English Heritage to come up with a major redevelopment plan in 2010. After many iterations of plans were proposed and scrapped, a £27m visitor centre opened in 2013, 2.4 kilometres (1.5 miles) west of the stones themselves. Visitors are transported to the stones on buses. Walkers can see the stones free of charge, as a footpath now passes close by.

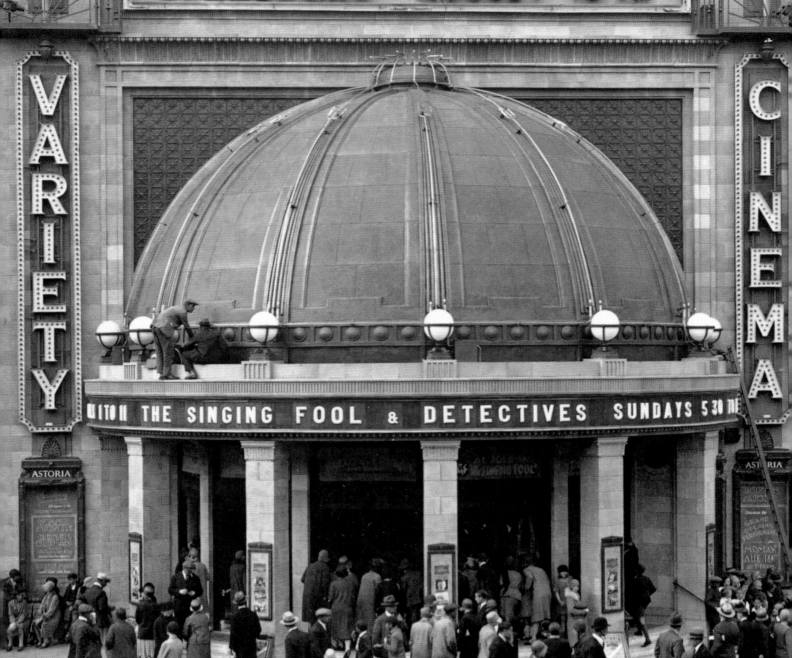

THE CINEMA

Moving pictures were first shown in Britain in darkened halls, variety theatres, fairgrounds and 'penny gaffs'. The first cinemas – with padded seats, fluted columns and potted ferns, and a pianist or even a musical trio in attendance – gave way in the twenties to a wonderful riot of styles, from Spanish and Mexican to Art Deco and Odeon modernist.

Cinema-going in Britain today is different in many ways. Vast, multi-screen complexes on the edge of nearly every town dominate the industry. Movie-goers, with tickets bought online, park within yards of the entrance, arm themselves with buckets of popcorn and other delights, and settle in sofas and armchairs to have their senses assaulted by the effects of the latest computer-generated film technology.

Conversely, classic independent theatres are experiencing a renaissance as people seek a more traditional cinematic experience. Lovingly restored buildings show revival screenings as well as the latest blockbusters, and show live performances by satellite from such major arts venues as Britain's National Theatre and the New York Metropolitan Opera. These have proved immensely popular. Cinema-going is once again as exciting, and even as glamorous, as it was in the thirties, when it first became a major part of the national culture.

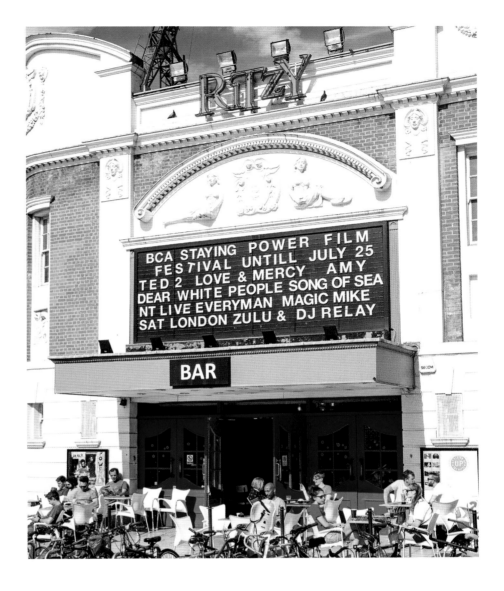

1929
Fans queue round the block at the Astoria in Brixton, south London, to see variety entertainer Al Jolson's second 'talkie', *The Singing Fool*.

TODAY
Brixton's Ritzy Cinema plays blockbuster films as well as revival screenings, and the lively bar hosts activities such as karaoke, yoga and music.

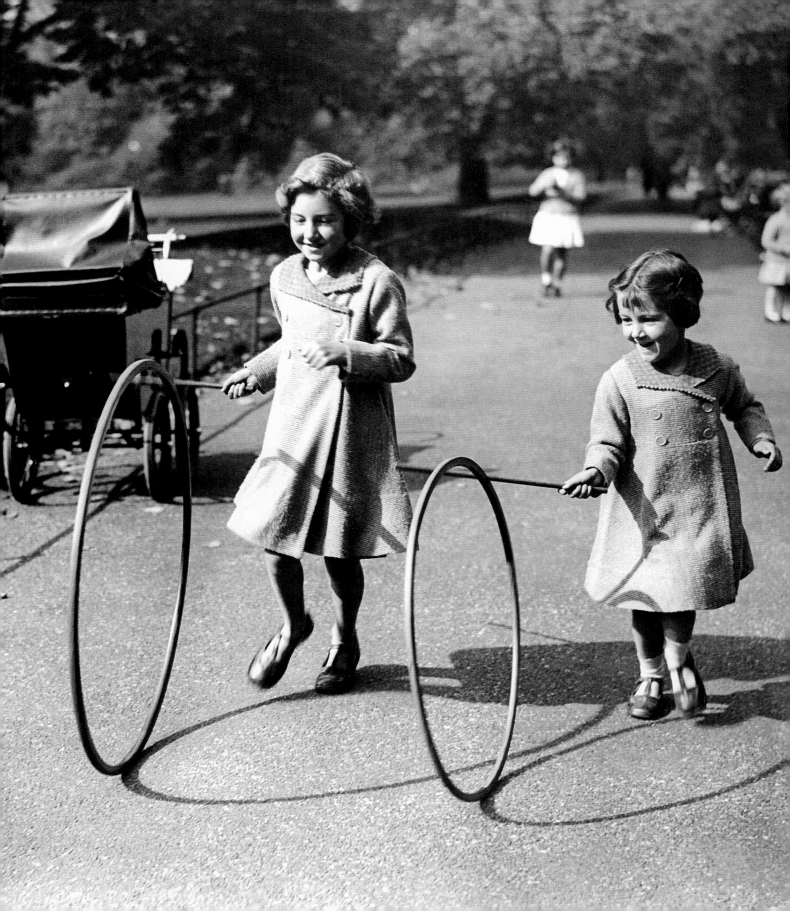

1932
Two sisters send their hoops bowling along a path popular with children and their mothers in Hyde Park, London.

TODAY
Children have fun in a colourful, well-designed play area in Lydiard Park, Swindon.

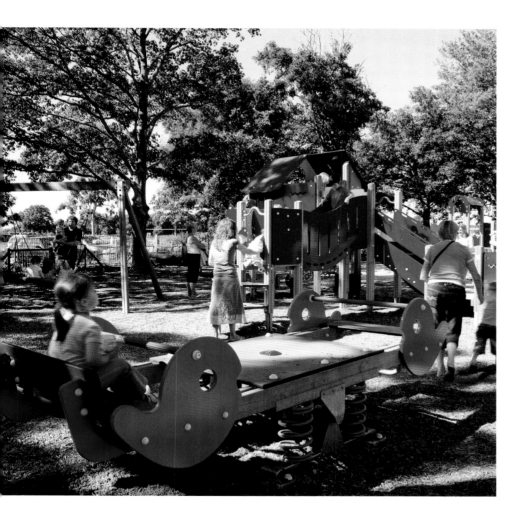

PLAYING IN THE PARK

Providing fresh air and fun for children became an objective of early Victorian town planners, horrified by the appalling conditions in which so many people in Britain's towns lived.

Increasing numbers of parks and gardens, hitherto usually privately owned, were opened for everyone to enjoy. Manchester, for instance, opened three public parks in 1846, all paid for by public subscription. One of them, Peel Park, included among the trees and flowerbeds swings and see-saws for children and areas set aside for ninepins, bowls and gymnastics.

Play areas in parks still have a big part to play in children's well-being. The fight today is against the results of affluence. Too much fast food, too much sitting in front of TV and computer screens and too little exercise is making children fat. The brightly painted, cleverly designed play areas are there to attract children away from their television and computer screens and out into the park.

LOWRY'S WORLD

Although a city in its own right, with a charter granted in 1230 and an important part played in the creation of Britain's industrial wealth, Salford has become almost submerged in the urban sprawl of Greater Manchester.

This once-grimy centre of industry became a big star in the arts firmament when The Lowry arts complex was opened at Salford Quays. L S Lowry, who was born in Salford in 1887, began his working life as a clerk but soon turned to art, training in Manchester. In hundreds of drawings and paintings he recorded industrial life in Lancashire. Many of his paintings are peopled with ant-like crowds of stick figures scurrying among factories and grimy buildings. He was made a Royal Academician in 1962 in recognition of his unique contribution to art.

The Lowry was built in 1999 with the help of a £64 million grant from National Lottery funding. Set in the heart of the re-developed Salford Quays, The Lowry is a centre for performing and visual arts and a registered charity, offering creative opportunities to the local community. It's the place to go and see L S Lowry's finest work.

1955
Two children play in the back garden of their house in Salford while the baby of the family sleeps in his splendid pram.

TODAY
The impressive architecture of Salford Quays' glass-walled The Lowry arts complex has transformed the Greater Manchester waterfront.

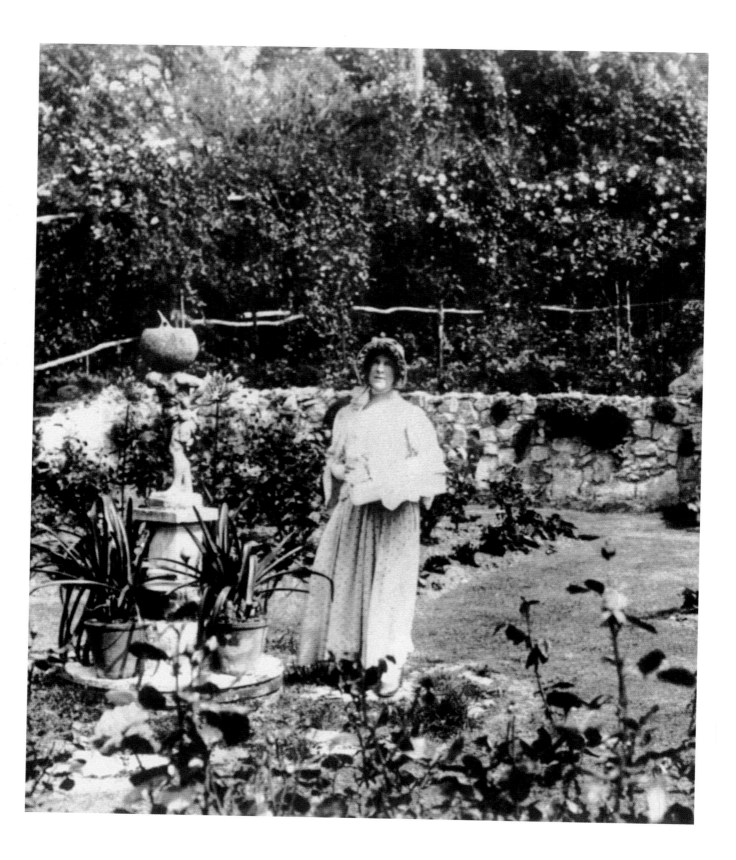

IN THE GARDEN

'Our England is a garden ... full of borders, beds and shrubberies,' wrote Rudyard Kipling. His countrymen tried to emulate nature rather than formalize it, in the Continental style, in their home gardens. Herbaceous borders were planted with tall hollyhocks, lupins and delphiniums, while petunias, carnations and pansies spilled over onto paths. Pergolas draped with honeysuckle, rambler roses and clematis provided gardens with private areas where ladies, wearing bonnets to protect their faces from the sun, could enjoy moments of quiet.

Until the mid-twentieth century, gardeners were widely employed, but rising wages and alternative job opportunities caused their disappearance. Today, everyone is their own gardener. Inspired by TV gardeners, at weekends they head for garden centres, which have blossomed under the influence of television, radio and newspaper gardening experts.

The Chelsea Flower Show has been a top gardening (and social) event since its inception in 1913. Today's show runs for five days, and on the last day everything is sold off to the garden-loving public.

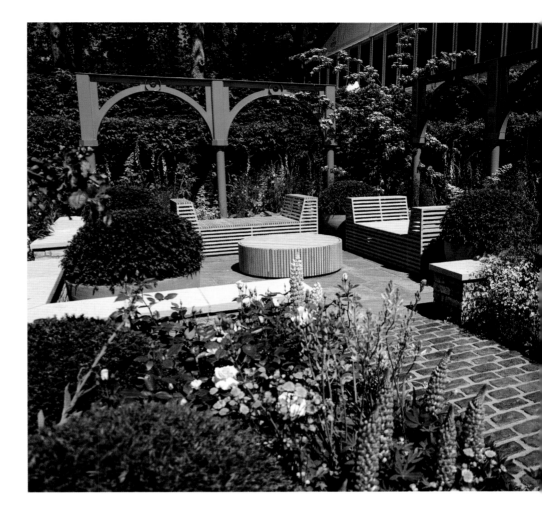

1890s
Roses and potted plants flourish round a statue in this Victorian garden, which also has a terrace reached by stone steps.

TODAY
A garden to commemorate 500 years of Covent Garden at the 2017 Chelsea Flower Show.

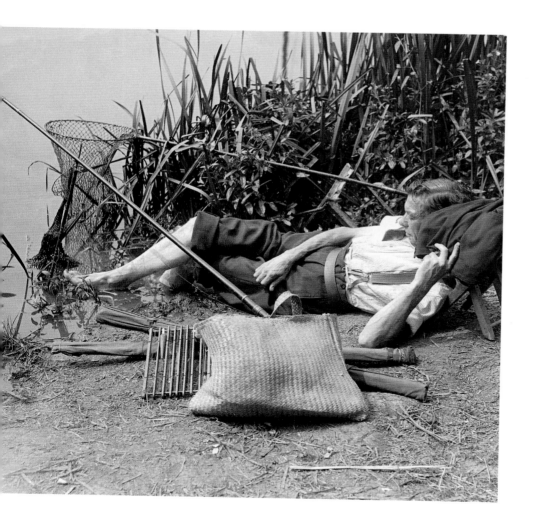

ANGLING

The soothing experience of a day's fishing has been enjoyed by country folk and townspeople alike for centuries. Enthusiasm for the pastime grew in the nineteenth century and steps toward its regulation began. For the better-off, land-owning classes, fishing meant fishing for salmon and trout on private stretches of rivers. The ordinary fish of rivers and streams, such as perch, carp and pike, provided coarse fishing for everyone else.

Village shops near rivers began to carry stocks of rods, reels, lines and floats. Specialist shops were opened and the first angling magazines were published, giving advice on how and where to fish.

Today, a licence is always needed for anyone fishing for salmon and trout. Coarse fishing on streams and rivers usually requires a water-authority licence, too, but the fee is modest and easily obtained. Many anglers opt for fishing specially stocked, privately run lakes and reservoirs. Wherever the setting, outwitting the wily denizens of inland waters is always a challenge for the angler's patience.

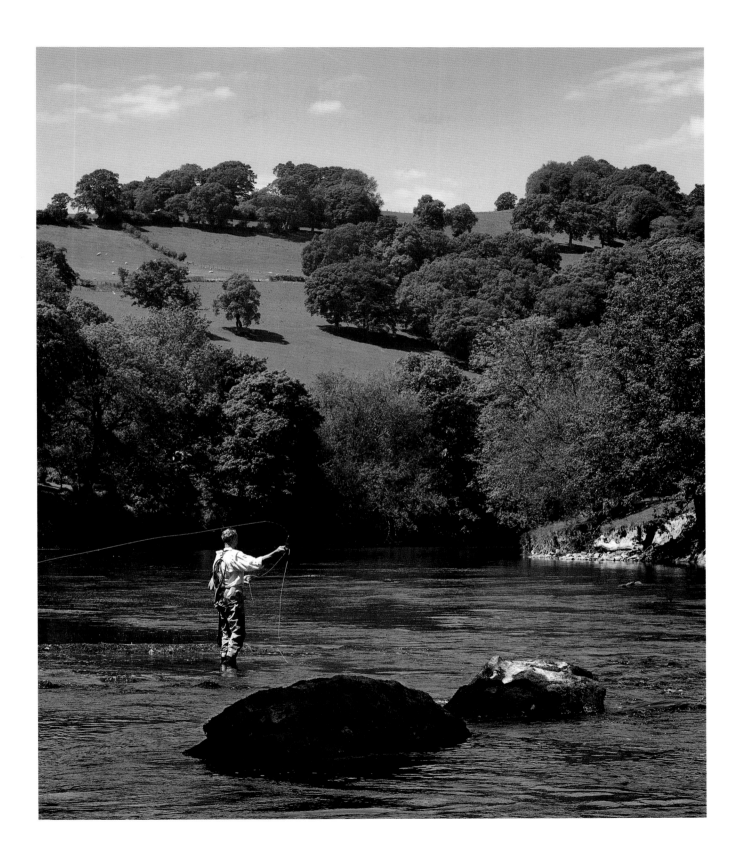

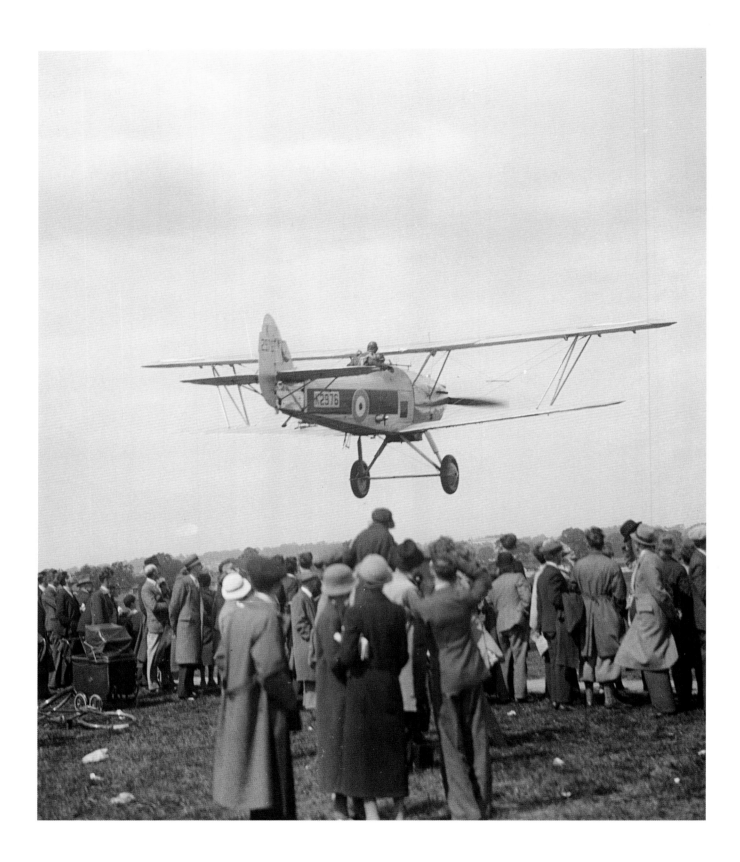

FUN IN THE AIR

Taking to the air in a flying machine caught the public imagination in the 1920s. Pilots from the Royal Flying Corps (re-named the Royal Air Force in 1918) found new work at airshows, demonstrating the capabilities of the biplanes that had taken part in the First World War and even offering aerial flips for a few shillings.

Much of this kind of flying was done from farm fields, or from the long, flat beaches of resorts such as Tenby in southwest Wales. Flying displays were regular events at two former military airfields in London, Hendon and Northolt.

As flying became more commonplace, simply going up into the air for a few minutes lost its attraction. From 1948, the public's greater expectations were met for 50 years by the annual Farnborough Air Show, with its flying displays at the frontiers of technology. At the same time, fine air museums such as the Royal Air Force Museum at Hendon and the Imperial War Museum's air museum at Duxford in Cambridgeshire were taking shape. Today, their displays, in the air and on the ground, recreate the thrill of flying for everyone.

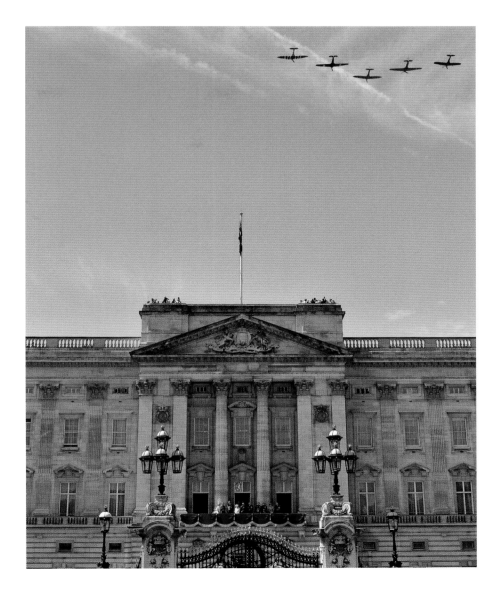

1935
A low-flying Hawker Hart biplane gives the crowd a hair-raising thrill at an airshow at the Hendon airfield in north London.

TODAY
The RAF Red Arrows stage a flypast over Buckingham Palace during the annual Trooping the Colour ceremony.

GREAT
BOTANIC
GARDENS

The world's first horticultural garden began as a private botanic garden laid out along the Thames in the grounds of Kew Palace by Augusta, Princess of Wales in the 1750s.

Today, the Royal Botanic Gardens at Kew is a major horticultural and botanic institution and a fine public garden. Among Kew's many attractions are several glasshouses, ranging from Decimus Burton's great Palm House of 1848 to the Princess of Wales Conservatory, named after Princess Augusta and opened by Diana, Princess of Wales in 1987.

Since 2000, Kew's glasshouses have been rivalled for garden lovers' attention by the giant domes, called biomes, of the Eden Project in Cornwall. Essentially a conservatory of the world's ecological systems, the Eden Project attracts one million visitors a year to its two biomes, devoted to the humid tropics and the warm temperate zone. In 2006 the Queen opened a third biome, The Core, an educational centre providing the visitor with a deeper understanding into 'learning to live with the grain of nature'.

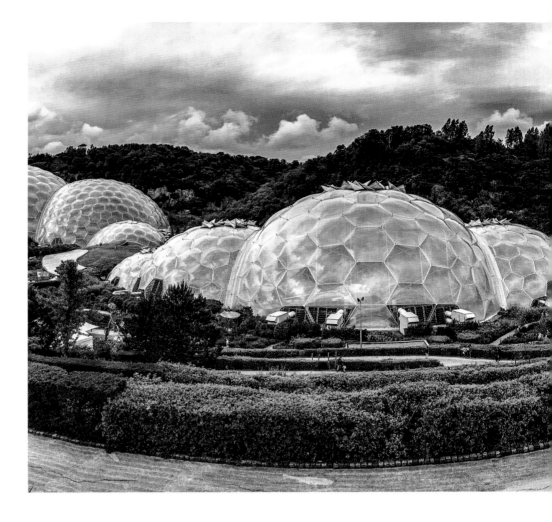

1892
The Temperate House at Kew Gardens was opened in 1860. By 1892, the house's central walk was dwarfed by its plants.

TODAY
Clouds gather but don't affect the microclimates within the biomes of the Eden Project, built in a disused china-clay pit near St Austell in Cornwall.

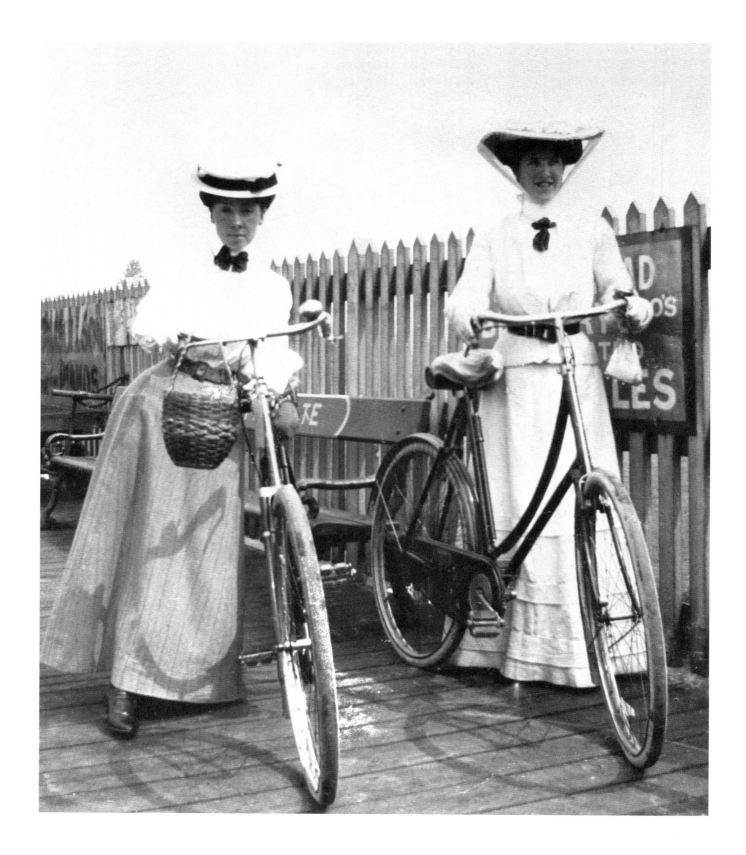

CYCLING

The invention of the safety bicycle with a protected chain guard in the 1870s brought the age of universal cycling into being. Even Prime Minister Gladstone approved, saying that cycling offered almost unbounded benefits, physically, morally and socially.

Mr Gladstone had only men in mind, but soon women were as enthusiastic cyclists as men, the 'new women' among them going as far as adopting the American Mrs Amelia Bloomer's splendid trousers for cycling wear. For the Victorian man, the cycling club became a major attraction of the weekends. Men liked the competitive aspect of the cycling club, which included cycling round specially built oval circuits and taking part in long-distance cross-country rallies.

The present-day popularity of leisure-time cycling led to the development of the National Cycle Network, which will eventually cover the country. Now 20 years old, the Network covers 22,500 kilometres (14,000 miles) of safe, traffic-free routes criss-crossing the UK. Twenty-five towns and cities across the country now offer cycle-sharing schemes, encouraging yet more bike enthusiasts to get on the road.

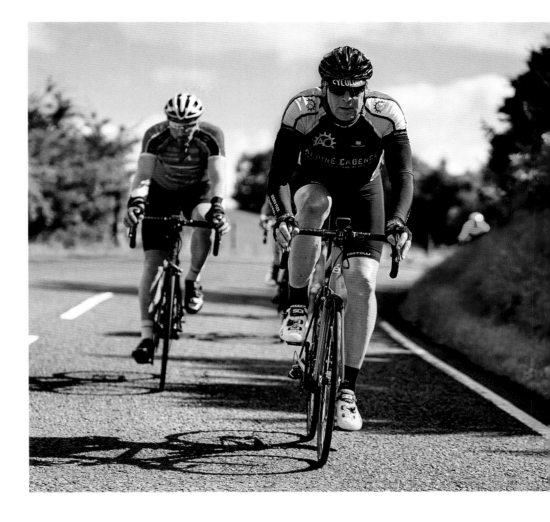

c.1900s
A crisp white shirt, black tie and a stylish straw hat was the standard dress worn by Victorian amd Edwardian ladies when cycling.

TODAY
Lycra-clad cyclists with feather-light, high-tech bikes can frequently be seen speeding along country roads.

ESSENTIALLY

BRITISH

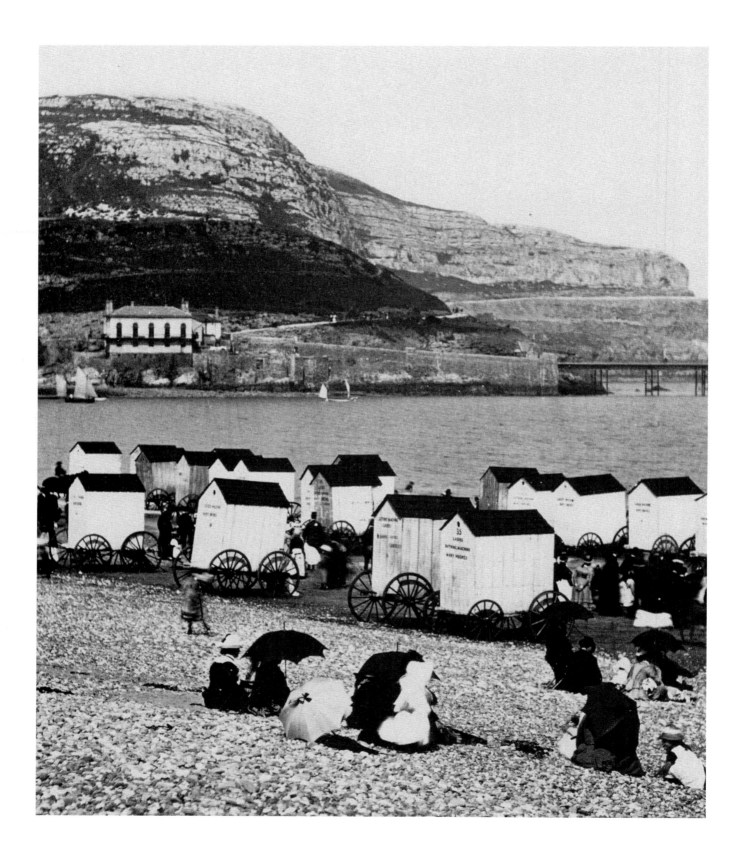

AT THE SEASIDE

By the end of the Edwardian age, mixed bathing had become acceptable at Britain's seaside resorts. Only the most modest of women felt the need to step into the sea from the steps of a bathing machine that had been dragged into the briny by a horse.

The bathing machines, which had been a feature of every English seaside resort since the mid-eighteenth century, were damp, dark and smelly and were not much missed. Many of them had their huge wheels removed and were converted into huts – the provision of shelter being particularly welcome given the unpredictable British summer weather.

Modern beach huts are a much-loved amenity and many of them, being privately owned, fetch large sums when sold. More than just somewhere to change out of wet bathing costumes and store the beach equipment, today's beach hut may have all the amenities of a summer house, often well furnished and with electricity for lighting and making a cup of tea. The British seaside resorts may have stiff competition from Continental beaches, but they still draw the crowds with their charm.

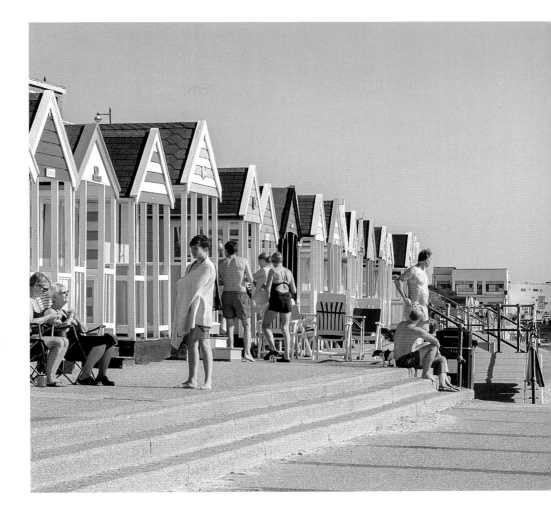

1880
Unused bathing machines and well-clad people suggest there's a cool breeze blowing on the beach at Pensarn in Colwyn Bay, Wales.

TODAY
Brightly painted beach huts, some of which may be old bathing machines, are among the amenities of Southwold beach, Suffolk.

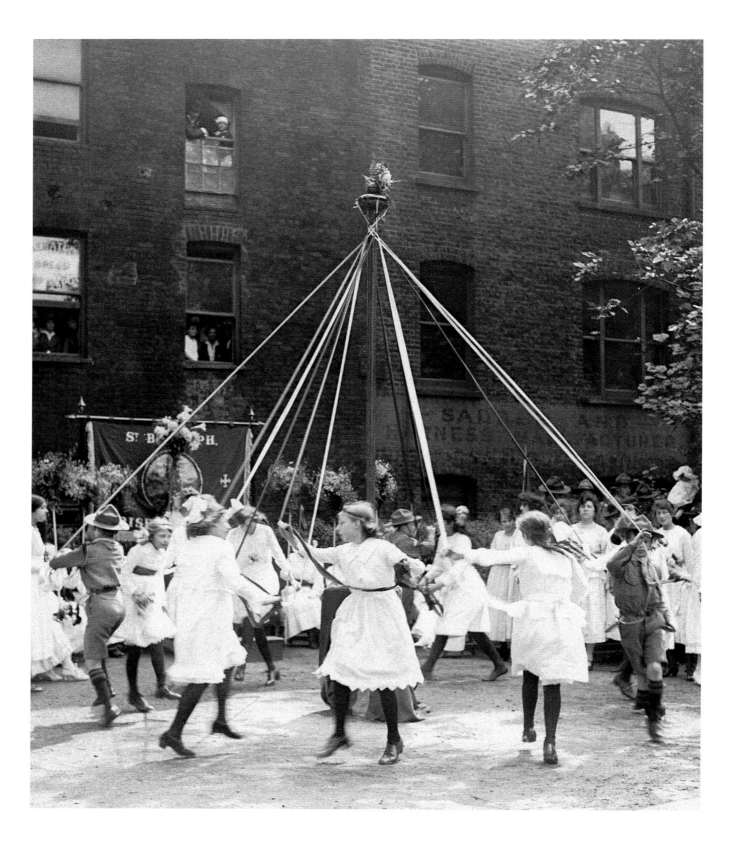

1919

It is 21 June, and the parish of St Botolph in Bishopsgate, London, celebrates the Summer Solstice by dancing round a maypole.

TODAY

On May Day, folk dancers and revellers fill the streets of Oxford at dawn, in a tradition dating back to the seventeenth century.

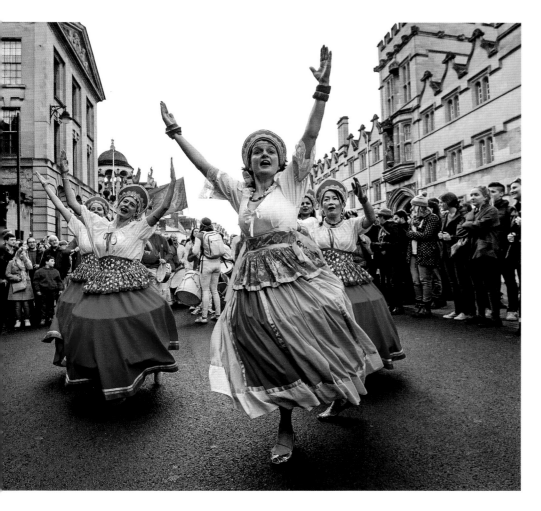

DANCING ROUND THE MAYPOLE

Pagans danced round trees as part of a tree-worshipping ritual. In Christian times, the worship of nature turned into a celebration of its life-giving force on May Day and at the Summer Solstice in June. The tree was replaced by a be-ribboned pole for young people to dance round.

Dancing round maypoles – like that other medieval custom, Morris dancing – is still very popular in smaller towns and villages. It is a regular feature of primary-school fetes, the children putting many hours of practice into getting their dancing right, so that their ribbons wrap themselves in a colourful pattern round the pole.

May Day itself is often celebrated in a style more akin to medieval revelry – the streets of Oxford traditionally fill up at daybreak with party-goers who've been out all night, gathering outside Magdalen College to hear the choir greet the dawn and the Great Tower bells ring out.

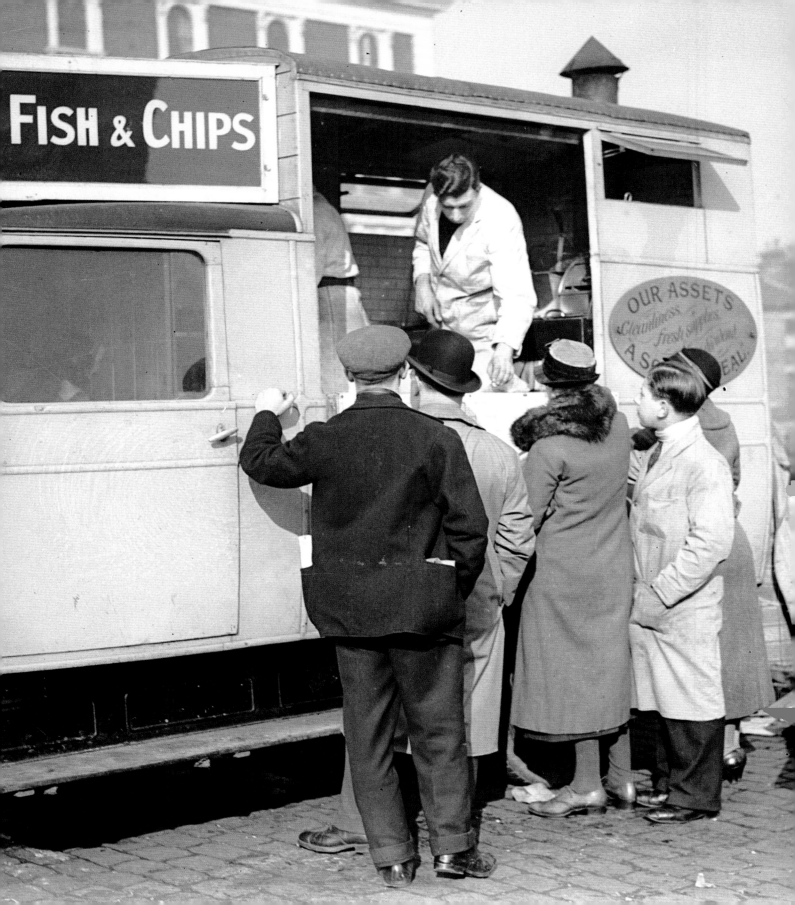

FISH & CHIPS

The railway relieved Britain's long-standing problem of how to supply cheap food to urban workers by quickly moving plentiful supplies of fish from fishing harbours to the towns. Fish and chips, bought for a few pence, sprinkled with vinegar and wrapped in cornets made from the daily newspaper, became the favourite meal of the urban working classes.

The supremacy of the fish supper was not challenged until quite late in the twentieth century. Cheap package holidays introduced millions of Britons to different kinds of food at a time when Indian and Chinese food, the American hamburger and hot dog were all beginning to cast their spells over British high streets.

Then the cod, haddock, whiting and plaice that were the essentials of the fish and chip business became scarce and expensive. Fish and chips has lost its place as Britain's top dish, with sales falling among millennials. However, new, stylish fish and chip shops are opening across the country – embracing contemporary interior design and modern ingredients. These restaurants are revitalizing the industry.

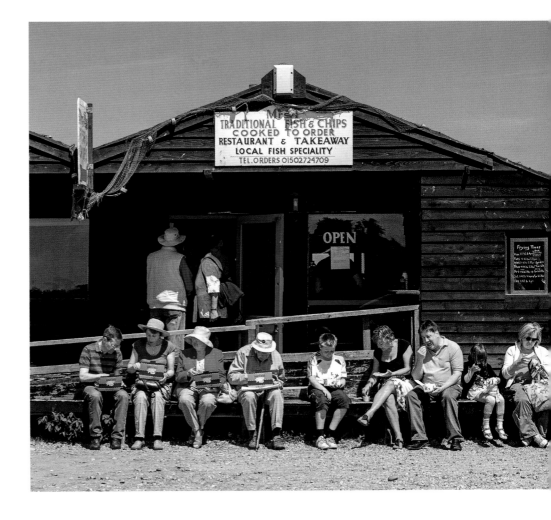

1935
Shoppers and workers queue at a van at London's Caledonian Market for a portion of fish and chips, wrapped in newspaper.

TODAY
Customers queue out of the door at this fish and chip shop in Southwold, Suffolk, and enjoy their meals outside in the sun.

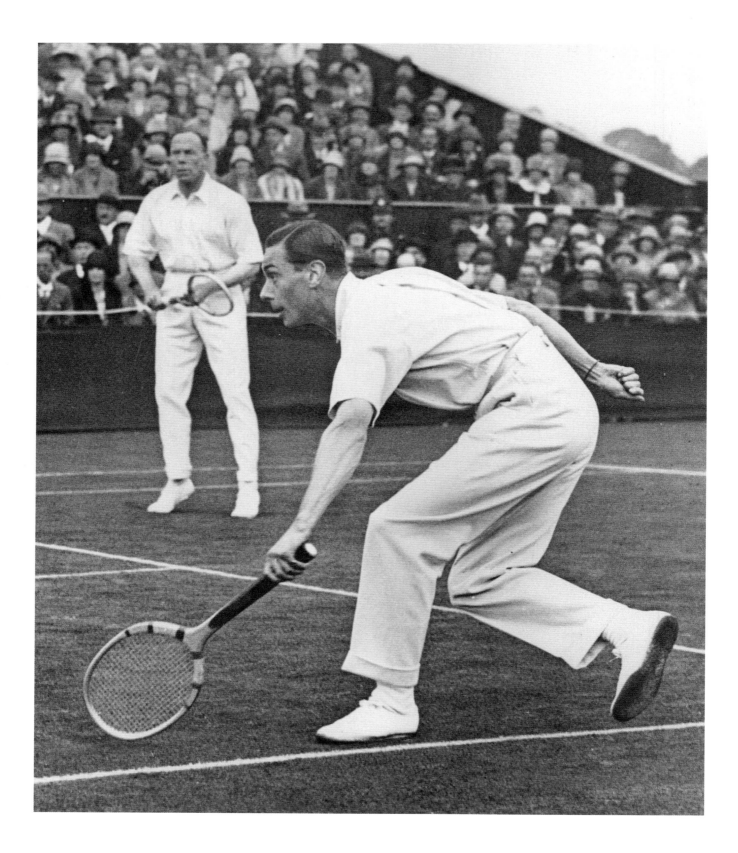

WIMBLEDON

The first Wimbledon tennis championships, all-Englishmen affairs, were held in 1877, at the grounds of the All-England Croquet Club. Players from overseas, first from the United States then from Australia and New Zealand, began taking part from the late 1880s.

Although tennis players began changing from amateurs to professionals in the 1920s in America, it was not until 1968 that Wimbledon, one of the world's four 'Grand Slam' tournaments, was opened to amateur and professional players alike. This move, helped by the arrival of colour television bounced off satellites to every country in the world, turned tennis into today's multimillion-dollar business in which the stars of the game can quickly become wealthy celebrities, with lucrative media opportunities on offer as well as large prizes.

Wimbledon is the only Grand Slam tennis tournament played on grass. So crowded is the sport's calendar today that in 2003 Wimbledon was moved back a week to allow more time for players to adjust from playing on the French Open's clay to tackling the former Victorian croquet club's lawn.

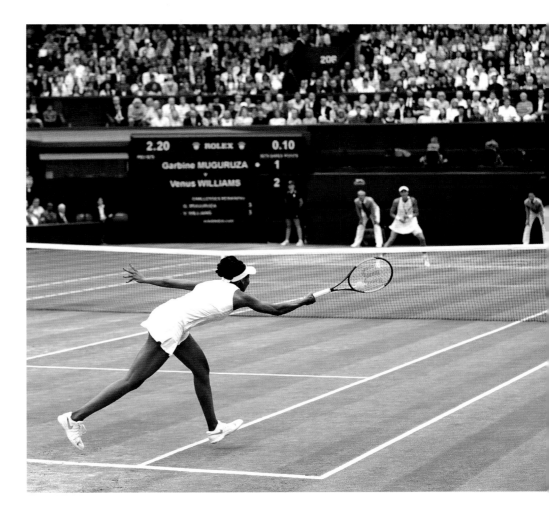

1926
A left-hander, the Duke of York – later George VI – took part in the doubles in the 1926 Championships, partnered by Commander Greig.

TODAY
Garbiñe Muguruza of Spain on her way to winning the 2017 Wimbledon Ladies' final against five-time Wimbledon champion Venus Williams of the US.

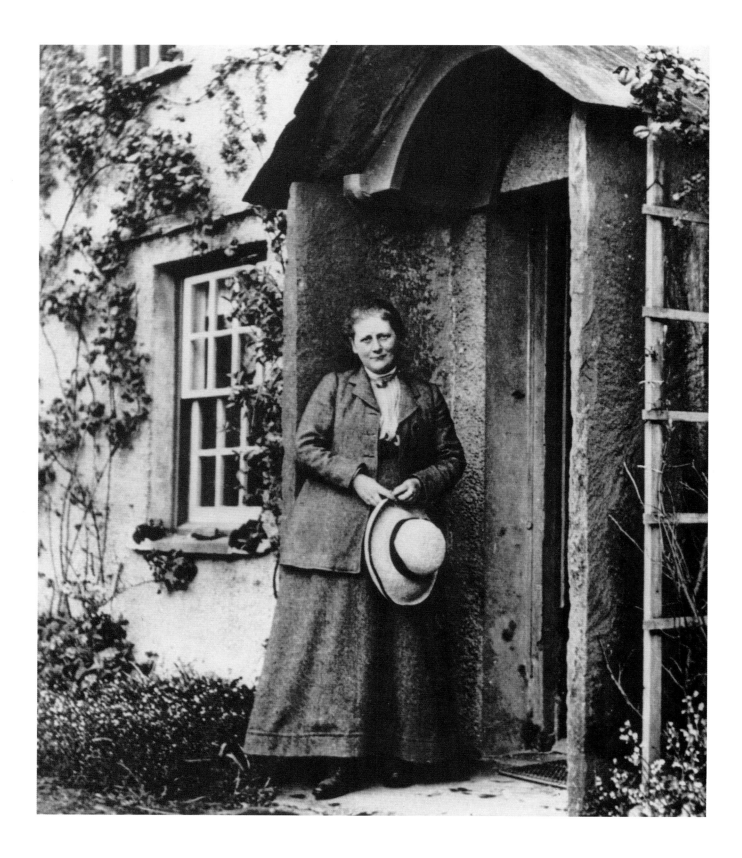

NATIONAL TRUST

Among the many organizations in the UK concerned with protecting the environment, the National Trust and the National Trust for Scotland stand out as charities that protect and conserve both buildings of historic interest and areas of natural beauty.

Founded in 1895, the NT acquired its first property, Alfriston Clergy House in Sussex, in 1896. Today, it looks after 248,000 hectares (610,000 acres) of land in England, Wales and Northern Ireland, on which stand over 500 historic houses, monument, gardens and nature reserves – and 59 villages. Over the border, the National Trust for Scotland has in its care 129 properties and 76,000 hectares (187,000 acres) of land. The Trust now has over four million members.

To visit a National Trust property is to step into a piece of Britain's heritage. From Hill Top, birthplace of Peter Rabbit and other famous characters created by novelist Beatrix Potter, to spectacular Tyntesfield in Somerset, from Lundy Island in the Bristol Channel to the Farne Islands, an enormous part of the nation's history is in the NT's devoted care.

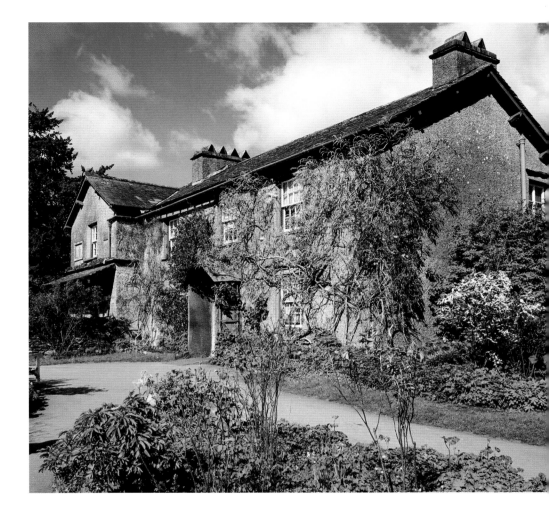

1905
Beatrix Potter at the door of Hill Top, her Lake District home and the setting for many of her delightful children's stories.

TODAY
Beatrix Potter bequeathed Hill Top farm, near Sawrey, to the National Trust, which keeps the farmhouse and its garden exactly as she left it.

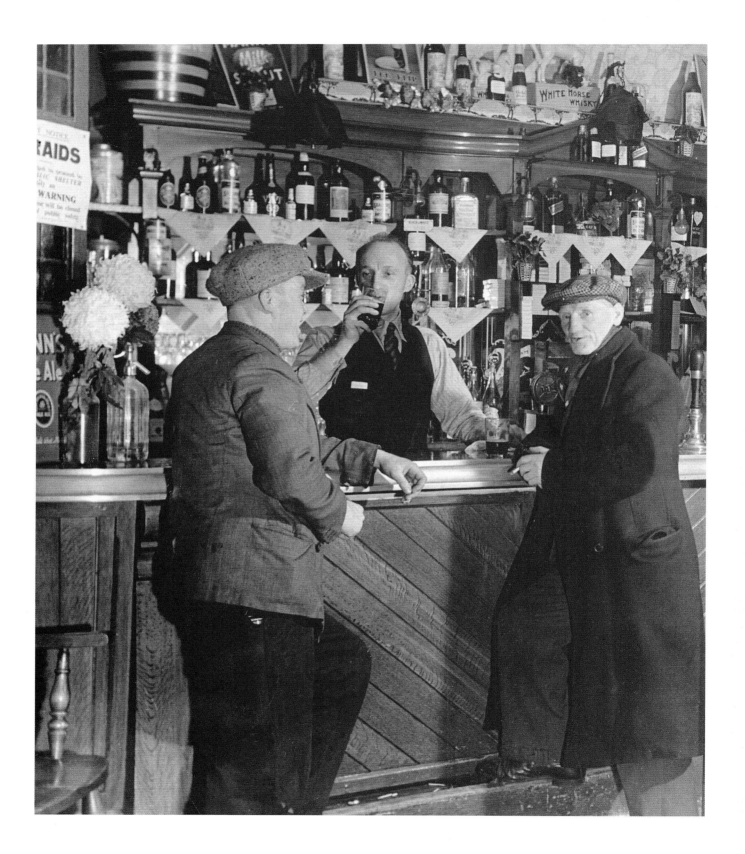

1939

The talk among the patrons of this London pub is all about the War, a weighty matter best discussed over a pint and a smoke.

TODAY

In 2016, Leicester City FC fans filled pubs to watch their team win the Premier League for the first time in their 132-year history.

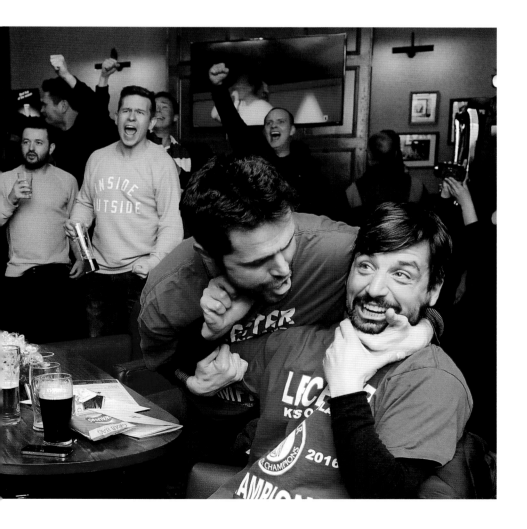

THE PUB

The character of the public house, licensed to sell beers and spirits to local people – mostly men – has changed fundamentally in recent decades. A change in drinking habits, begun when men chose to go to working men's clubs rather than to the pub, was accelerated by television, which has tended to keep families at home in the evenings.

Since the 1970s, nearly 30,000 UK pubs have closed. The smoking ban, which came into force in July 2007, had a big effect on pub culture. However the last few years have shown improved profits for pubs, as many establishments have radically changed what they offer in order to attract more customers.

The biggest change that publicans have made is to sell well-made food and a huge variety of specialist drinks. Pubs with a theme, pubs that offer karaoke or DJs on Friday and Saturday nights, quiz evenings and jazz nights all attract the crowds, and the passion for craft and specialist beer and spirits brings in new customers every day. But there's nothing like watching a big football match among a like-minded crowd, and football on the TV still gets people out of their living rooms and into the pub.

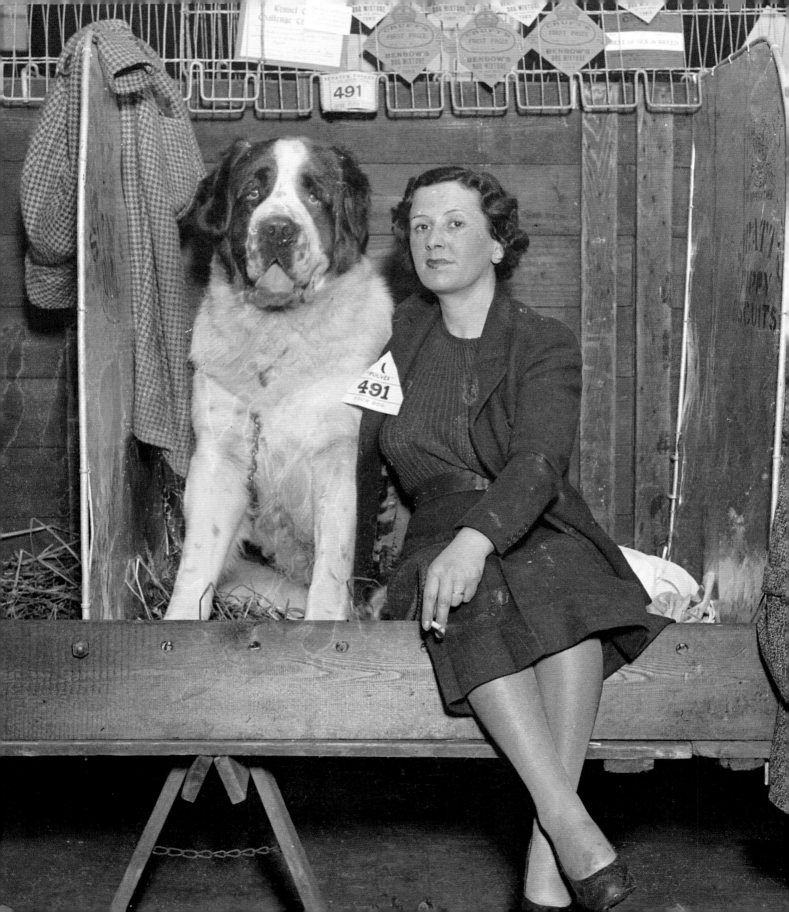

CRUFTS

The world's greatest dog show does not need a long name: everyone knows what Crufts is. The annual competition, the most important in the pedigree dog show year, is named after Charles Cruft, the general manager of James Spratt, a dog-biscuit manufacturing company.

In 1886, Mr Cruft organized a dog show, perhaps seeing it as a good way to promote his company's products. The competition he began has been held nearly every year since then, apart from the war years. The 100th Crufts Show was held in 2003, with more than 22,000 dogs from 177 different breeds taking part – 27,000 took part in 2018.

Crufts was a show solely for British dogs until anti-rabies laws were relaxed – since 2001, dogs from abroad have taken part, provided they have won qualifying events at home. Dogs compete in seven major classes for the title Supreme Champion, take part in obedience classes, and demonstrate their speed and agility in other events. Owners and handlers start young: children from up to 20 countries help to show and handle dogs at Crufts.

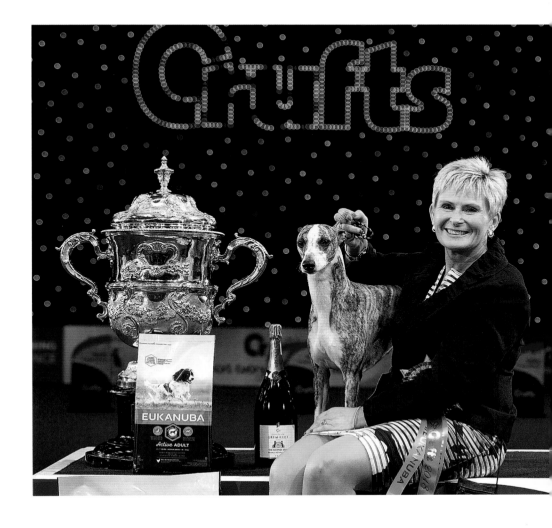

1932
A St Bernard rests after having won eight awards at Crufts while its owner relaxes with a celebratory smoke.

TODAY
Collooney Tartan Tease the Whippet poses after winning the most coveted prize, Best in Show, at Crufts 2018.

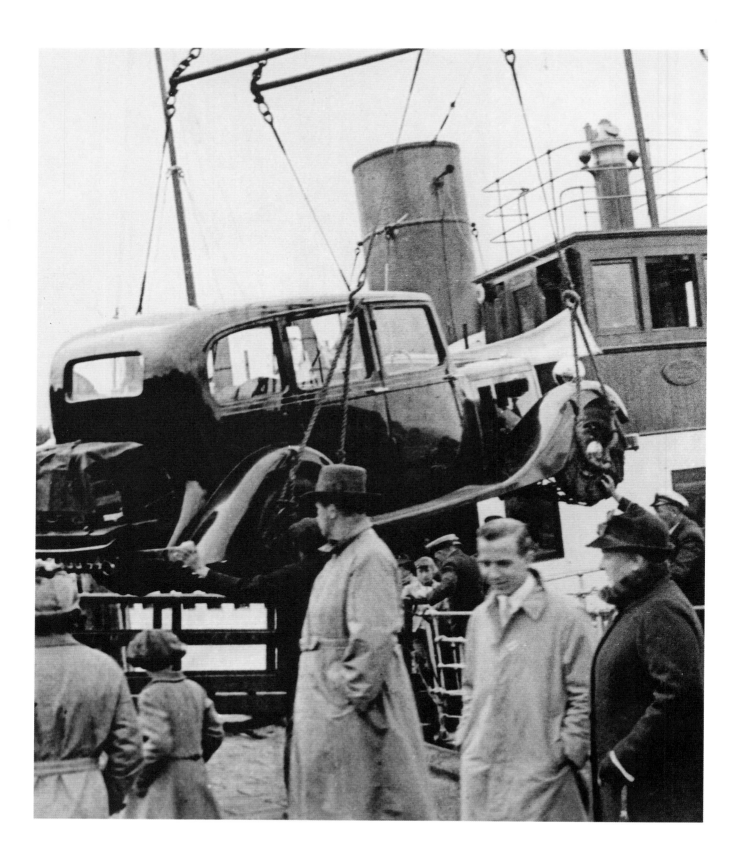

THE CHANNEL

Until the steamship brought regular services and cheap fares to the business, crossing the Channel was a hazardous and unreliable business dependent on tide, wind and weather.

The steamship made crossing the Channel so much easier that increasing numbers of people, many of them led by travel pioneer Thomas Cook, found their way to Europe. The age of the motor car gave cross-Channel ferries a new problem, overcome by treating cars as freight to be hoisted aboard with the help of a crane. Then came the roll-on, roll-off ferry, revolutionizing the cross-Channel trip for both commercial and holiday traffic.

But nothing has revolutionized cross-Channel travel like the Channel Tunnel. First planned by a Frenchman in 1802, attempted in 1880 and finally realized in 1994, the Channel Tunnel is used by a drive-on, drive-off shuttle train service and by a high-speed passenger service, operated by British, French and Belgian railways. With London only three hours from Paris, no wonder over 20 million people travel under the Channel every year.

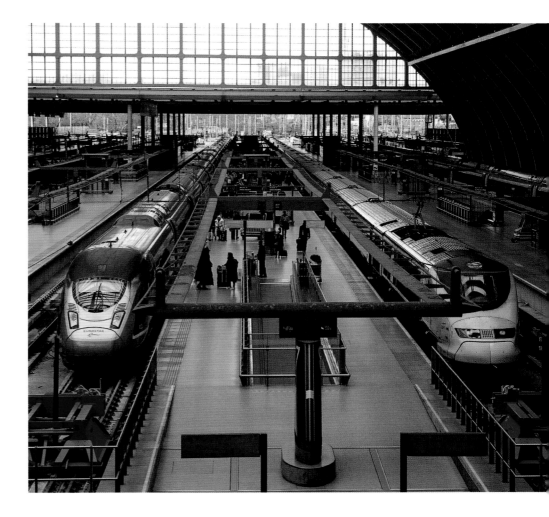

1930s
There are a few anxious moments for a car owner as his car, luggage strapped to the back, is hoisted aboard a cross-Channel ferry.

TODAY
St Pancras station, renamed St Pancras International, replaced Waterloo as the Eurostar Channel Tunnel passenger service's London terminal in 2007.

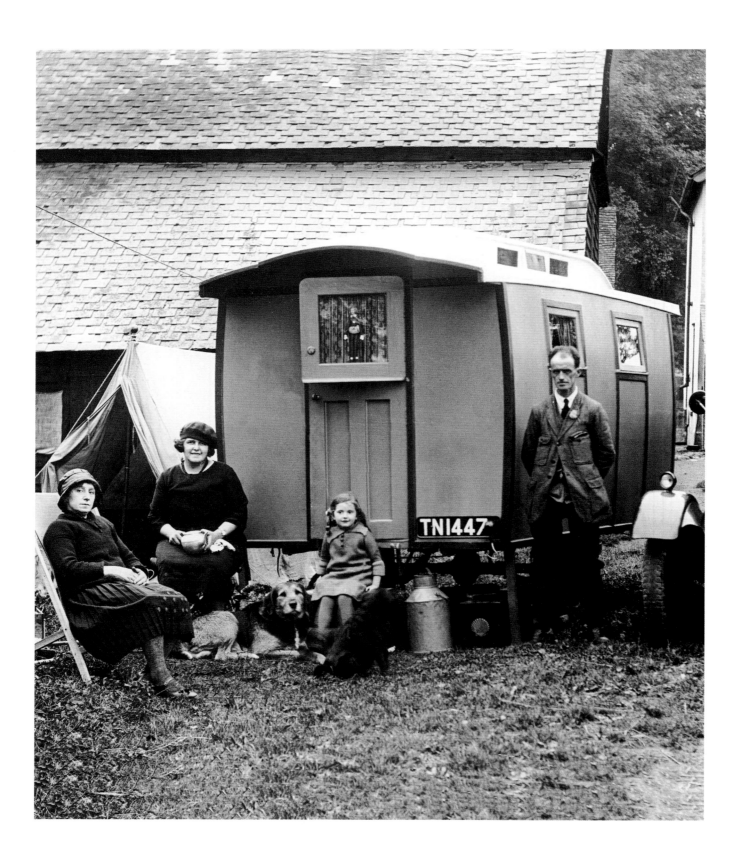

1926

This family's 1925 Morris Oxford 14/28 motor car has towed them and their caravan, plus tent and dogs, to Eccles, near Manchester.

TODAY

The sun shines down on this caravan at Loch Dunvegan on the Isle of Skye.

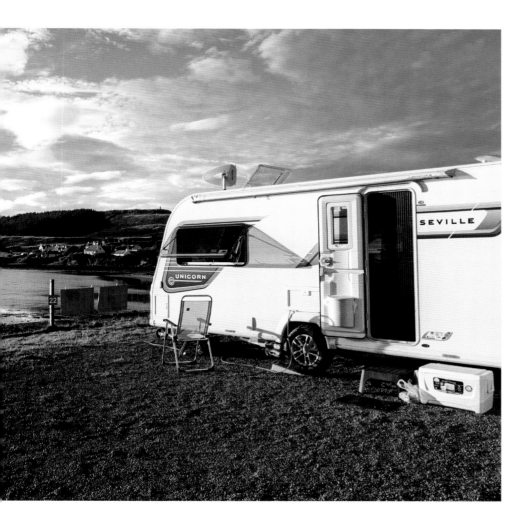

CARAVANING

It does not take a large car to tow a caravan, so the motor car opened up new vistas of enjoyable holidays for British people in the years after the First World War. Visits to the countryside or the seaside, with a place to stay already attached to the car, sounded irresistible, especially with the Automobile Association and, later, the Caravan Club able to offer advice and assistance.

British-made Austin and Morris tourers could get about country roads at 48 kilometres (30 miles) an hour and were reliable enough to need only simple repairs that most motorists could do themselves. The caravans they towed were not spacious, but had primus stoves for cooking and offered good shelter from bad weather.

The modern trailer or motorhome is a very different thing, the grandest offering all the creature comforts of a hotel. Parked on a good caravan site, the facilities of which could include a swimming pool and tennis courts as well as the more usual shops and laundry facilities, even the simplest caravan offers its owners the chance of a memorable holiday.

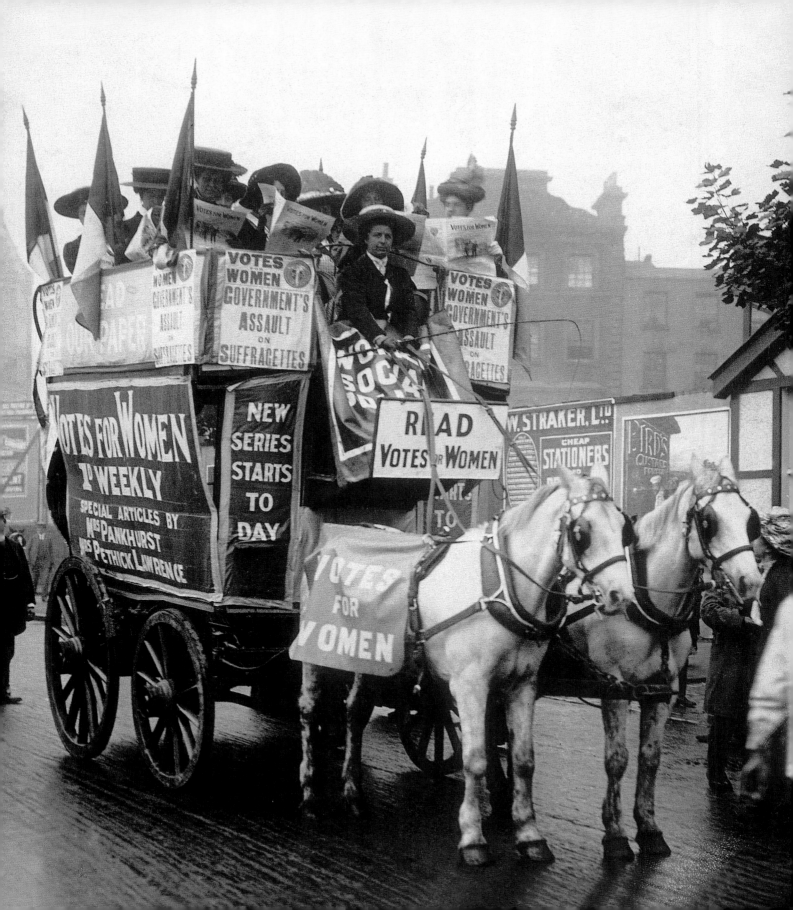

WOMEN GET THE VOTE

Although the move towards parliamentary democracy in Britain began in 1832, with the first Reform Act, by the end of the century women could still see no sign that they would ever be involved in the process.

Mrs Emmeline Pankhurst organized the Women's Social and Political Union in 1905 and led the fight, with increasing violence, for women's suffrage. One way the Union drew attention to the cause was by publishing a newspaper, *Votes for Women*, which carried articles by the principal figures in the campaign, including Mrs Pankhurst and Mrs Emmeline Pethick-Lawrence.

During the First World War, women did much of the work that men had done before August 1914. Their reward was the vote for women of property over the age of 30, used for the first time in the General Election of December 1918, winning electoral equality with men 10 years later. Today, all women have the vote and can play a full part in the electoral process.

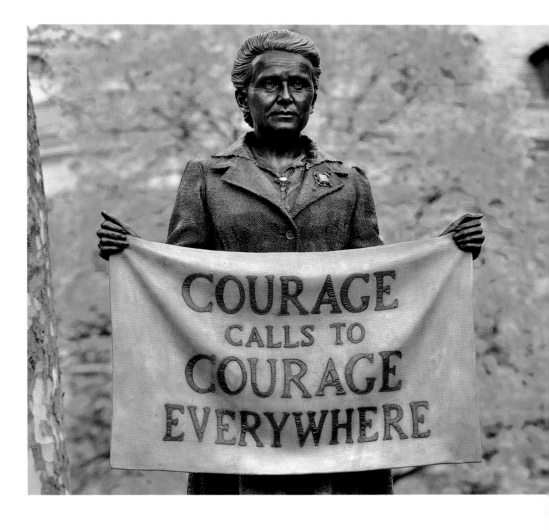

1909
Suffragettes used many methods, both peaceful and forceful, to put their case. This cart is advertising their newspaper, *Votes for Women*.

TODAY
The first statue of a woman to grace Parliament Square was unveiled in 2018. Turner Prize-winning artist Gillian Wearing created the sculpture of suffragist Millicent Fawcett to mark the centenary of the Representation of the People Act.

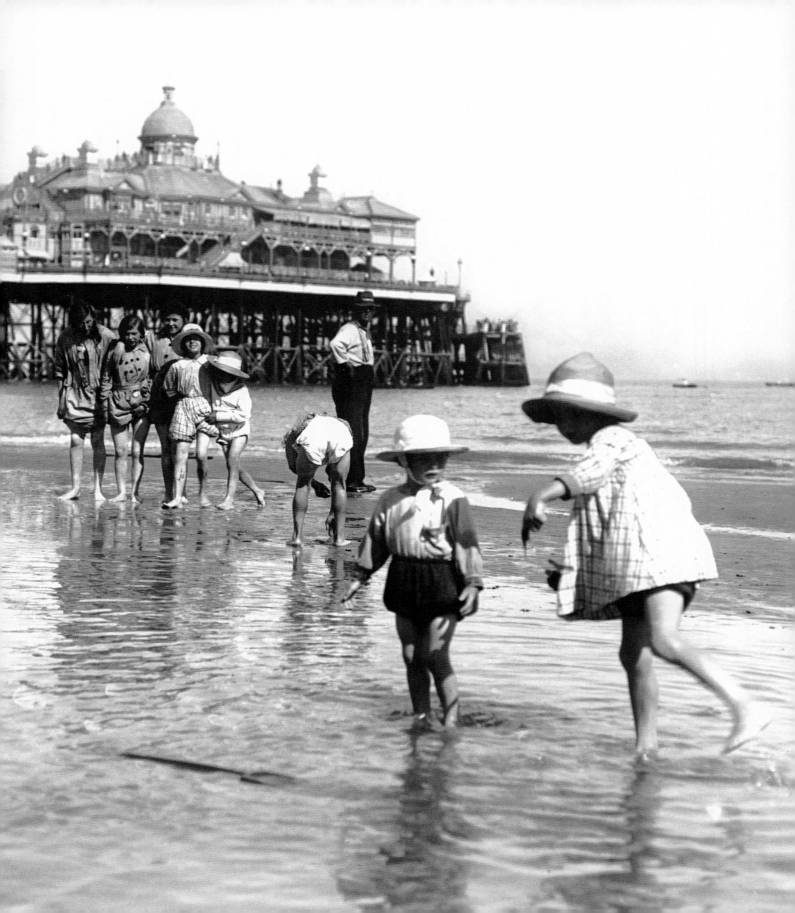

PLEASURE PIERS

'A good pier has long been regarded as an essential to a seaside town,' noted a Brighton guide book in the 1890s. In 1872, Eastbourne, along the coast from Brighton, got a pier to add to its other amenities. It was designed by the engineer Eugenius Birch, one of Britain's most prolific pier designers. In 1888, a pavilion and concert hall were added to the pier's amenities, which included an American bowling saloon, a rifle saloon with electric targets, and matinees in the concert hall.

Eastbourne Pier almost became a casualty of war in 1940, when the Army considered blowing it up to prevent it being used by German landing parties. In the end the Army simply removed a section of decking instead.

The pier was refurbished in 1996 and its Victorian splendour recreated, though many of its amenities, including a family amusement centre, nightclub and waterfront bar, are very much of the twenty-first century. Eastbourne Pier, unlike Birch's West Pier in Brighton, wrecked in a storm followed by fire in 2003, is again a premier south coast attraction.

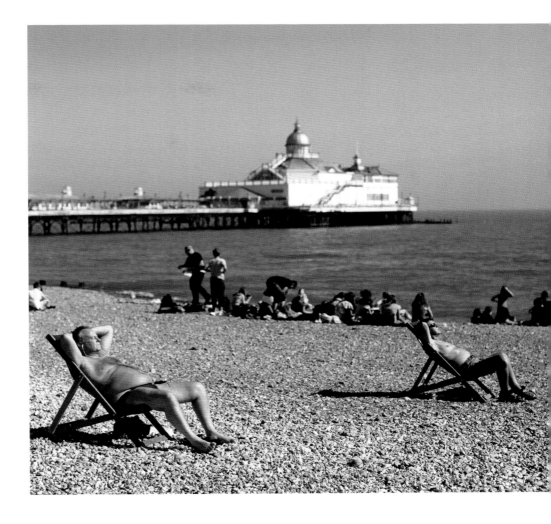

1918
Children have removed their shoes and tucked their clothing into their knickers to play on the beach near Eastbourne's pier.

TODAY
Sunbathers relax in front of Eastbourne's refurbished pier. Later, they will be able to enjoy the pier's evening attractions.

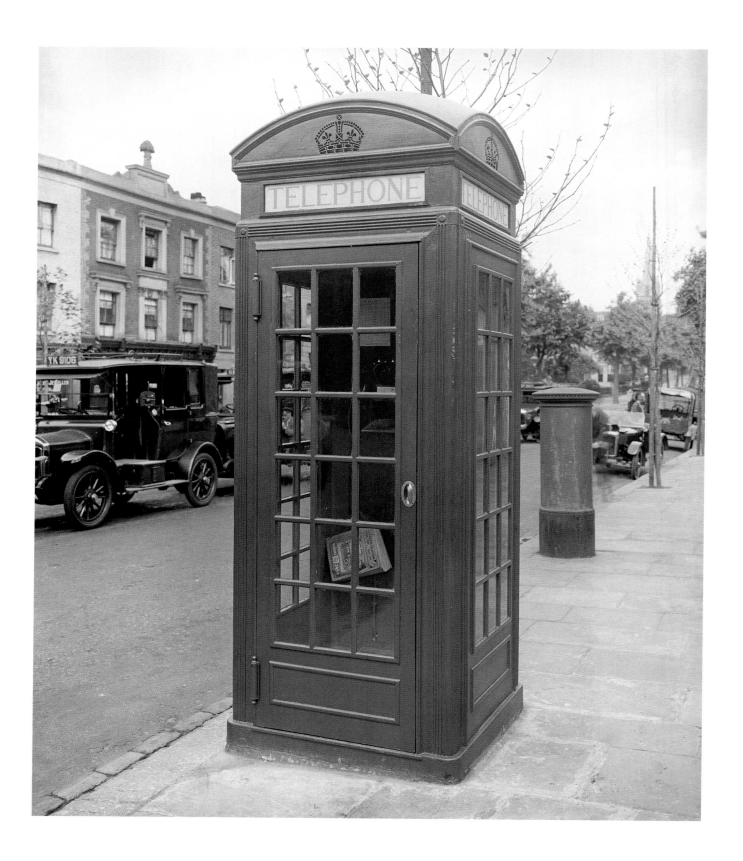

TELEPHONE ON THE STREET

When the telephone, patented by Alexander Graham Bell in 1876, was first made available for public use, callers were connected via a telephone exchange. An automatic dialling system, first used in Britain in 1912, made communication by phone much easier.

The General Post Office made the new system available in the street via a standardized design telephone box, introduced in 1921 and complete with dial phone, a coin box for payment and telephone directories. Painted bright red and with a royal crown displayed above the door, the telephone box remained a prominent piece of street furniture until the end of the century.

Declining standards of public behaviour brought about the end of the red telephone kiosk. Vandalized, their telephone books defaced and coin boxes broken into, most kiosks have been replaced by high-tech booths with Wi-Fi connections and card payment. The 20 remaining phone boxes in the city of Bath have been turned into mini hothouses and filled with plants.

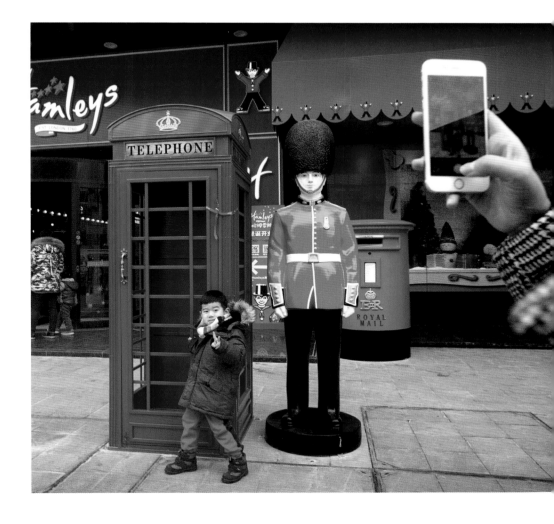

1926
A new-issue K2 telephone box in a London street. The K2, designed by Giles Gilbert Scott in 1921, was Britain's best-known phone kiosk.

TODAY
Red telephone boxes are still tourist attractions, but a smartphone in every pocket means they are rarely required for their original use.

SPORTS
& ENTERTAINMENT

THE
OLYMPICS
IN BRITAIN

Britain has been the host nation of the Olympic Games three times since the games of ancient Greece were revived in the modern world at the end of the nineteenth century. London hosted the IVth Olympiad in 1908. Some 1,500 competitors from 19 nations took part, and association football was included for the first time.

London's second hosting came in 1948, three years after the end of the Second World War. This time, 4,468 competitors (390 of them women) from 59 nations competed in 136 events over 17 sports. Two 'firsts' of the 1948 Games: starting blocks appeared on the athletics track, in races from 100 metres to 400 metres, and events were shown on home television.

There would be no feeling of austerity about Britain's third hosting of the Olympics in 2012, or the Paralympics that followed them. Rather than make do with existing facilities – Wembley Stadium had been the main venue in 1948 – a stylish new Olympic Park was built at Stratford in east London, with some sports also sited outside London so that more spectators could attend.

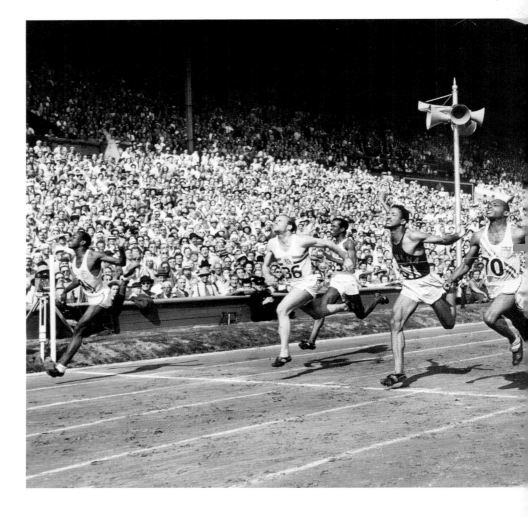

1948
The 100 Metres final: the USA's Harrison Dillard takes the Gold Medal, while Alastair McCorquodale of Great Britain narrowly misses a medal, coming in fourth.

TODAY
Great Britain's Dani King elated and celebrating after winning Gold, and breaking the World Record, in the Women's Team Pursuit at the London 2012 Olympics.

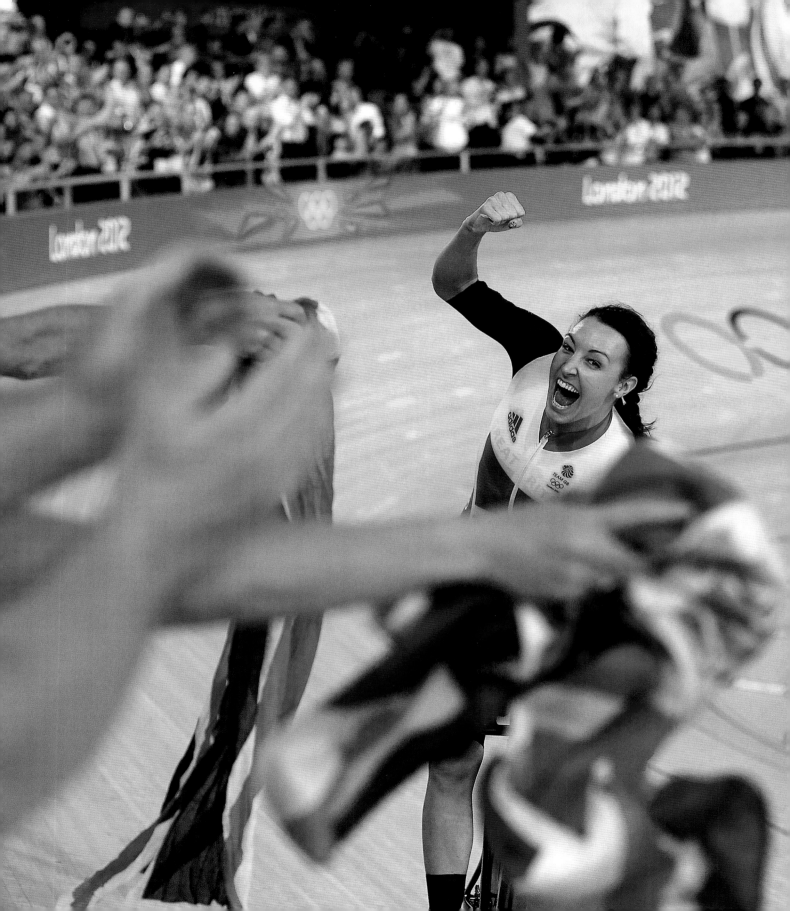

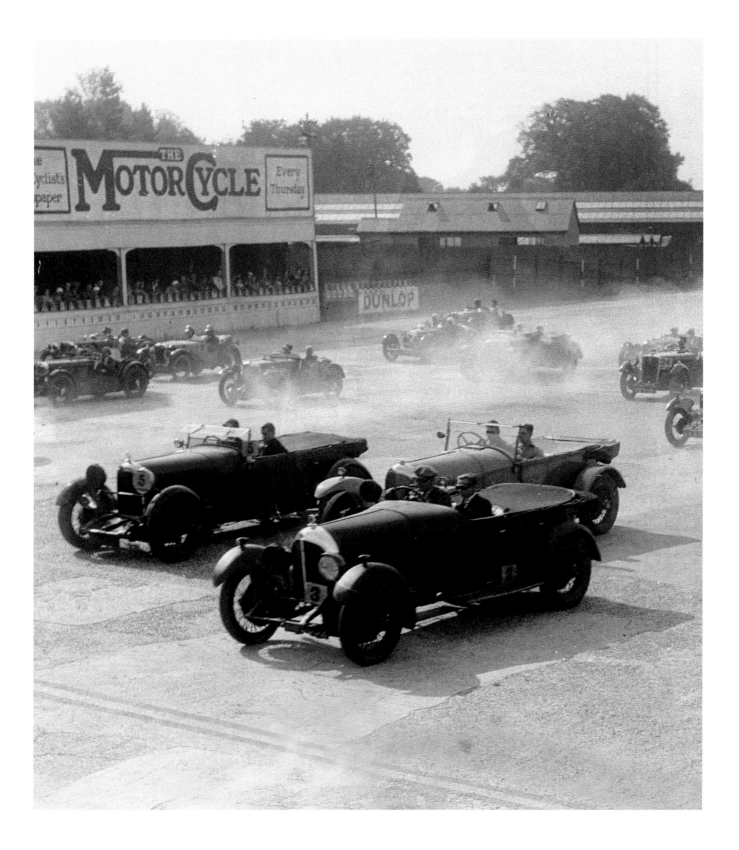

MOTOR RACING

Once motorcars became reliable at speed, motor racing took off. The first races were over roads for long periods of time that tested the endurance of car and driver alike.

The world's first special motor course was built at Brooklands, near Weybridge in Surrey, in 1906–07. Here, on a specially banked circuit, the Brooklands Automobile Racing Club and other clubs held races, driving tests, speed trials and long-distance races for sports cars and pure racing cars up to 1939. Circuits built after Brooklands included Donington Park, Brands Hatch and, after the Second World War, Silverstone in Northamptonshire, which is today the venue of the British Grand Prix.

The first Grand Prix race was held in France in 1906, and by the 1930s, when Grand Prix races had long been held on closed circuits, pit work on the cars was becoming a fine art.

Today's Grand-Prix racing car's pit team is a miracle of speedy efficiency, with each member an important element in the car's success. Behind the scenes is an army of designers, engineers, technicians and drivers who built and designed the car.

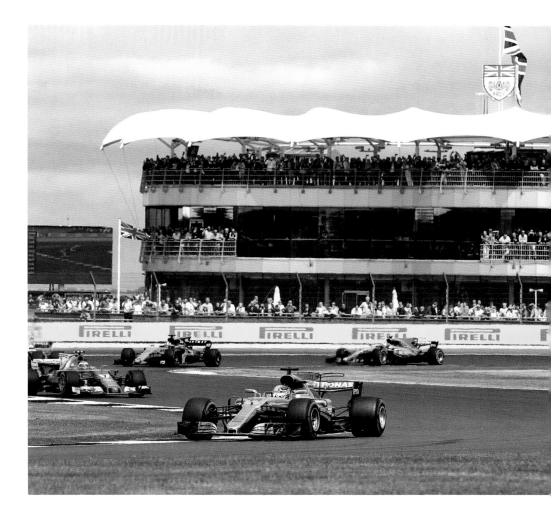

1933
Dust flies at a race meeting at Brooklands, with a Lagonda 1954 (left) and a Bentley 2996 (right) racing ahead.

TODAY
Lewis Hamilton takes the lead at Silverstone. The Formula One driver won his fifth British Grand Prix in 2017.

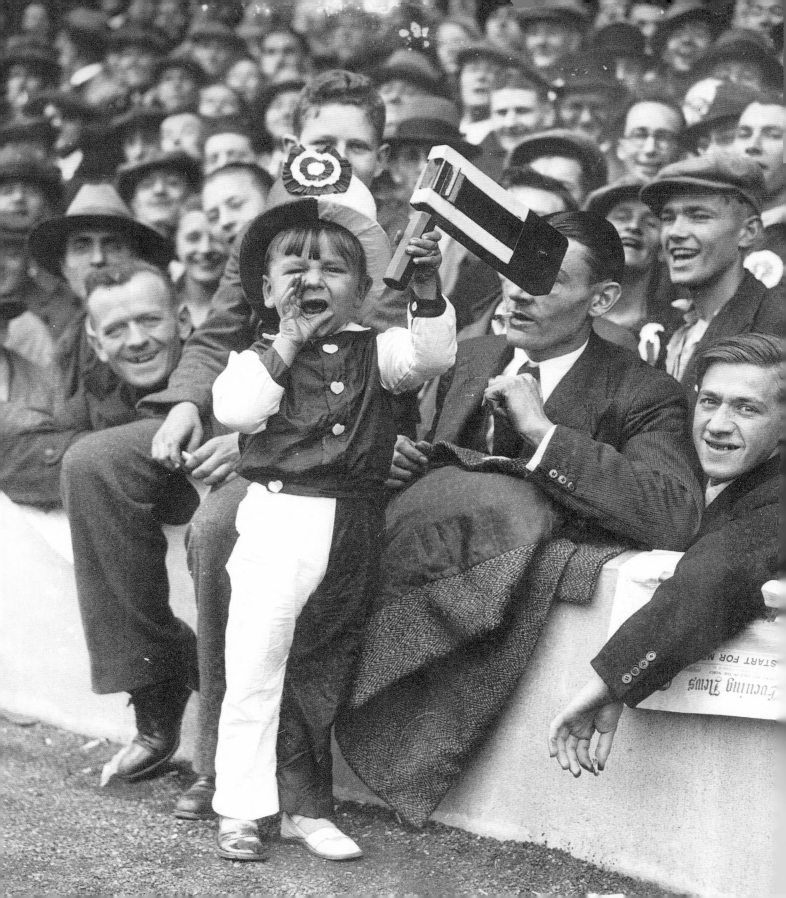

FOOTBALL

Association Football is Britain's favourite team sport, played and watched by millions. It has inspired best-selling novels, television soap operas, movies, plays and musicals.

The game in the UK today is run by four separate football associations, all descended from the Football Association founded in England in 1863. The FA and the Football League, founded in 1888, were both the first organizations of their kind in the world.

When the FA was formed, it had just a dozen or so teams to deal with, most of which were made up of players who worked together, rather than living in the same town. London's Arsenal team, for instance, was made up of workers at the Woolwich Arsenal – hence their nickname, 'the Gunners'.

Today, over 700 clubs are affiliated to the FA and in 2016's competition, matches were attended by over 1.8 million fans. The Scottish FA has over 70 full and associate clubs and nearly six thousand registered clubs under its jurisdiction. No longer just a sport, football is very big business indeed and success is vital for a major club's well-being.

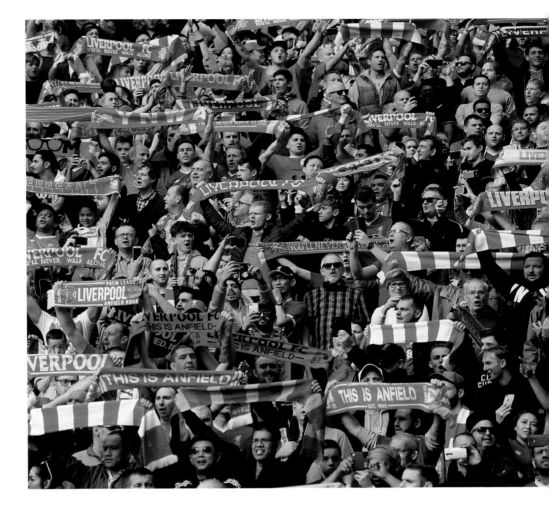

1934
A young Arsenal fan exercises his lungs at the start of a London derby, Arsenal v. Tottenham Hotspur, at Highbury, Arsenal's home from 1913.

TODAY
Fans show their support during a premier league match between Liverpool and Manchester United at Liverpool's home ground, Anfield, 2017.

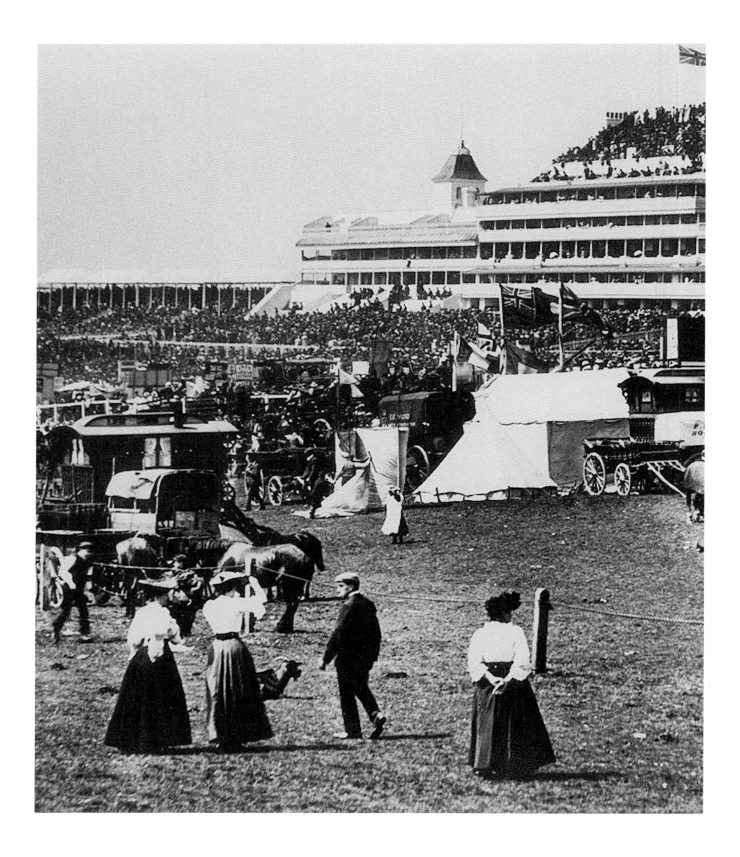

DERBY DAY

The Derby, a race for three-year-old colts and fillies, is one of the classics of British flat racing. It was first run at Epsom, even then a 50-year-old race course, in 1780.

By early in Victoria's reign, the Derby had become more than just another race. It was a highlight of the English racing calendar and a popular day out for the masses, who were able to enjoy all the fun of the fair that took over Epsom Downs for the day. William Frith's Derby Day, painted in 1858, captured well the fun and excitement of the occasion.

The Derby lost something of its shine in the last decade or so of the twentieth century. The prize money was less than that offered in other races and fewer people took time off in mid-week to attend. Moving the Derby to a Saturday and increasing the prize money helped return the race to the status of a must-attend event. The hospitality boxes and tents are packed, double-decker buses offer great views for those who arrive in them and the champagne flows freely. Within a horseshoe's throw of them all, the bookies win fortunes.

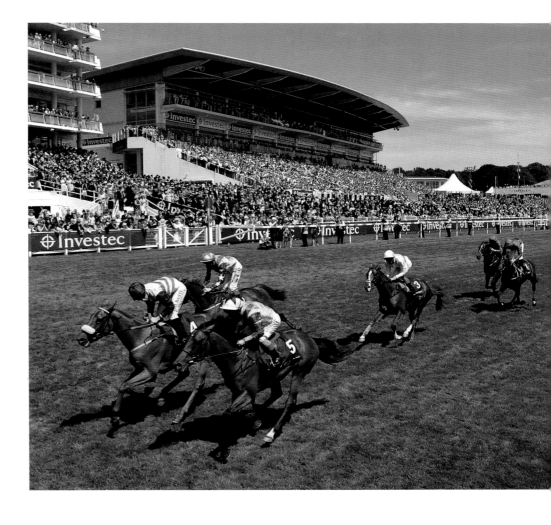

1898

The grandstands are full and gipsy caravans, tents and carts crowd the traditional fairground at Epsom for the running of the Derby.

TODAY

Racing fans crowd Epsom Downs on Derby Day. The on-course bookies are ranged along the fence, ready to take the punters' money.

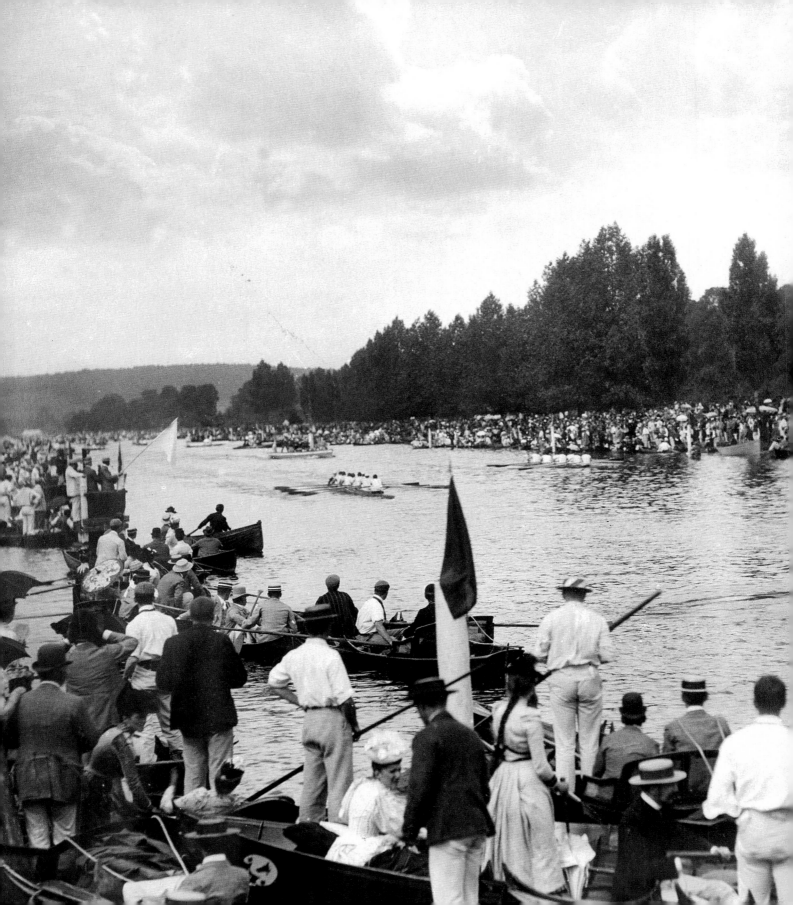

HENLEY REGATTA

A high point of the year for the sport of rowing in Britain is the Henley Royal Regatta. The oldest rowing regatta in Europe and the most famous in the world, the first Henley Regatta was held in 1839, 10 years after the first Oxford and Cambridge Boat Race was rowed over the reach at Henley-on-Thames.

Throughout Victoria's reign, the Henley Regatta was a major attraction for rowers and a high point of the summer social scene. Rowing clubs, universities and schools, both the great public schools and schools from local riverside towns, sent teams to compete for the various trophies, the oldest of which – the Grand Challenge Cup, for eights – was rowed for at the first Henley Regatta.

Today the Regatta, long a major event in the international rowing calendar, has acquired added celebrity. It was at the Henley Regatta that the five-times Olympic Gold Medal winner Steve Redgrave honed the race-winning skills that, added to years of practice on the Thames, enabled him to become the most successful male rower in Olympic history.

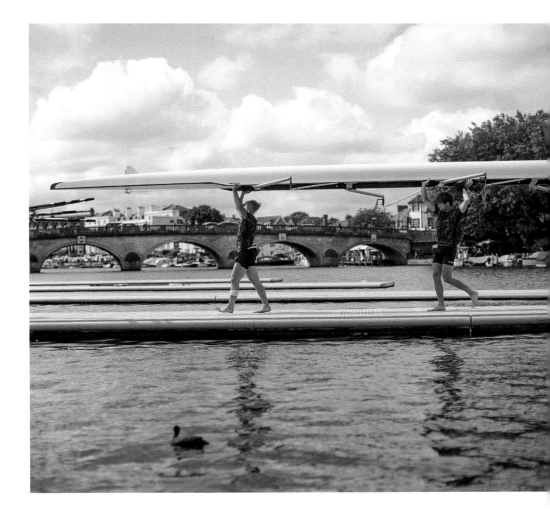

c.1901
Punts and rowing boats crowd together near the finishing line as their occupants watch an eights race at the Henley Regatta.

TODAY
The five-day Henley Royal Regatta is now in its 178th year, the rowers now having high-tech kit and equipment for superlative performance.

73

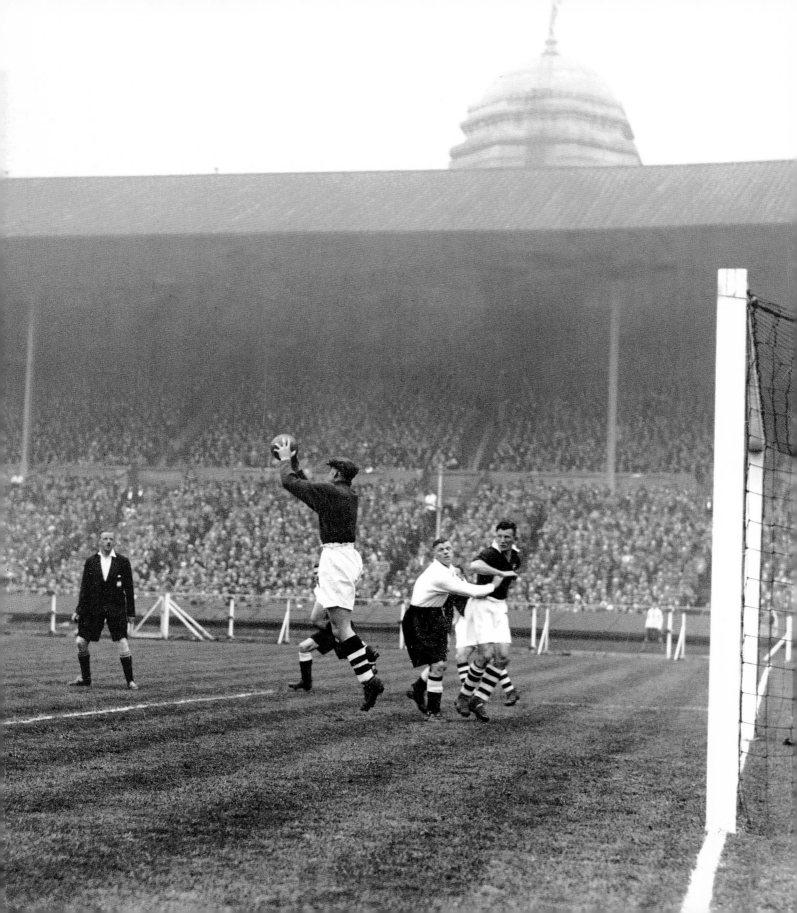

THE FA CUP

English football has its most glorious day of the year when the final of the FA (Football Association) Cup is played. It is the climax of a knock-out competition involving teams from all the football divisions – and involving, too, enough luck to ensure that it is not always the great teams from the Premier Division who reach the later stages and even the final.

The first FA Cup final was held in March 1872, when a crowd of about two thousand people saw Wanderers beat the Royal Engineers 1–0 at Kennington Oval. Fifteen clubs, including Queen's Park, Glasgow, entered the competition 'for a Challenge Cup open to all clubs belonging to the Football Association'.

Scotland having long had its own FA Cup, today's FA Cup final is an all-English affair. While the strength of, and therefore the main interest in, English football lies in the week-by-week programme of the Football League, the FA Cup knock-out competition retains all its exciting magic, especially with the later rounds restored to its traditional ground, the hallowed turf of Wembley Stadium.

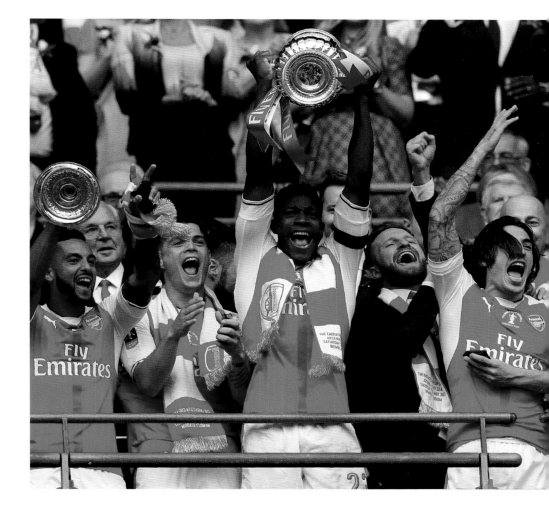

1934
The goalkeeper retains his flat cap when making a save at the Manchester City v. Portsmouth FA Cup final at Wembley Stadium.

TODAY
Arsenal's Danny Welbeck hoists aloft the FA Cup as the team celebrate their 2017 win.

1930

Highland Games rules require competitors tossing the weight to wear the kilt. This man has put on shorts beneath his kilt.

TODAY

A competitor attempts to toss the caber – a five-metre (17-foot) long tree trunk – at the Cornhill Highland Games in Aberdeenshire.

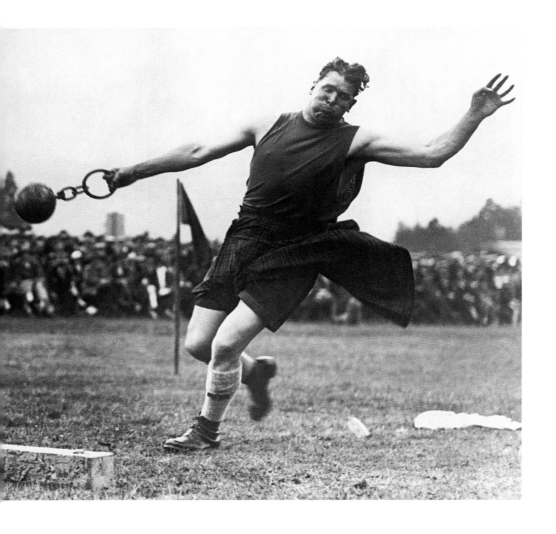

HIGHLAND GAMES

The athletics meetings known as Highland Games were first held in the highlands of Scotland early in the nineteenth century.

Similar sports meetings begun at much the same time, such as those in the Scottish lowlands (Border Games) and the Lake District of England (Lakeland Games), have lost something of their former glory. But the Highland Gathering, held every September at the small Deeside town of Braemar, continues to be very popular. The Queen and other members of the Royal Family never miss attending the Braemar Gathering if they are in residence at Balmoral Castle, the royal home in Scotland, just 10 kilometres (six miles) away.

Most Highland Games are a mixture of standard track and field events and competitions with a more cultural flavour, such as Scottish country dancing and bagpipe playing. Some peculiarly Scottish events, like tossing the caber and tossing the weight, add to visitors' enjoyment.

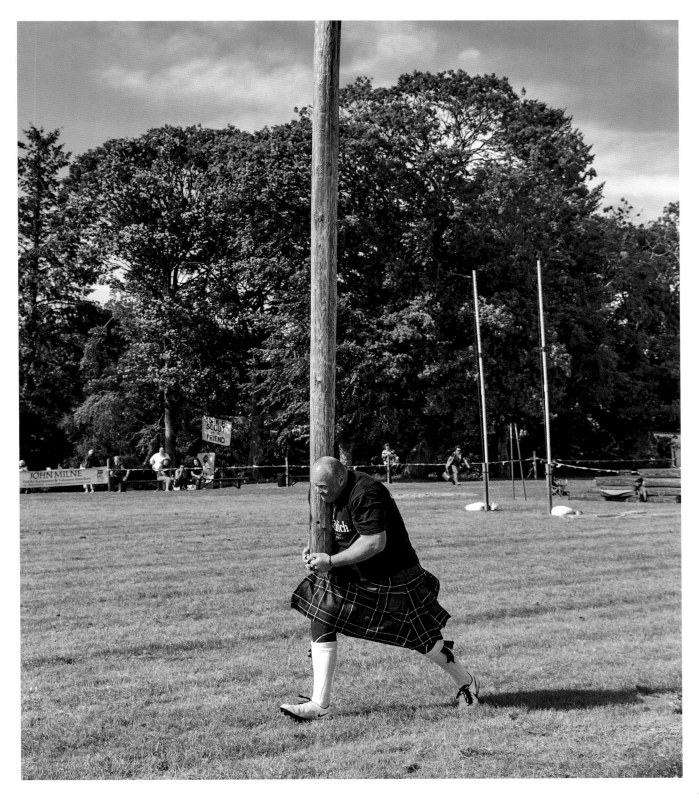

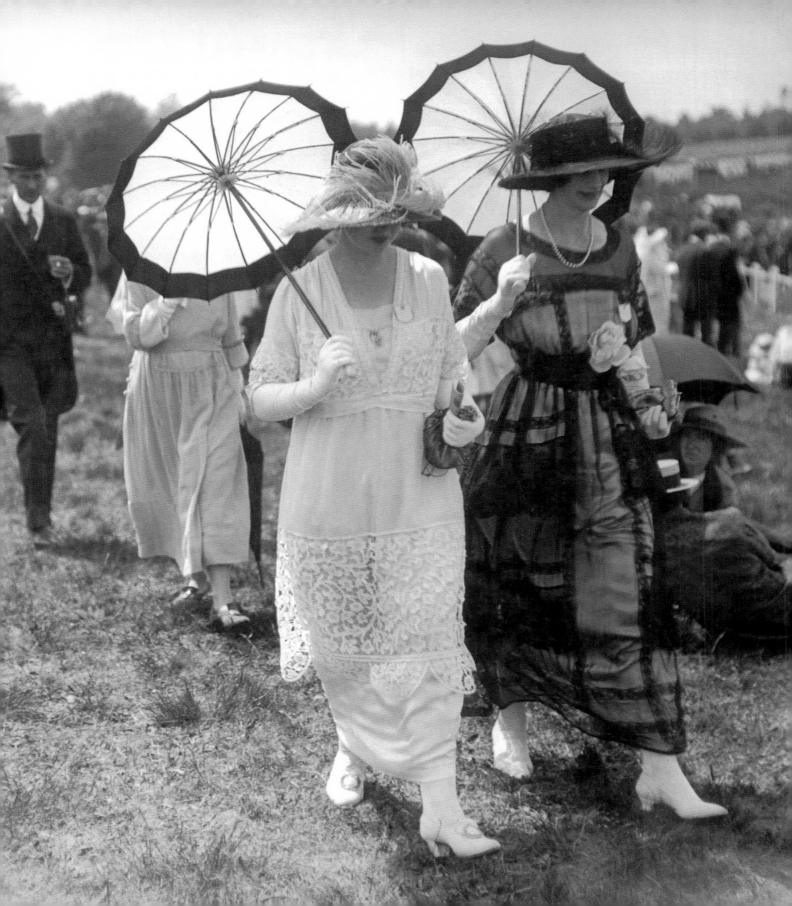

ROYAL ASCOT

Queen Anne started the Royal Ascot race meeting at her racecourse near Ascot in 1711. The racecourse, near Windsor Castle, is one of the finest in the UK and remains in royal hands. As does the organization of the Royal Ascot meeting, a highlight of the flat racing season, which takes place in June.

Royal Ascot is today, as it has been since Edward VII's reign, the highest point of England's society calendar. It is the Queen's racecourse and the only one in the country where she and her family and other guests arrive by way of a drive in elegant horse-drawn carriages up the race track.

The quality of the racing is generally outstanding, too. It is flat racing, under Jockey Club rules, and the cream of the country's race horses are entered for the four days of racing. Among the most important of the races held during Royal Ascot week is the Ascot Gold Cup, a race over 4,023 metres (2½ miles) first run in 1807 and now the highlight of Ladies' Day, when women race-goers don their largest and most extravagant hats and most glamorous outfits.

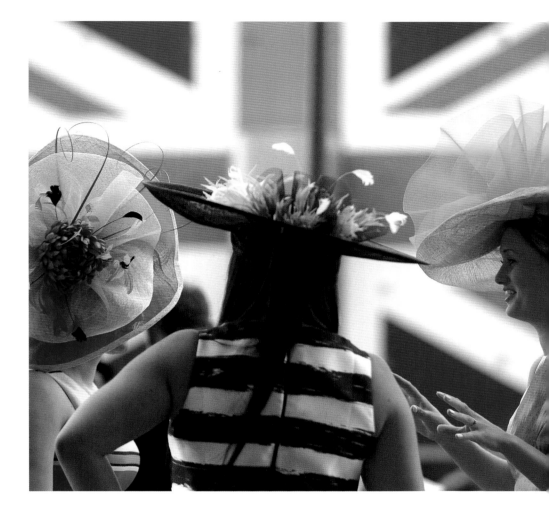

1919
Elegantly dressed Ascot race-goers make their way past ordinary folk who have no need of expensive grandstand tickets to enjoy their day.

TODAY
Ladies' Day at Royal Ascot, when the women's hats steal the limelight. Men, in contrast, wear grey toppers and morning coats.

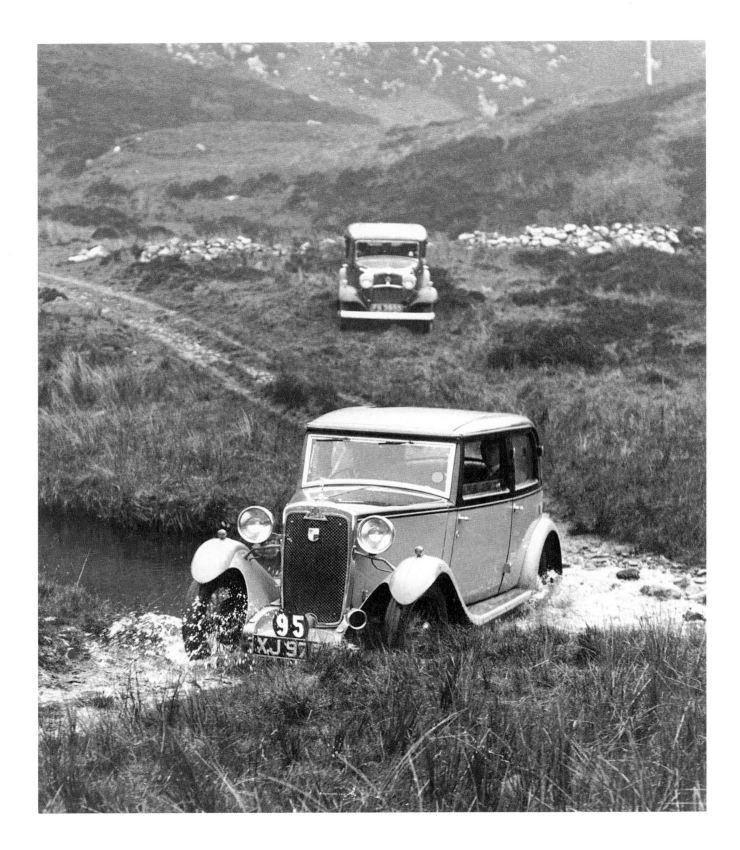

CAR RALLYING

In the early days of car rallying, a sport that included the excitement of driving cars across country in all weathers, the sport was open to everyone. A well-maintained and highly tuned car was the key to success, and even a humble Austin, Morris, Wolseley or Ford could provide a triumphant win in a major event.

As engines became more sophisticated, with electronic controls to increase efficiency and improve performance, keen motorists wanting to take part in the top rallies had to become technically expert too.

Car rallying is a motorsport that everyone with an ordinary car can enjoy, at the level of car club and similar rallies. At the top level of rallying – such as Wales Rally GB, an event in the World Rally Championship in which Britons have excelled in recent years – cars must be highly tuned and their drivers very skilled. The numbers who turn out to watch, in snowy Scottish forests and rain-swept Welsh hill country, attest to the great attraction of a motorsport with which all car drivers can identify.

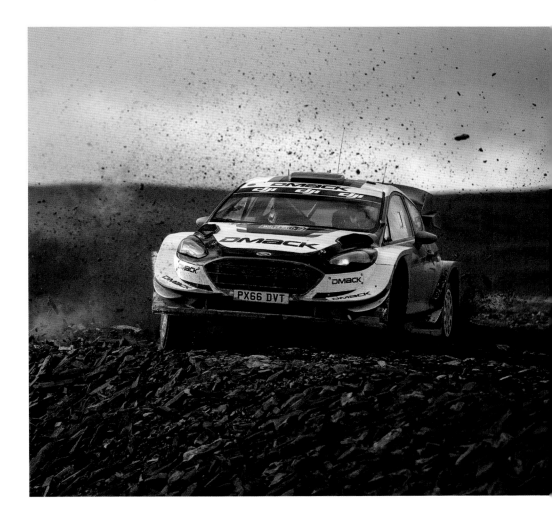

1930s
A 1933 Crossley 10hp, entry no. 95, splashes through a stream in rough country during a 1930s staging of the Scottish Rally.

TODAY
Elfyn Evans of Great Britain and M-Sport Ford World Rally Team in action during the 2017 Wales Rally GB, near Llangurig, Wales.

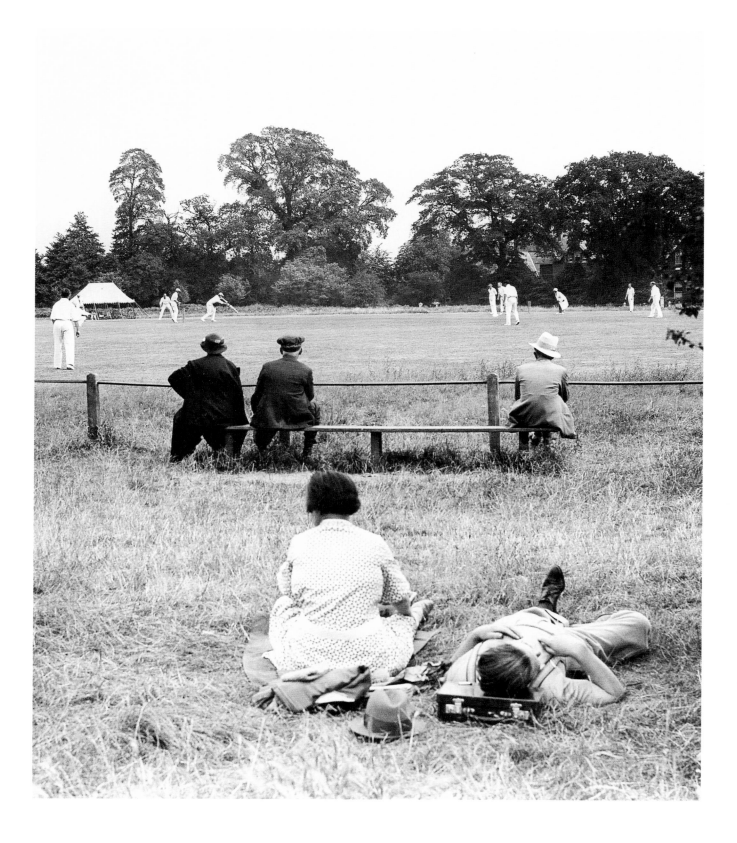

1930s
Fashions may change for players and spectators,
but the ingredients of club cricket – tea tent,
deckchairs, the sound of leather on willow – don't.

TODAY
The stands are packed at this Test match
between England and South Africa at Lord's
Cricket Ground, 2017.

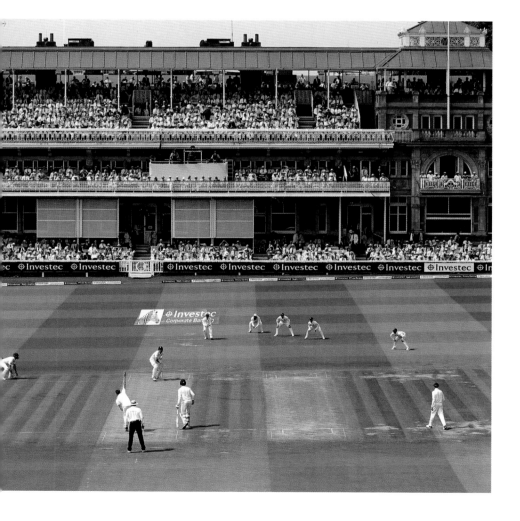

CRICKET

The quintessentially English game of cricket,
a form of which had been played in England
and other countries for centuries, began in its
modern form in the peaceful village of
Hambledon in Hampshire in the 1760s.
Although much has happened to cricket
since, quiet cricket on village greens and in
parks remains the bedrock of the game.

The centre of the game had moved to
London by the 1790s, when the Marylebone
Cricket Club was formed. The rules of the
game were agreed at the MCC in 1835, and
have changed little in essentials since.
Overarm bowling was allowed after 1864
and the classification of cricketers into
Gentlemen and Players (with their own
dressing rooms at Test matches) was
abolished in 1963.

Cricket is a hierarchy of club cricket,
county cricket, one-day cricket and Test-
match cricket. The latter is played between
countries introduced to the game by
Victorian empire-builders sent out to
reproduce the English way of life in their
colonial possessions. For many, cricket is the
best legacy of the Empire.

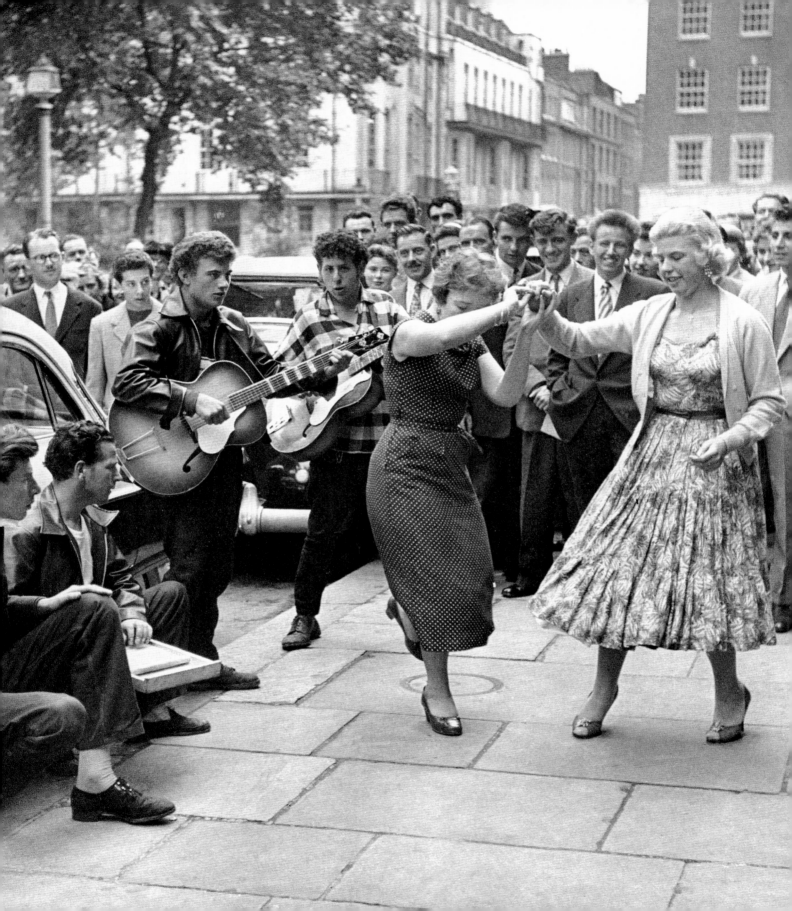

POPULAR MUSIC

A popular-music revolution got under way in Britain in the 1950s, strongly influenced by the amazing sounds coming across the Atlantic from such pioneers of rock 'n' roll as Bill Haley, Elvis Presley and Chuck Berry.

Skiffle was an early musical response in Britain to all this, and many teenagers formed their own skiffle groups. Few of them became as famous as John Lennon, whose first group, The Quarrymen, were happy to cut their performing teeth at church fetes and to include in their band a bass made out of a tea-chest, a broom handle and a length of string.

Today, great musicians are more likely to be found performing before vast crowds at yet another venue on their latest world tour or in front of equally large and often rain-soaked, mud-caked crowds at music festivals. Kicking off on the Isle of Wight in 1970 and at Glastonbury shortly afterward, the star-studded music festival is now an essential part of the British summer scene. Festivals may be simply a case of sex, drugs and rock 'n' roll to their elders, but to the young they are musical heaven.

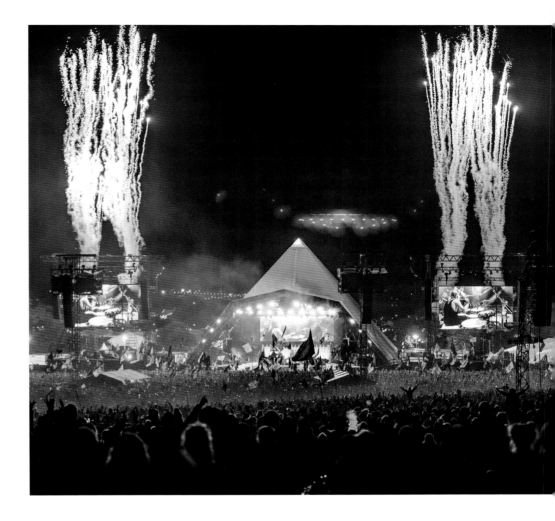

c.1956
Two women dance while a skiffle band plays at Soho Fair in London's Soho Square. Skiffle players often used homemade or improvised instruments.

TODAY
Glastonbury Festival started as a small gathering in a Somerset field in the 1970s. Today, it is the largest greenfield festival in the world.

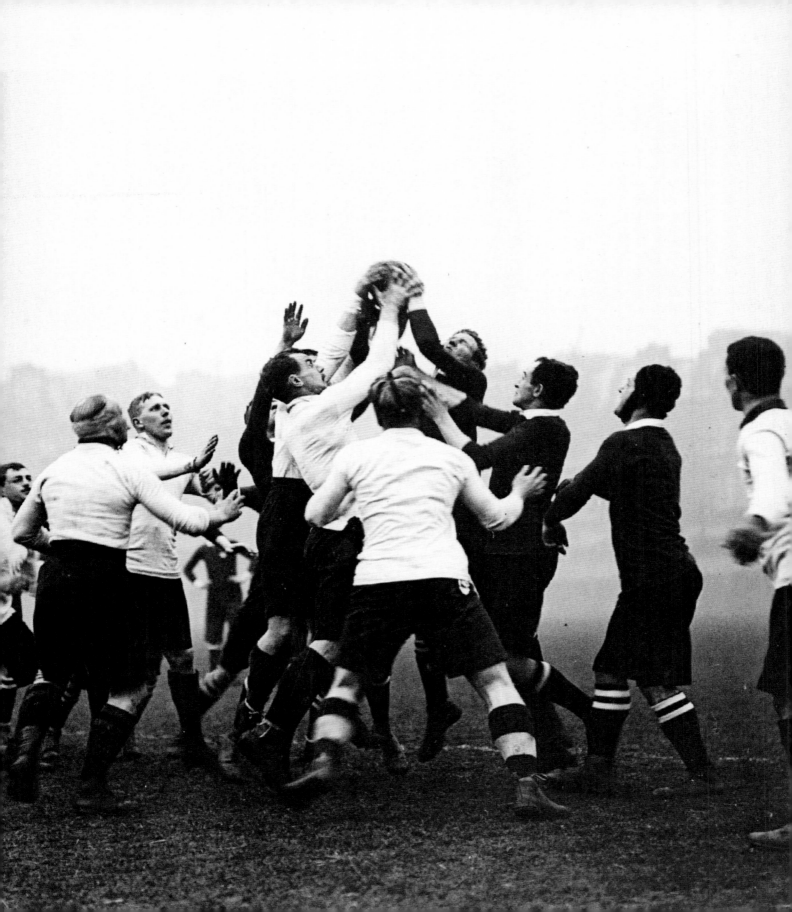

RUGBY

Rugby Football gets its name from Rugby School in England, where it is claimed that in 1823 a boy first picked up the ball in a football game and ran with it. Until mid-century, football, as played in most English boys' public and grammar schools, was seen as one game, with variations. Eventually, the differences became annoying, and separate sets of rules were formulated for football and rugby, which itself later divided in Union and League forms.

Rugby, taken to the far corners of the world by young empire-builders from English schools, is more limited in its international appeal than the much less physically violent football. Commonwealth countries such as Australia, New Zealand – home of the fearsome All Blacks – and South Africa provide particularly strong competition for the four home Rugby Union teams, with Argentina, France, Italy and others adding spice to the international game.

Both Union and League rugby are strong sports in Britain today, played by hundreds of men and women in both amateur and professional competitions.

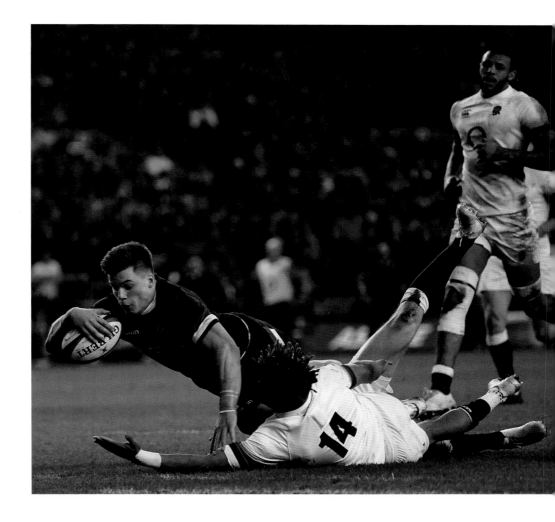

1907
A throw-in is taken during a rugby game played at the Queen's Club, now better known for its tennis, in west London.

TODAY
Scotland's Huw Jones scores a try against England during the 2018 Six Nations tournament, which includes England, France, Ireland, Italy, Scotland and Wales.

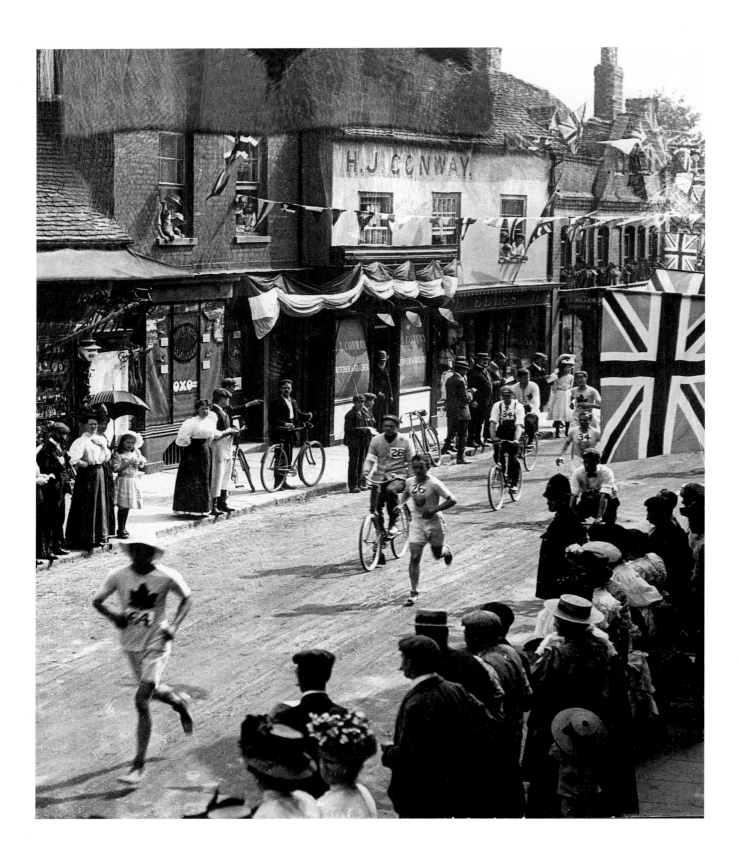

MARATHON RUNNING

The marathon is the longest race to figure in major athletics championships. It gets its name from the story of Pheidippides, a Greek soldier who ran from the Battle of Marathon to Athens, 35 kilometres (22 miles) away, with the news of the Greeks' victory over the Persians.

When the first Olympic Games of the modern era were held in 1896, a marathon race was included. Set at 42 kilometres (26 miles), it had an extra 352 metres (385 yards) added in 1908 so that the competitors, having run from Windsor to London, would end up opposite the Royal Box in the White City stadium.

Today, Londoners can watch a great marathon every year. The London Marathon, first organized by Olympic Gold Medal winner Chris Brasher in 1981, is the world's biggest marathon. It draws the cream of the world's long-distance runners, plus thousands of amateurs running for personal satisfaction and to raise money for good causes.

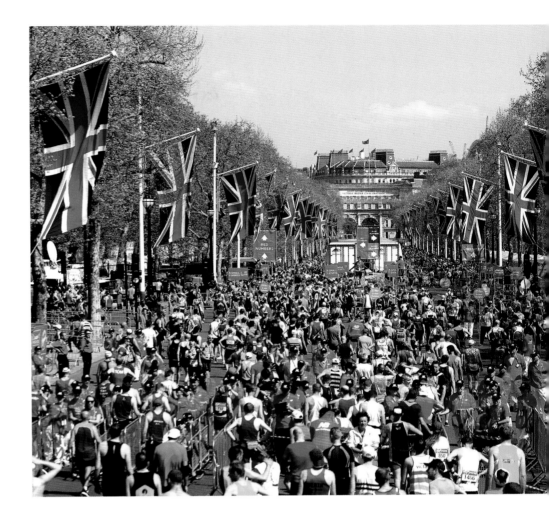

1908
Competitors in the marathon in the 1908 Olympics, held in London, are applauded as they run through a town on the race's Windsor–London route.

TODAY
Competitors mingle with officials and spectators in The Mall after crossing the finishing line of the London Marathon in 2018.

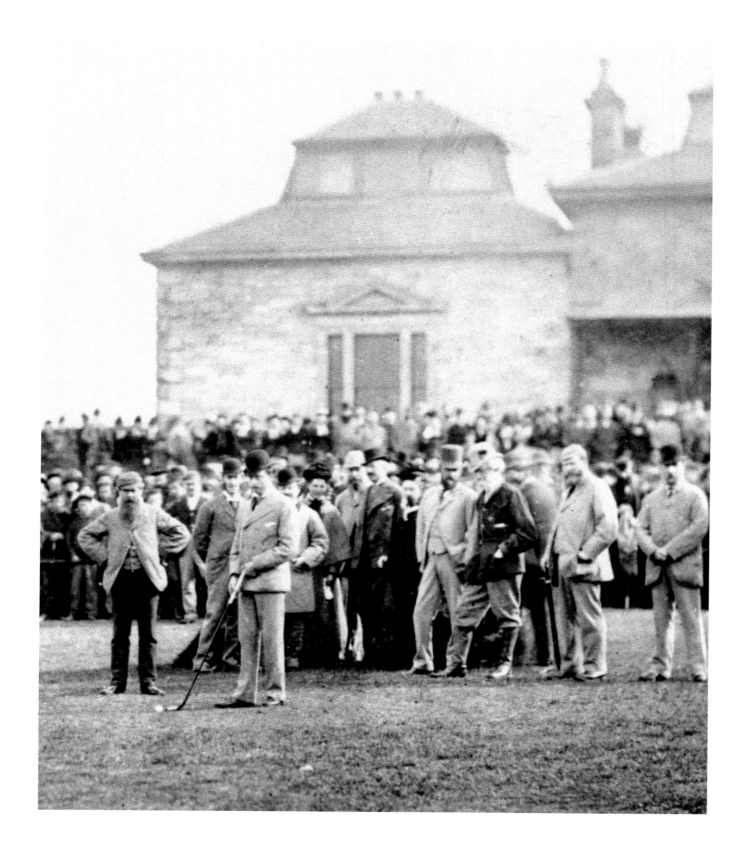

1865

A golfer makes ready to putt at the Royal and Ancient Golf Club, St Andrews. There are no golf bags, so caddies carry the clubs underarm.

TODAY

Northern Ireland golfer Rory McIlroy holds aloft the famous Claret Jug after winning the Open, Britain's premier golf championship, in 2014.

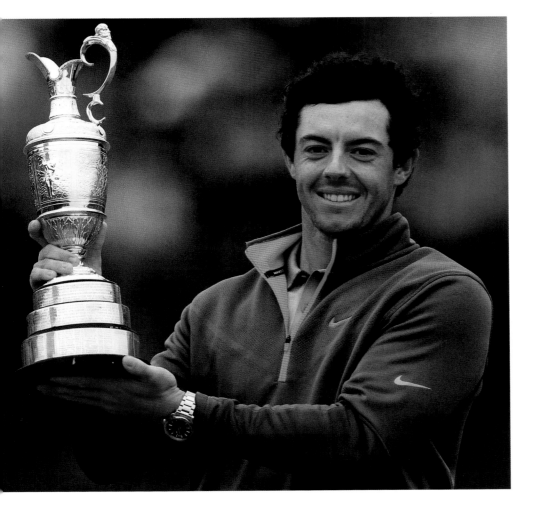

GOLF

The modern game of golf developed in Scotland in the eighteenth century out of a game the Scots had played for centuries. Mary, Queen of Scots, was a keen player and her son, James VI (James I of England), took the game to England, although it did not really catch on south of the border until late in the nineteenth century.

Golfers from a new club at St Andrews in Scotland, later the Royal and Ancient Golf Club of St Andrews, administer the rules of golf worldwide, except in the US and Mexico. The rules they administer are infinitely more complex than the 13 they started with in 1754.

Golfers have a choice of more than two thousand courses on which to play the game in the UK today. The amateur game long ago opened its doors to women, whose golf is governed by the Ladies' Golf Union. For every lover of the game, the highlight of the golfing year is the Open Championship, one of the world's four 'major' events.

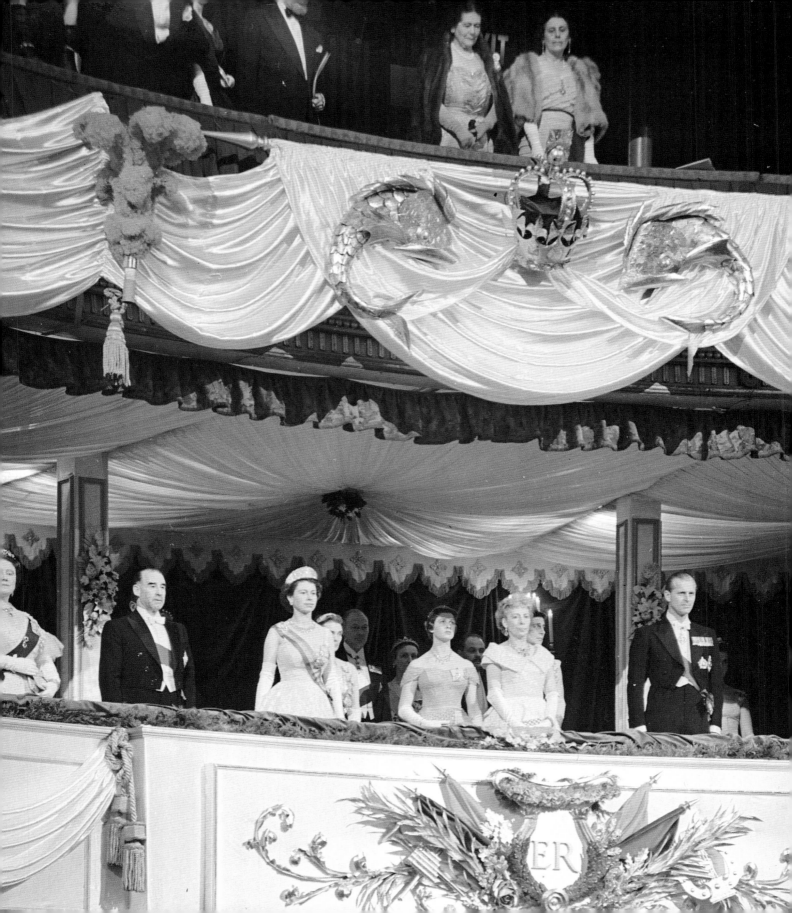

OPERA
FOR ALL

There has been an opera house in London's Covent Garden since 1732, and the present building is the third one on the site. Until World War II it was privately owned and presented seasons of opera and ballet to largely rich and aristocratic audiences.

After 1945, when the Royal Opera House re-opened as a public company and was given a state subsidy, its audiences changed, in line with the social changes that were taking place in Britain. Black tie and evening dress, essential in 1946, had given way to jeans and T-shirts (in the stalls as well as the gallery) by 1997, when the Opera House closed for a controversial and very expensive refit.

In its handsomely rebuilt and much more welcoming new form, the Royal Opera House is still devoted to its core ideal of presenting opera and ballet to world-class standards. But this is an expensive business and publicly funded organizations must not seem elitist – with its BP Big Screens summer festival, the ROH brings its productions to outdoor spaces across the UK, where the public can enjoy them free of charge.

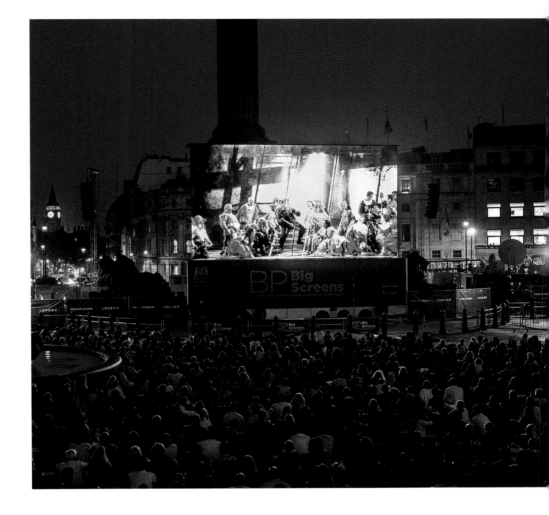

1955
A state occasion at Covent Garden. The Queen, the President of Portugal and their suites arrive for a performance of *The Bartered Bride*.

TODAY
Watching Verdi's *Rigoletto* for free. A live performance at the Royal Opera House is shown on a big screen in Trafalgar Square.

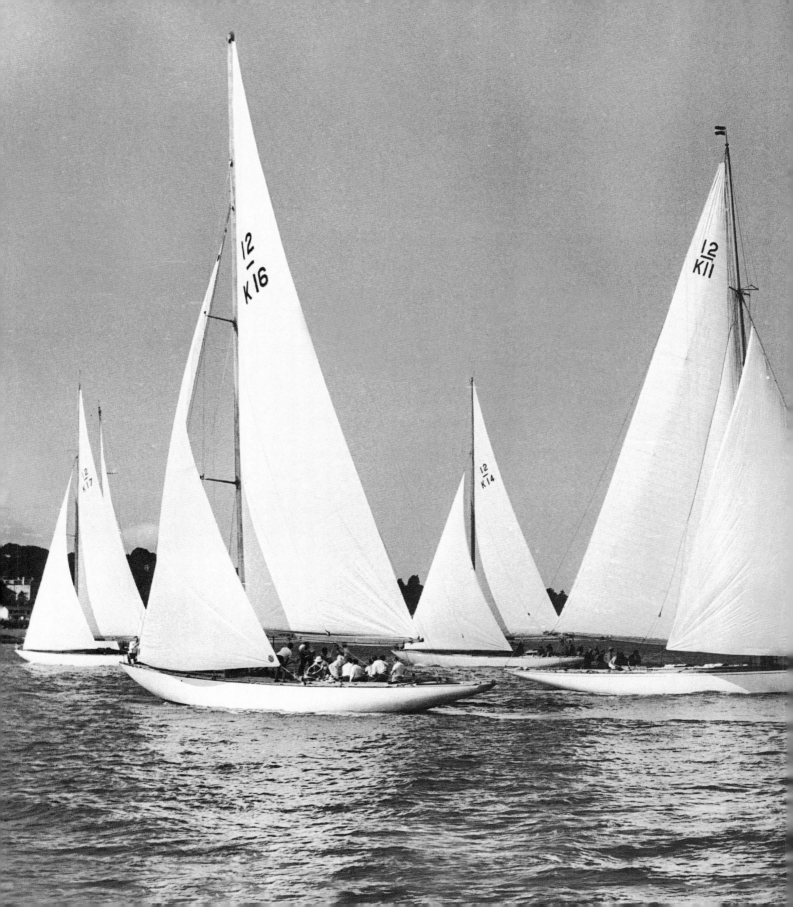

SAILING

The British, called 'an island race' so often it is almost a cliché, nevertheless have a special relationship with the sea. The poet John Masefield called it 'sea fever', and wrote that 'the call of the running tide … is a clear call that may not be denied'.

At the 2000 Olympic Games, the British team demonstrated this special relationship by winning five medals, making Britain the most successful nation in the sailing events.

Where 'sailing' once meant simply being at sea in a craft with a sail, today it is a broad term covering yacht and dinghy sailing, powerboat racing, motor cruising, jet skiing and windsurfing on inland and offshore waters. One of the main aims of sailing's national body, the Royal Yachting Association, is to make all forms of boating as accessible as possible.

From club moorings and harbour jetties, from river mouths, beaches and rocky shores all round the coast, over four million Britons launch themselves on to waters in and around the country every year in pursuit of their favourite watersports.

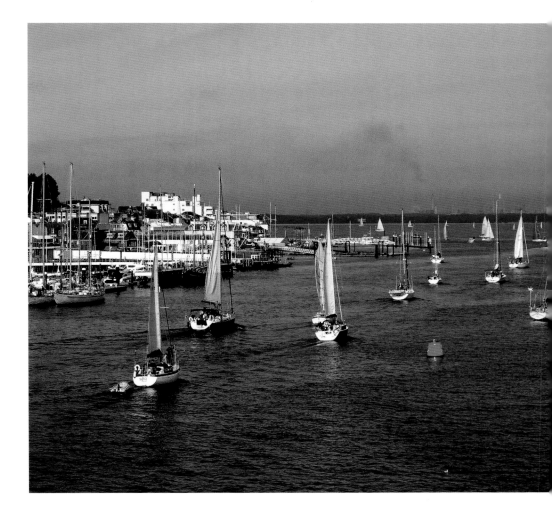

1960
Racing yachts in action off the Isle of Wight during the annual Cowes Week regatta.

TODAY
Yachts head out for a day's racing at Cowes. Every British sailor's dream is to take part in a race during Cowes Week.

1921
The Nottingham Goose Fair is in full swing, and the crowds enjoy the wide range of attractions and entertainments on offer.

TODAY
The colourful lights and electrifying rides of Nottingham Goose Fair, still one of the great attractions in the Midlands every year.

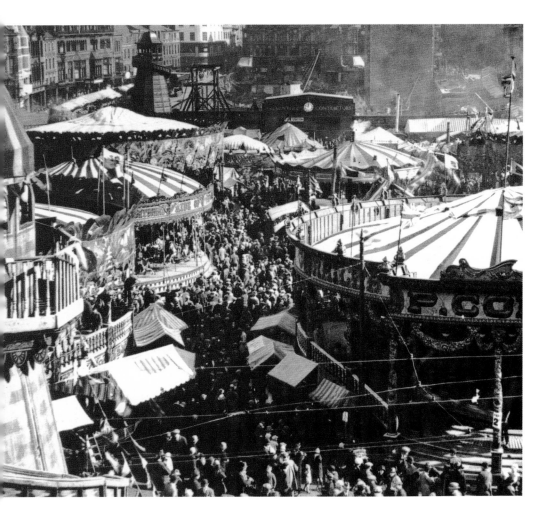

FUN AT THE FAIR

Many of the fairs held around the United Kingdom every year are descendants of the great markets and fairs that were established by royal charter from medieval times for the sale of a wide range of foods and goods or for the hiring of labour. Some can trace their beginnings to Saxon times.

Nottingham's Goose Fair, three days of fun and merrymaking every October, was established by a charter of Edward I as an annual fair for the selling of geese and other goods. Thousands of geese were driven to the fair, their feet treated with tar and sand to help them cover the many miles from as far away as Lincolnshire and Norfolk.

Geese ceased to be the major reason for the Nottingham Goose Fair long ago and by the nineteenth century people were attending just for the merrymaking. Today, Goose Fair is a national institution, and one of the biggest annual funfairs in the country. Its opening is proclaimed by the town clerk, with full traditional ceremony, involving the Lord Mayor and the Sheriff of Nottingham.

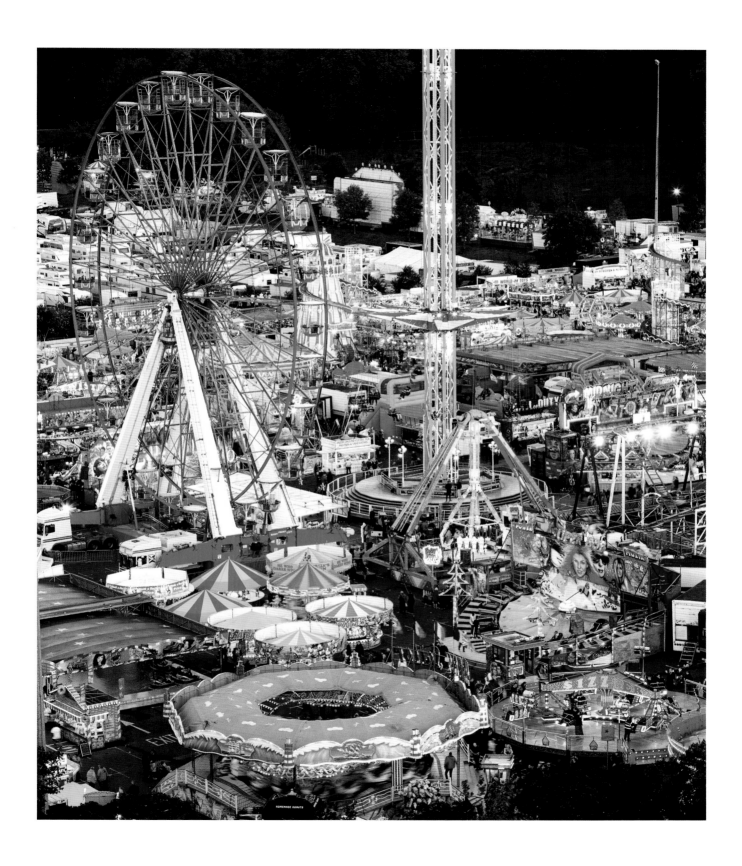

COUNTRY
LIFE

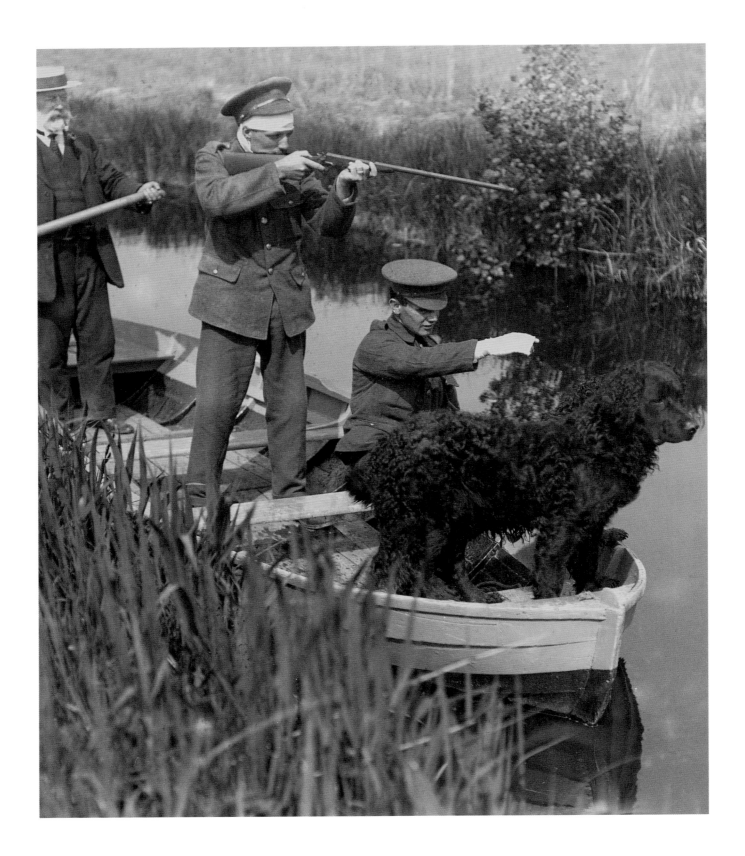

FIELD SPORTS

Field sports in the UK include hunting, shooting, stalking, ferreting, falconry and hare coursing. Country people have followed them all for centuries, in the past more for survival than for sport. Today, shooting is the favourite field sport for thousands of men and women in all parts of the country.

Not all shooting is for live birds or game. Clay pigeon, or trap, shooting, and skeet, which grew out of sportsmen's desire to have all-year-round shooting practice, quickly became very popular sports in their own right. Clay-shooting schools are increasing in number all over the UK.

Game-bird shooting seasons are strictly controlled in the UK, to protect bird populations and their breeding seasons. The grouse shooting season, for instance, starts on 12 August, long known as 'the Glorious Twelfth'. From then until early December, butts on the grouse moors of Scotland are filled with sportsmen and women seeking, often at considerable expense, to shoot hundreds of birds a day.

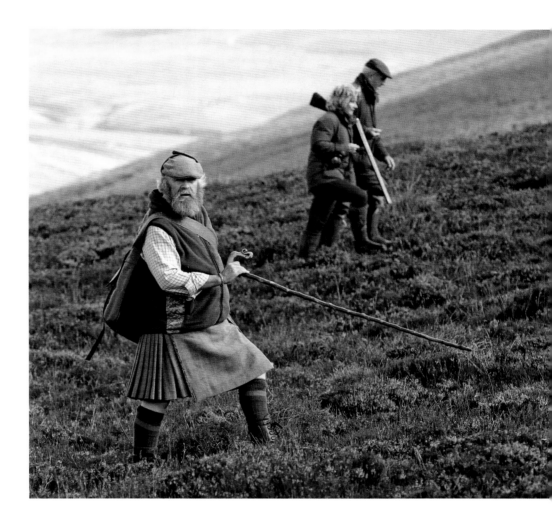

1914
Target shooting practice with a difference. Three men and a dog in a boat, rat shooting on the Norfolk Broads.

TODAY
Grouse shooting with the head gamekeeper on the Alvie estate, near Aviemore, Scotland.

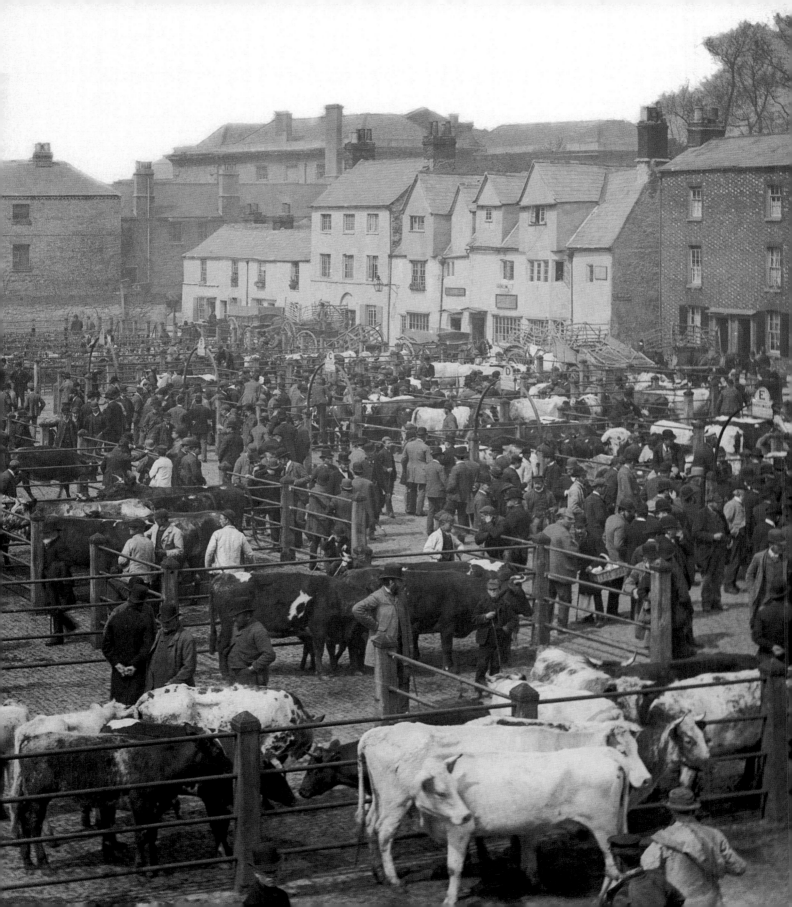

MARKET DAYS

For centuries, livestock and food markets in towns and villages were the main outlets for farmers' cattle and produce. Market day might have been a day for doing business, but it was also a social occasion, and a time for meeting friends over pints of ale in the market tavern.

Changing trading patterns and transport systems, and more stringent health laws, caused livestock markets to be merged on sites away from town centres. While general markets still flourish, most of us today buy our food at supermarkets, where much of what is on the fresh food shelves gets there long after it leaves the farm it was grown on. Discount stores like Aldi and Lidl, with their incredibly low prices, have gained in popularity.

However for those looking for fresh, organically grown food, farmers' markets are the only place in town, from Islington and Pimlico in London to Aberystwyth and Hexham, for buying fresh meat, fruit and vegetables, unpasteurized cheeses, baked goods, venison sausages and a lot more directly from the producers. There is even a fully-fledged National Association of Farmers' Markets to oversee their work.

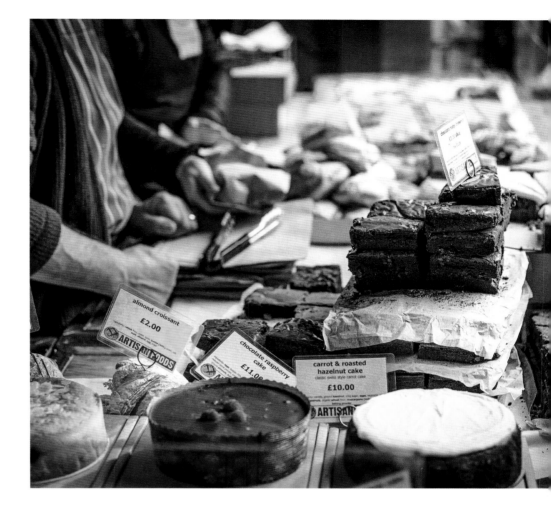

1900
The cattle section of the centuries-old charter market on Gloucester Green, in the heart of Oxford, in full swing.

TODAY
London's Borough market has existed in some form for over 1,000 years, and attracts over 16 million visitors a year with its artisanal produce.

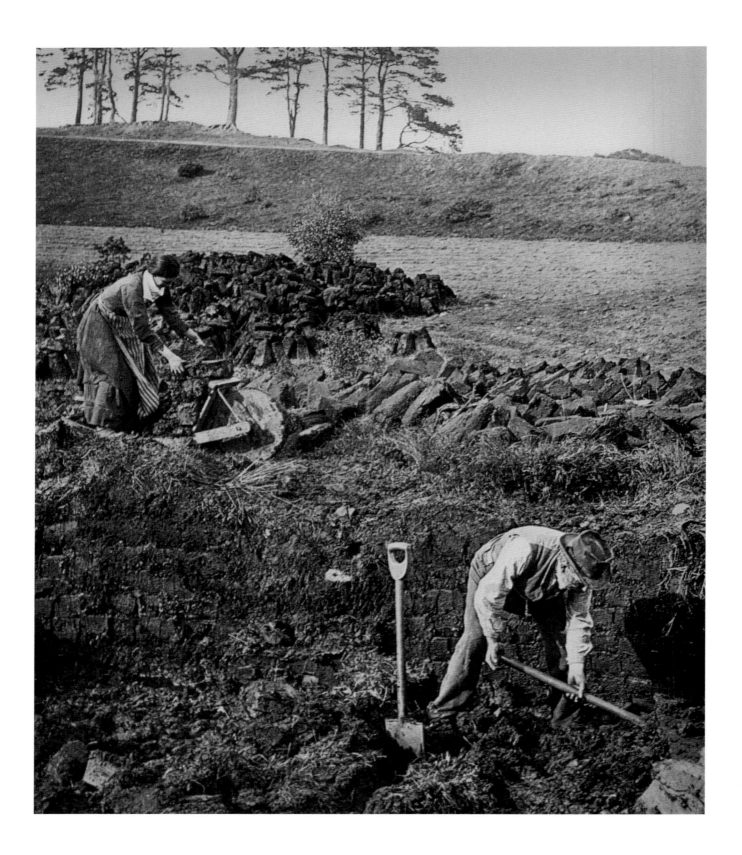

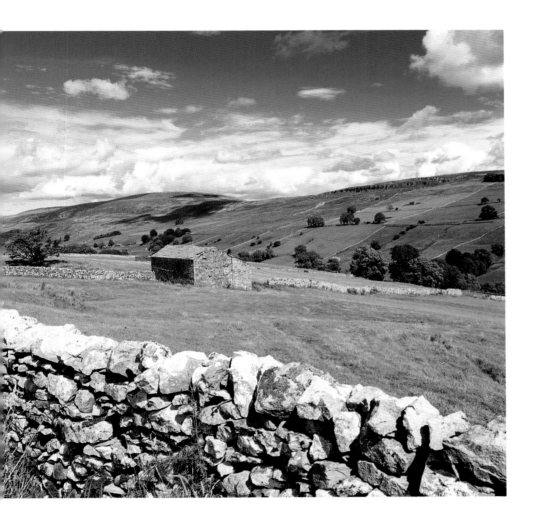

COUNTRY CRAFTS

Although farming in Britain is a highly mechanized business, many old crafts and skills, once essential to maintaining a farm's land and buildings in good condition, are still practised today. Some, like thatching and hedge-laying, are no longer vitally important in modern countryside management but are kept going by organizations such as the Countryside Agency because they provide such strong links with the country's past.

Other crafts are still a part of everyday life in many parts of Britain. Go to County Armagh in Northern Ireland or to Sutherland and Strathspey in the far north of Scotland and you will find people cutting precisely sized turfs from the peat bogs for winter fuel.

In Welsh slate quarries, slate is split and prepared to make roofing tiles. And in many upland districts of Britain, such as the Derbyshire Peak District and the Yorkshire Moors, stone from the land provides material for drystone walls that shelter stock and withstand for decades the wind and weather that would rapidly destroy hedges and fences.

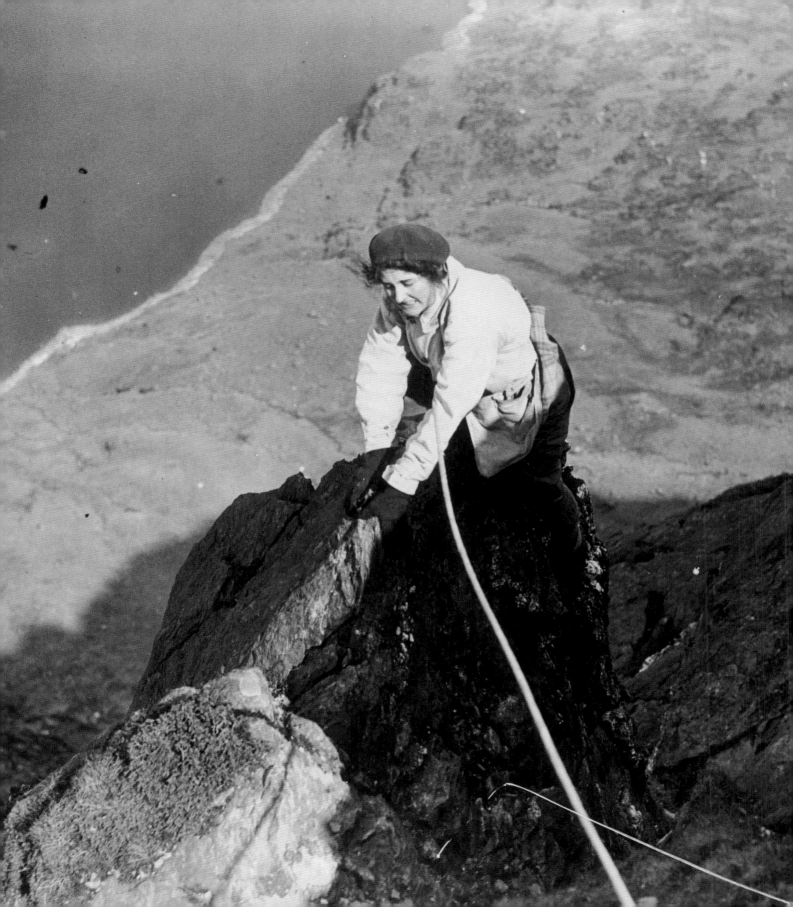

NATIONAL PARKS

The idea of establishing national parks in Britain grew out of a fear that too much of the countryside was being lost to industry and the spread of urbanization and, at the same time, that too few people were able to enjoy the beauty of Britain's lovely land. National parks, established by an Act of Parliament in 1949, are areas of countryside where the landscape, biodiversity and recreational resources are recognized as having national importance.

The country's first national park was the Peak District National Park, mainly in Derbyshire but extending into surrounding counties, which was established in 1951. It was soon followed by the Lake District National Park in Cumbria and the Snowdonia National Park, covering 2,180 square kilometres (838 square miles) of wild and beautiful country in Gwynedd, North Wales, with the Snowdon massif at its heart.

Today, there are 10 national parks in England, three in Wales and two in Scotland, each containing countryside of great natural beauty and extraordinarily diverse ranges of flora and fauna.

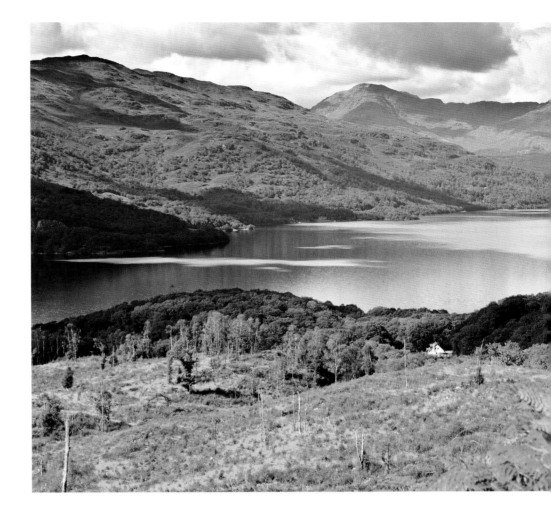

1930
A climber scales the heights in Snowdonia, which was formally established as a National Park in 1951.

TODAY
Beautiful Loch Lomond is at the heart of the Loch Lomond and Trossachs National Park, Scotland's first such park, established in 2002.

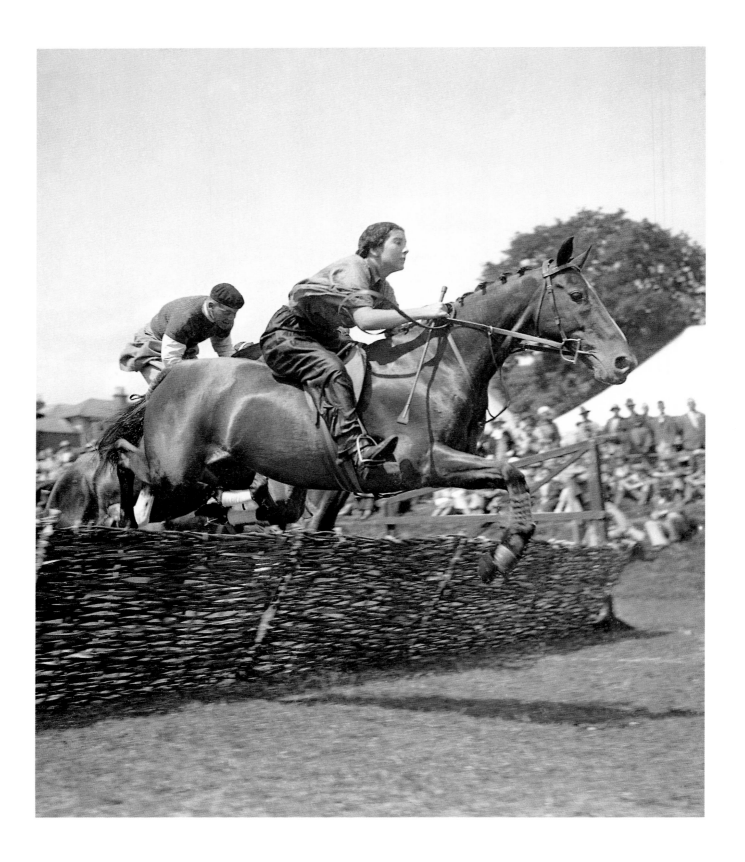

1936
The 'Costume' race, with riders in fancy dress, underway at the Haywards Heath Horticultural Society's summer show.

TODAY
Taking a fence in the cross-country phase of the Gatcombe Park Horse Trials, held each year at the Gloucestershire home of the Princess Royal.

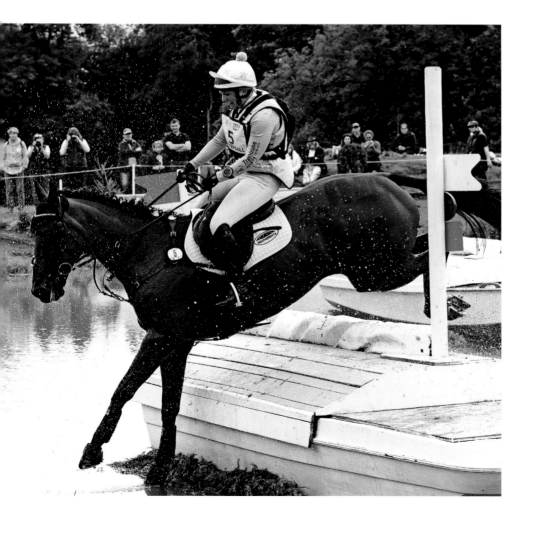

EQUESTRIAN EVENTS

The steam and combustion engines may have ended the horse's essential part in transport, but it still plays a major role in people's leisure activities, especially in the countryside and in competition.

The late nineteenth and early twentieth centuries saw a blossoming of many kinds of equestrian competition. Some of them, like point-to-points, involved races across country, and others, like show jumping, took place in show rings at agricultural shows. Between the wars, horse riding and the many events associated with it flourished, with many Pony Clubs helping to train children to become the competitive riders of the future.

Competing with show-jumping in popularity today, among both competitors and spectators, is the Three-Day Event or Horse Trials. This supreme form of horse competition, held over three days, tests the all-round ability of horse and rider by way of dressage; speed, endurance and cross-country; and show jumping.

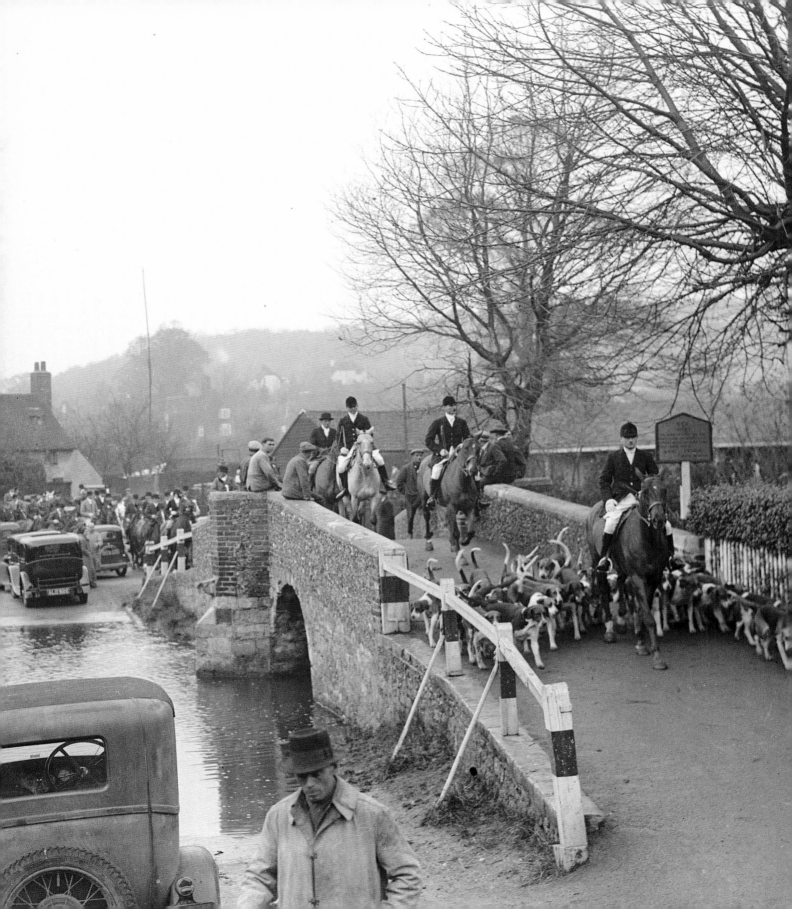

FOX HUNTING

Hunting has long been a traditional country activity. Organized fox hunting, which began in the eighteenth century, soon became a regular part of the winter scene, especially in those Midlands counties such as Leicestershire where the rolling fields and scattered pockets of woodland made ideal hunting country.

Oscar Wilde may have crisply summarized fox hunting as 'the unspeakable in full pursuit of the uneatable', but for hunt enthusiasts, riding to hounds has meant centuries of tradition, and galloping across country and facing up to the challenges posed by ditches, hedges and stone walls.

The practice of fox hunting has changed dramatically with the times. In the early 2000s, the hunting of animals with dogs was outlawed by the English and Scottish parliaments. Loopholes in the Hunting Act, allowing non-lethal hunting, have meant that hunts continue across the UK, using trail hunting and hawking – although hunt saboteur organizations claim these practices still result in the deaths of foxes. Hunts remain popular with riders and spectators, with 250,000 people attending Boxing Day meets in 2017.

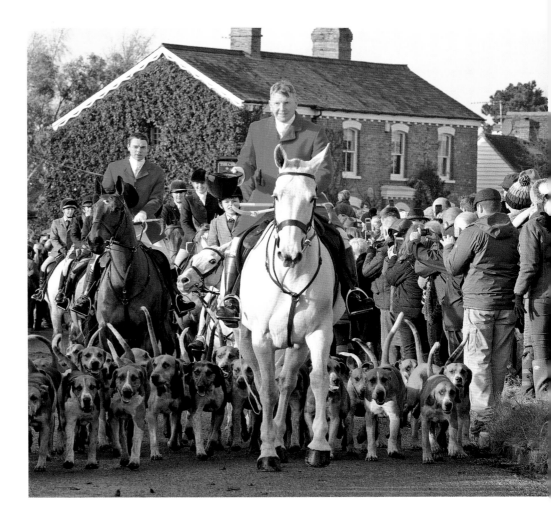

1930
Hounds lead the way as a hunt moves off from its gathering place in front of a Tudor house in the village of Eynsford, Kent.

TODAY
The Avon Vale Hunt moves off from a Boxing Day meet in Lacock, Wiltshire, in 2011.

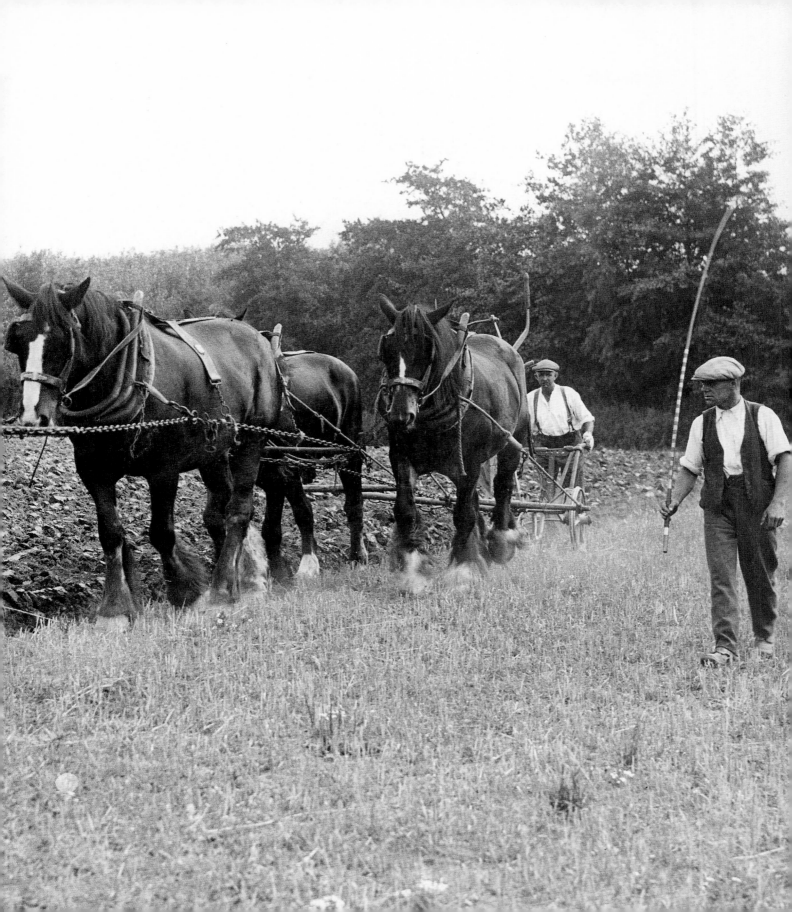

HORSE-POWER ON THE FARM

Handsome heavy horses once provided most of the power needed to work farmland, pulling ploughs, harrows and drills. They symbolized the endless toil and ceaseless care that went into creating the British farming landscape.

Heavy horses still work in Britain, often in small, enclosed areas and woodland, where machinery is too large to use. But for most of us, the only connection we have today with these magnificent creatures is the horse brasses from their collars and harnesses that decorate the bars of country pubs or find their way into antique and bric-a-brac shops.

When horsepower came to mean the power in the engines of farm machinery, farming changed radically, especially in those areas where crop-growing was paramount. Fewer people now worked in agriculture, and hundreds of miles of centuries-old hedgerows were torn out to make large fields that the great machinery could manoeuvre in.

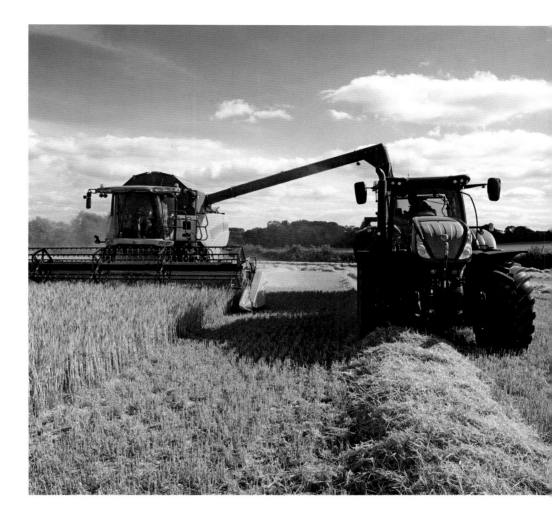

1937
A team of heavy horses provides the power that pulls the load of a plough on a farm near Paddock Wood in Kent.

TODAY
A mighty combine harvester and tractor team up to move across a large field and harvest its crop of winter wheat.

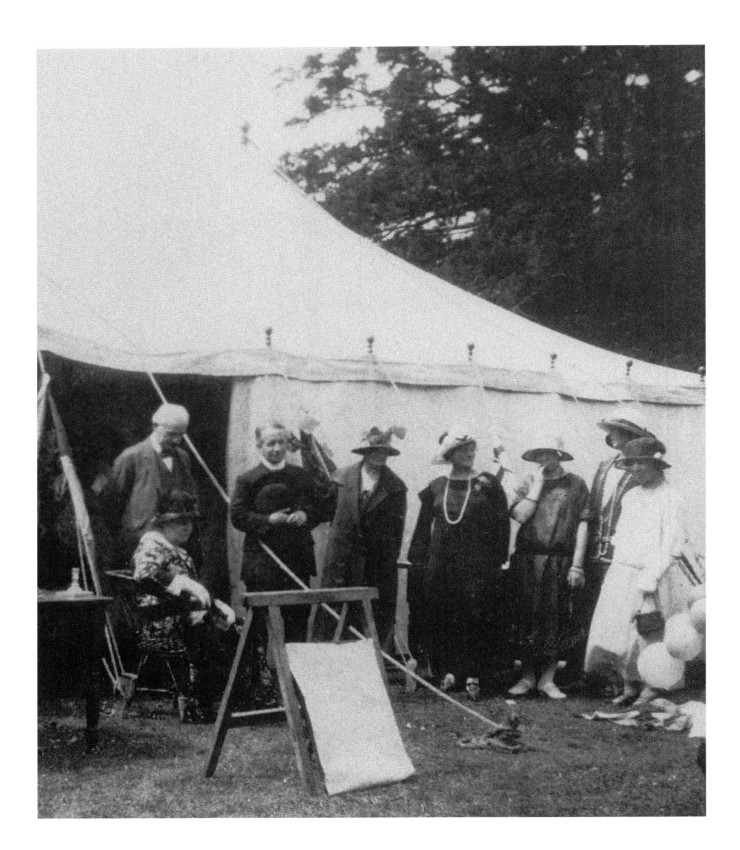

1920
The vicar prepares to hand out prizes at the summer fete of an English country church.

TODAY
The vicarage garden is the location of the annual summer fete in Chiddingly, Sussex.

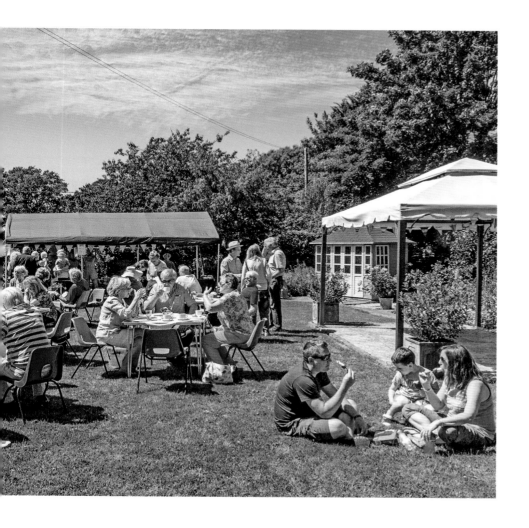

CHURCH FETES

A conscientious Victorian vicar or rector and his wife, spending most if not all of their time in their country parish, could fill much of their day visiting the old, sick and disabled, overseeing and even teaching at the village's church school, or holding adult education classes in the vicarage.

In our own, more affluent times, the state has taken over many of these responsibilities and church-goers need be less concerned with the problems and needs of the poor at home than with those in third-world countries. For them, the country church remains a very active and often architecturally beautiful centre of Christian worship as well as a focal point of village social life.

Today, as in Victorian times, the rural church fete – with its beer and tea tent, homemade cake and embroidery stalls, bran tub for the children and games for everyone – remains a high point in the local social calendar, as well as an important source of funds for the upkeep of the church.

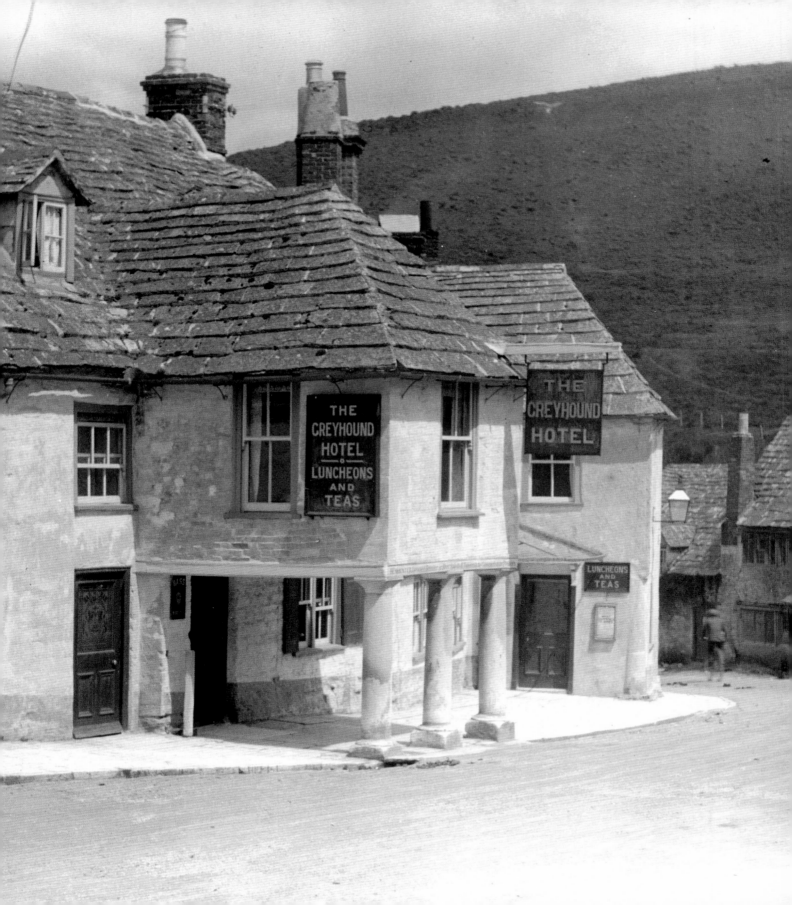

STAYING
IN THE
COUNTRY

The railway and the motor car changed the city dweller's attitude to the country. While the Edwardian upper classes perfected the art of the country-house weekend, everyone else who had a car or a motorcycle began to discover the delights of country inns, hitherto used to provide a night's food and a bed for relatively few coach travellers.

Country inns, often simple places, were soon upgrading their facilities and putting in extra bathrooms and lavatories. Others joined in the business, so that offering 'bed and breakfast' became a valuable source of extra income for many in country villages and on farms.

Today, the country holiday, promoted by tourist authorities and local councils, can mean bed and breakfast in a country pub, self-catering in a remote farm cottage, or being pampered in a luxurious country-house hotel. They all make great holidays and are invaluable revenue earners for the countryside.

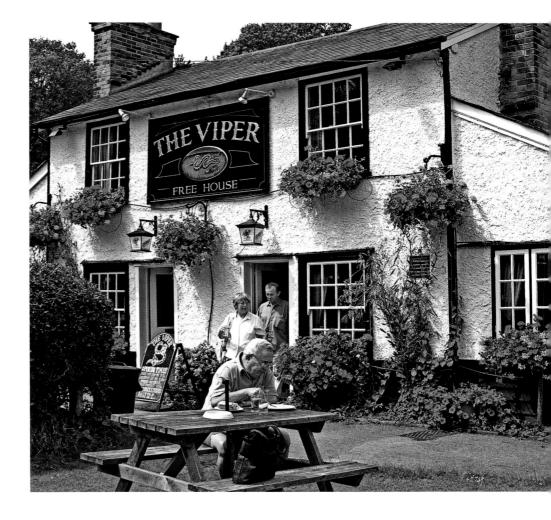

c.1930
Only a cyclist breaks the stillness of the day in front of the Greyhound Hotel, once a less grand-sounding inn, in Corfe, Dorset.

TODAY
Dining al fresco at The Viper country pub, Ingatestone, Essex, which is the only public house in the country with this unusual name.

CHANGING
CITY

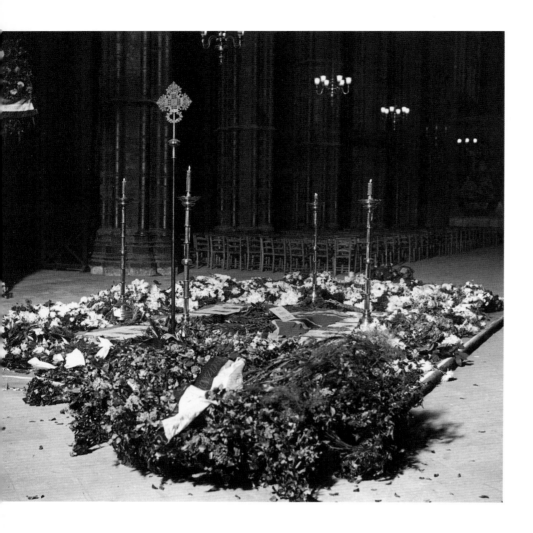

WESTMINSTER ABBEY

Among the many features that attract visitors to the Gothic splendour of near-1,000-year-old Westminster Abbey in London, few arouse as much emotional response as the Grave of the Unknown Warrior. Set under a black granite slab in the floor of the nave near the Abbey's great West Door, it contains the body of a British serviceman, 'unknown by name or rank', killed on the Western Front during World War I.

Brought with some ceremony from France, the body was interred in the Abbey on 11 November 1920 to commemorate 'the many multitudes who during the Great War of 1914–1918 gave the most that Man can give – life itself – for King and Country'.

In 1923, Lady Elizabeth Bowes-Lyon married the Duke of York, later King George VI, in Westminster Abbey. After the ceremony, she sent her bouquet to be placed on the grave in memory of her young brother, Fergus, killed on the Western Front in 1915.

Her action began a tradition for royal brides married in Westminster Abbey. In April 2011, the new Duchess of Cambridge followed suit with her bouquet of delicate white blooms.

1920
The grave of the newly interred Unknown Warrior, respectfully decked with wreaths and flowers.

TODAY
The Duke and Duchess of Cambridge walk up the aisle of Westminster Abbey after their marriage on 29 April 2011.

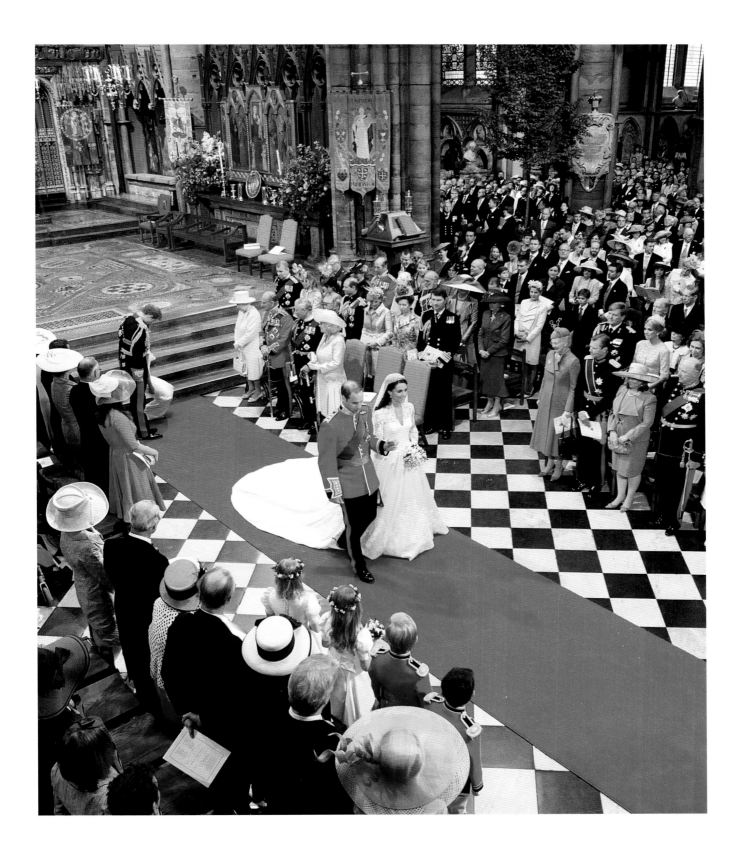

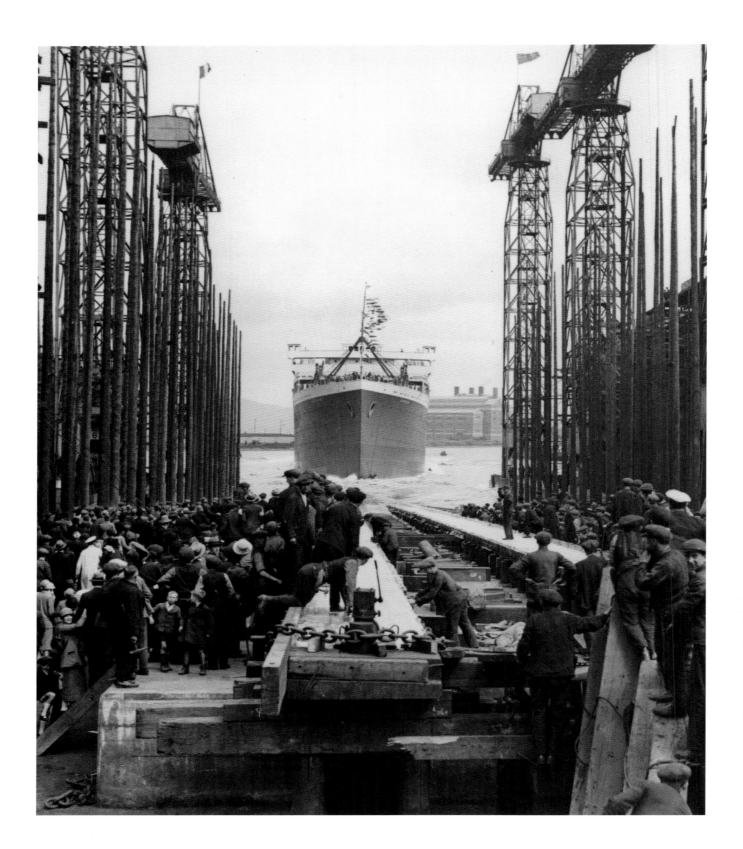

1925

Another great ship, RMS *Asturias*, leaves the slipway after its launch at Belfast docks on 7 July.

TODAY

Concert-goers at Belfast's splendid Waterfront Hall, opened in 1997, have a fine view of the River Lagan from the hall's entrance foyers.

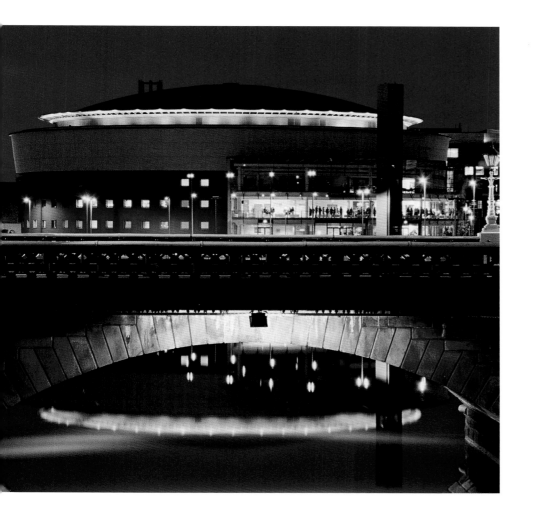

BELFAST

Back in the nineteenth century, Belfast was one of the fastest-growing cities in the British Isles as it developed its ship-building and engineering industries. At the huge Harland and Wolff Shipyard many of the world's great liners, including the White Star Line's *Titanic*, were built and launched.

The development of the jet engine, which made long-haul flights possible, meant the end of the great days of the ocean liner and also severely damaged merchant shipping. Belfast's glory days were over; the dockyard cranes no longer dominated the city's waterfront skyline, and shipyards closed. After this disaster, Northern Ireland also endured terrible years of virtual civil war that polarized society.

There is a new spirit abroad in Belfast today, and an optimism that is everywhere expressed in a large rebuilding programme. One of the city's finest modern buildings is the Waterfront Hall, described as 'a fresh, Modernist take on the Albert Hall', the curved glass frontage of which is very different to the cranes that once lined the waterfront.

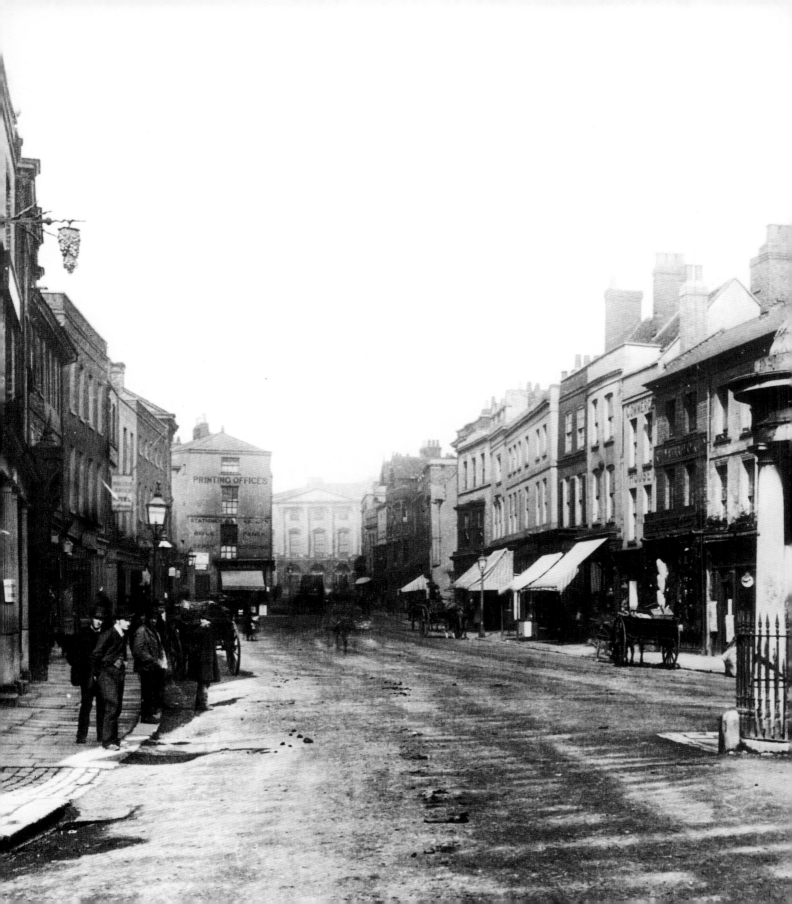

ENGLAND'S NEWEST CITY

There are 66 urban areas in the United Kingdom – 50 of them in England, six in Scotland, five in Wales and five in Northern Ireland – that have been granted city status, a great mark of distinction.

Although a town may think it has all the attributes of a city, only the sovereign, on the advice of her ministers, can grant city status.

Three towns, Brighton & Hove and Wolverhampton in England and Inverness in Scotland, were granted city status in 2000 to mark the millennium.

One of England's latest cities is Chelmsford, Essex, which achieved status in celebration of the Queen's Diamond Jubilee in 2012. Chelmsford was recently named as the best place to live in the east of England and has seen significant redevelopment since being made a city.

1890
Chelmsford High Street, Essex. The impressive Georgian structure of the Shire Hall is just visible at the end of the street.

TODAY
Chelmsford has many new attractions as a city, including the £150 million development of Bond Street shopping centre.

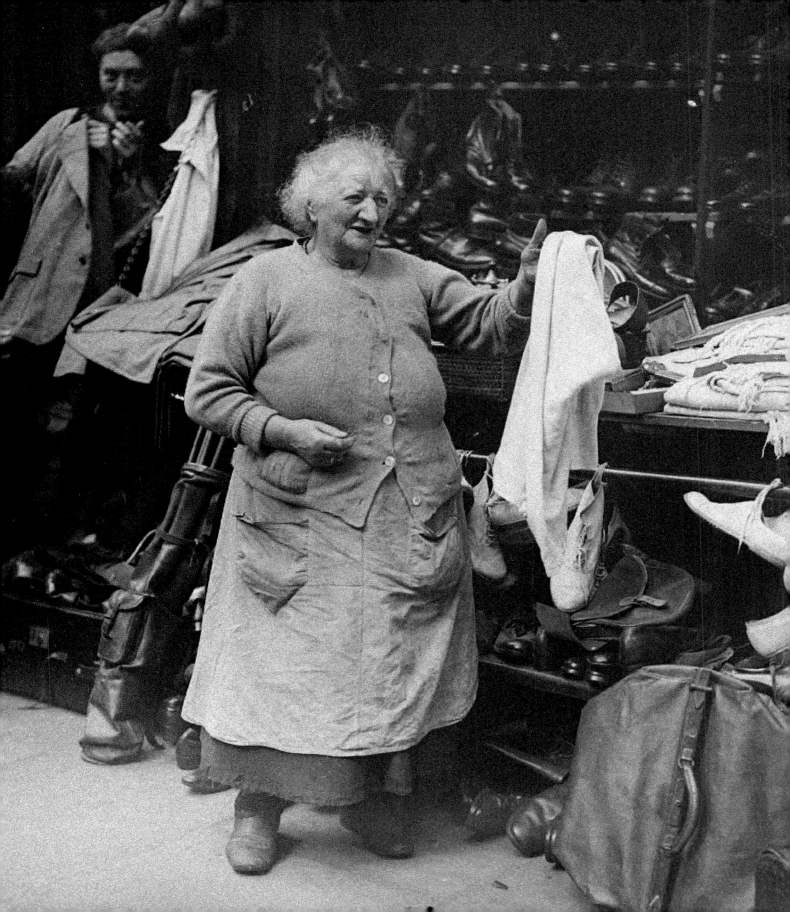

LONDON MARKETS

Shopping at market stalls in the street was the norm in the poorer districts of London from the nineteenth century up to World War II. Cheap food and clothing were the most essential goods for the low-paid workers who crowded into the run-down housing near the markets. Much of this housing was medieval in origin, while other areas grew up to feed the needs of immigrant populations fleeing persecution, such as the Huguenots and Jews.

The changing cultural mix of London's population has altered the character, but not the liveliness and vibrancy, of London's street markets. Brick Lane, in Shoreditch, east London, began as a fruit and vegetable market in the eighteenth century and now has many second-hand and vintage stalls, attracting the local young fashionable crowd. Brixton, in south London, is the place to go to find the ingredients essential for good West Indian cooking. Petticoat Lane, its Sunday opening indicating its Jewish origins, offers something for everyone. Collectors of vintage fashion, jewellery and antiques head to Portobello Road in Notting Hill.

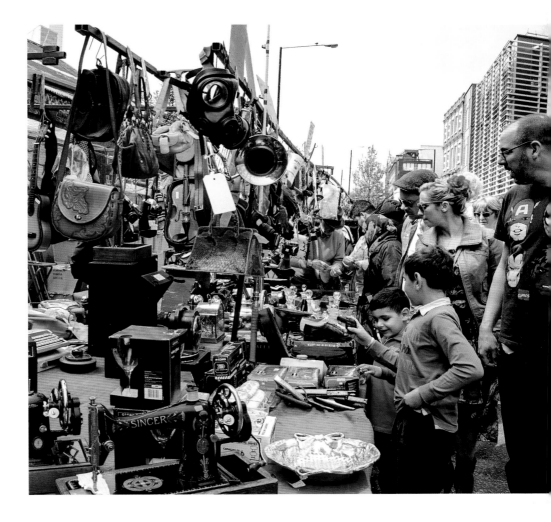

1930s
A second-hand clothes stall in Whitechapel, the Jewish quarter of London's East End, where much trading was done on the streets.

TODAY
Shoppers hunt for vintage treasures at Brick Lane's traditional Sunday flea market.

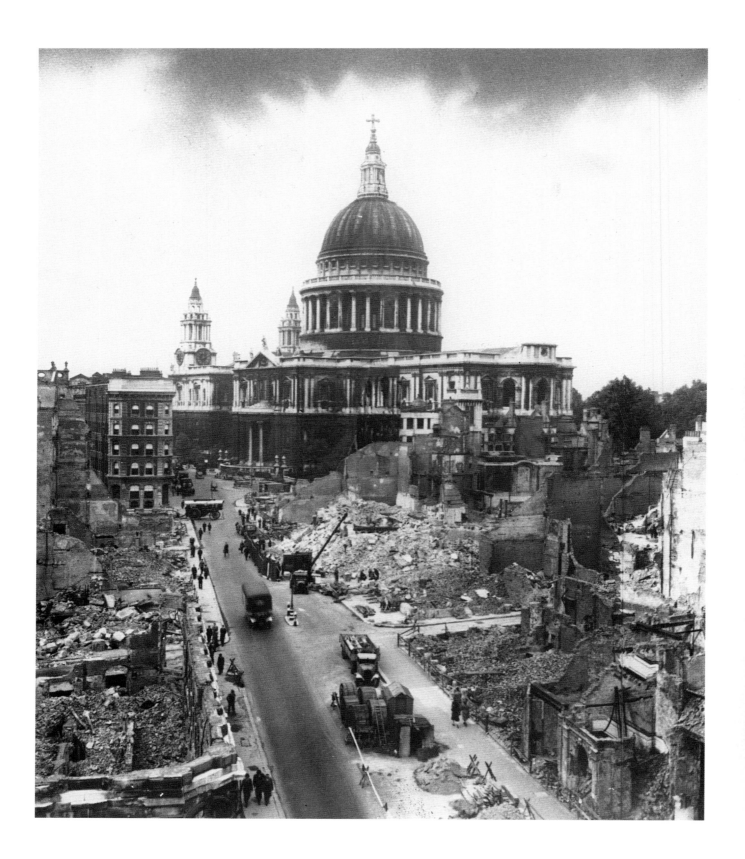

1941

Fire-watchers on the roof saved St Paul's Cathedral from the consequences of the bombs that destroyed much of the City of London in World War II.

TODAY

Unchanged in the midst of change, the great dome of St Paul's Cathedral rises above surrounding buildings and the streams of traffic.

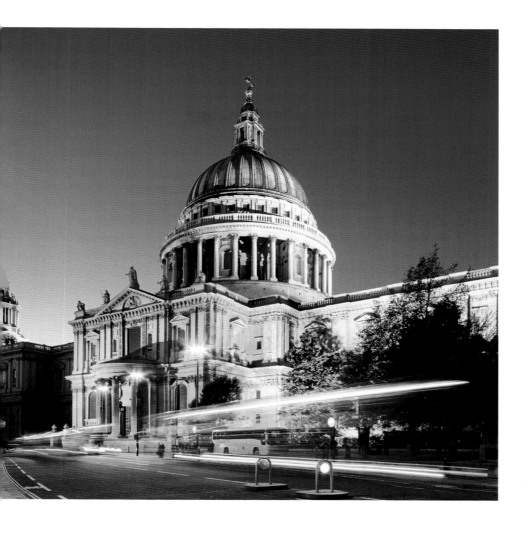

ST PAUL'S IN WAR & PEACE

Every great city needs a focus for its pride and self-belief. Sir Christopher Wren's great masterpiece in the City of London, St Paul's Cathedral, provides such a focus for Londoners. St Paul's was built after the Great Fire of London destroyed the old cathedral in 1666. Nearly three hundred years later, the cathedral survived a far more devastating series of fires, the result of the Blitz of the Second World War.

In 1941, pictures of the dome of St Paul's rising undamaged through the smoke and fire of the Blitz did almost as much as Prime Minister Winston Churchill's stirring speeches to maintain morale and confidence on the Home Front.

St Paul's remains a focus of national pride, attracting over 1.5 million visitors a year. An exciting new view of the dome and south side of St Paul's was opened up for Londoners when a pedestrian walk was constructed down to the new Millennium footbridge over the Thames to the South Bank.

DIVERSITY

Perhaps because its early history involved the settling on its lands of so many culturally diverse peoples, Britain has always given a sympathetic, if sometimes muted, welcome to outsiders coming in search of a better life.

Whether they have been Huguenots fleeing from religious persecution in France, Jews escaping the horrors of Nazi Germany, or citizens from Britain's former Empire, most immigrants have chosen to live in big cities. This has given many British cities an extraordinarily vibrant cultural and ethnic diversity.

Among the longest-term 'newcomers' are Muslims. There has been a Muslim community in Britain since the sixteenth century and today their faith, Islam, is the most common in Britain after Christianity. More than a third of British Muslims live in London and many more live in the cities of the West Midlands. Their community in Wales, mostly in Cardiff, is much smaller.

1937
The Muslim community in Wales forms a procession through the streets of Cardiff as part of the El Elbekir religious ceremony.

TODAY
A British-Yemeni boy is given instruction on the finer points of the Qur'an at the South Wales Islamic Centre mosque in Cardiff.

131

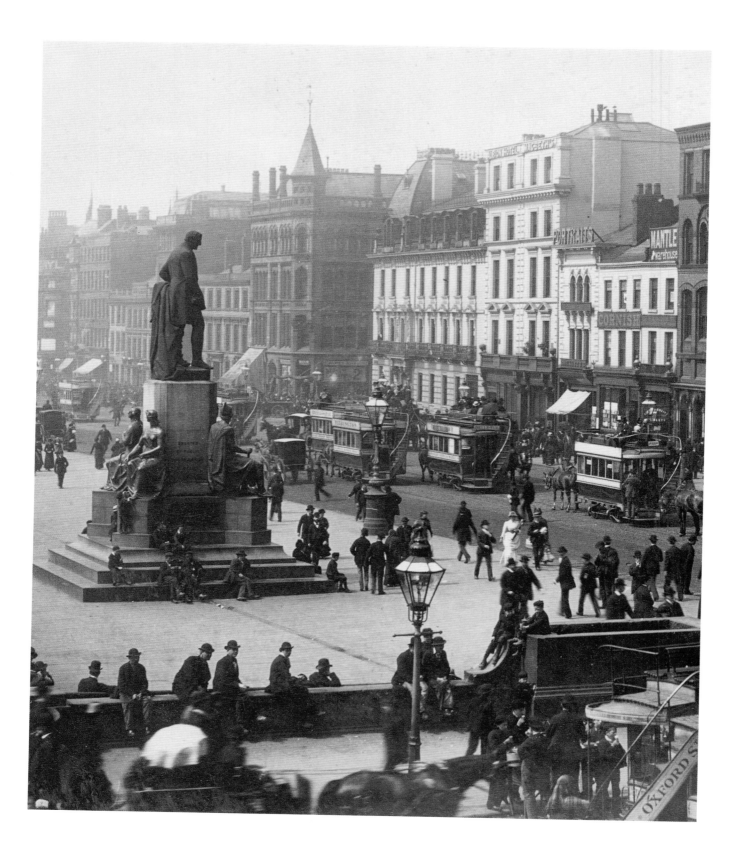

TRANSPORT IN THE CITY

Because the early railway was not ideal for urban transport, the first mass moving of people round towns and cities was by double-decker, horse-drawn omnibus.

The first omnibus route in London opened in 1829 and by the 1860s omnibuses were carrying 40 million passengers a year. Other big cities could boast similar numbers. By the end of the century horse-drawn omnibuses were being replaced by petrol-driven ones.

Urban railways went underground in 1863, with the construction of the Metropolitan Line in London, and two decades later, urban tramways turned electric, the first electric trams running in Blackpool in 1885.

Trams and light railways, which do not generate as much pollution as buses, are back in fashion in Britain's cities today. The 1990s saw tram and light-railway systems opening across the country, in London's Docklands and Croydon as well as Birmingham, Manchester and Newcastle.

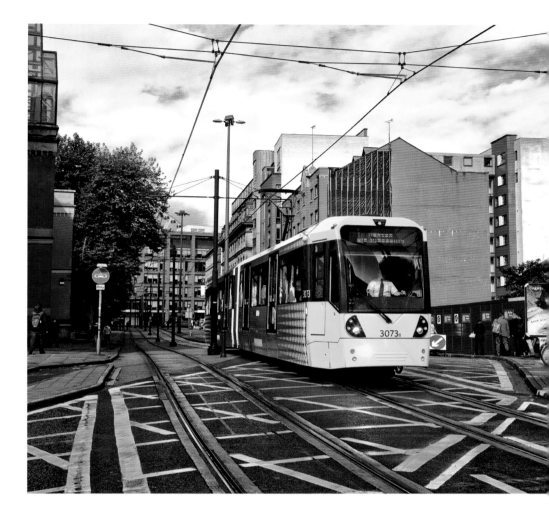

1880
Even though horse-drawn trams are almost nose-to-tail in Manchester's Piccadilly, the pavements are still filled with pedestrians.

TODAY
Manchester's Metrolink, officially opened in 1992, was Britain's first modern street-operating light-rail system.

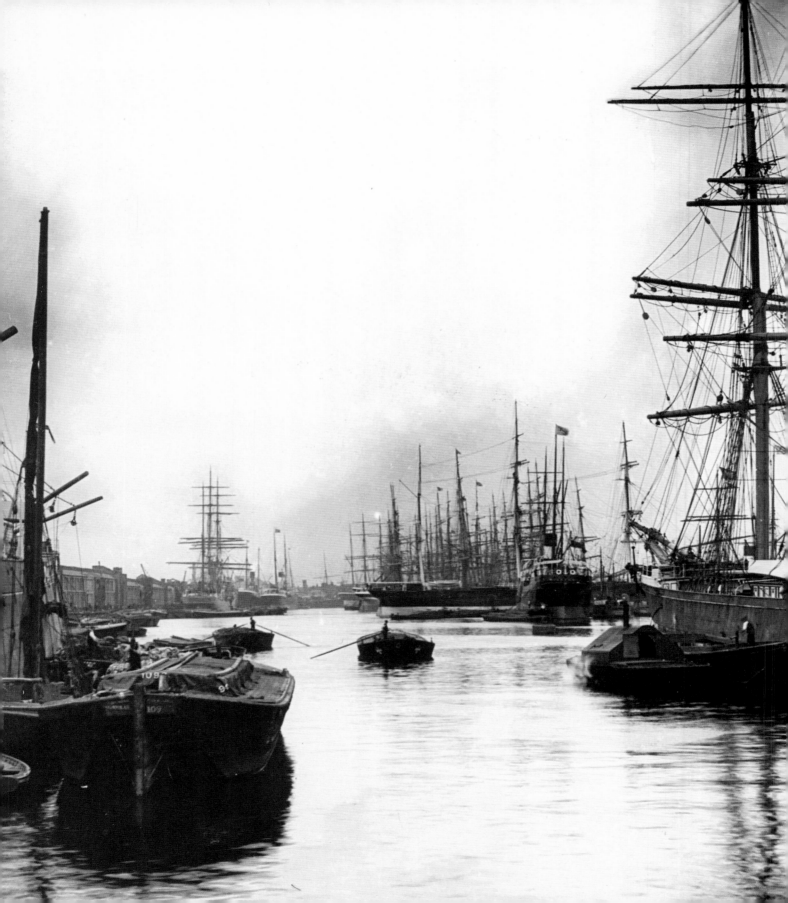

LONDON'S DOCKLANDS

Until the advent of World War II, the Thames below London Bridge was always crowded with ships from Britain's worldwide empire unloading their goods. Ships that could not find a berth on the river were moved into specially built docks, known by their trading regions – such as the West India Docks and the East India Docks – or given royal names.

London's docklands was a very picturesque quarter, the masts and riggings of the ships and the dockside cranes providing a backdrop for an area teeming with cosmopolitan life. Chinatown in Limehouse had the best Chinese restaurants in England – and the most opium dens.

A thriving new city, still called Docklands, has taken over the docks today. Towering office buildings rise above smart riverside housing, pubs, stylish restaurants and shops. In the old docks, cabin cruisers, sailing boats and floating restaurants bob on the waters once filled with the shipping of a vast empire.

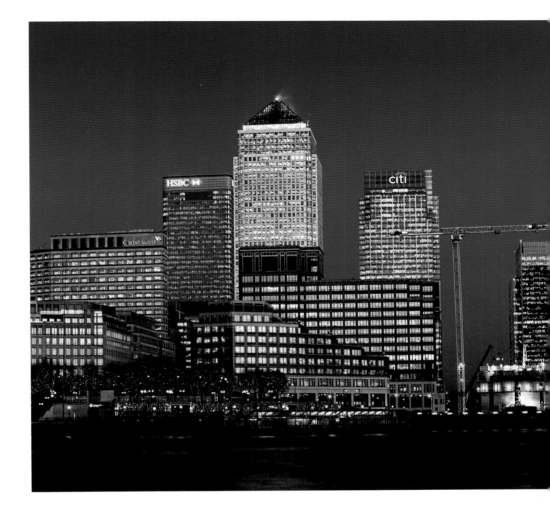

c.1900
Sailing ships and steam freighters are moored closely together in the crowded West India Docks on the Thames in east London.

TODAY
At Canary Wharf, towering office blocks displaying the names of major banks reveal Docklands as a modern financial hub.

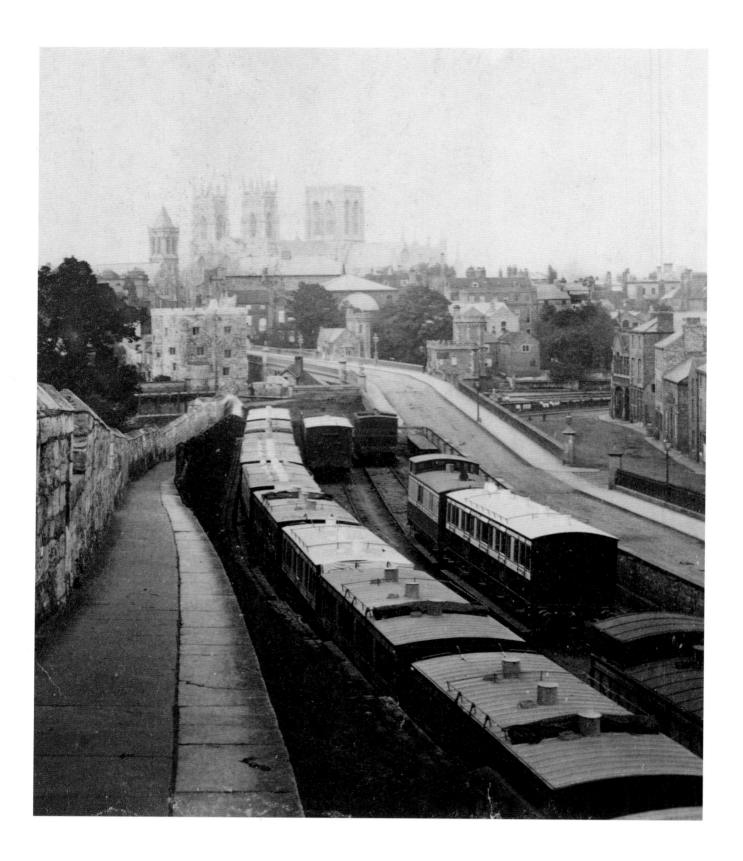

HISTORIC YORK

Ironically – given its present troubles with flooding, supposedly caused by global warming – the Romans chose York as a site for its fortress of Eburacum because it was very dry.

After the Romans came the Danes, who founded a colony here, then the Normans, who built massive fortifications of their own, including great walls, partly on Roman foundations. Real prosperity came to York with the medieval wool trade, much of the profits of which went – over two and a half centuries – into the building of York's magnificent Minster, seat of the Archbishop of York, which has been called a 'poem in stone'.

Today, York within its city walls is virtually, as King George VI once remarked, a living museum of English history from Roman times, via the Danes – the JORVIK Viking Centre is a big draw – to the present day. Its Castle Museum and Heritage Centre are other attractions that help bring over seven million visitors to York every year. Outside the medieval walls, York is home to the National Railway Museum.

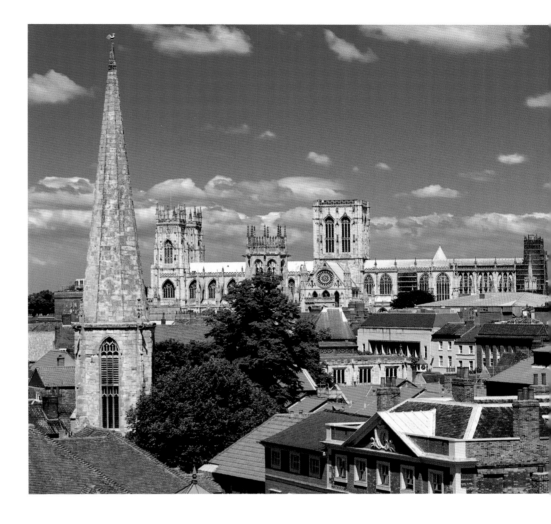

1858
The towers of York Minster loom large over carriages in the sidings at York railway station, built just inside the ancient walls of the city.

TODAY
York's rich heritage is immediately visible in its architecture – but hints of modern glass and steel can be spotted among the brick and stone.

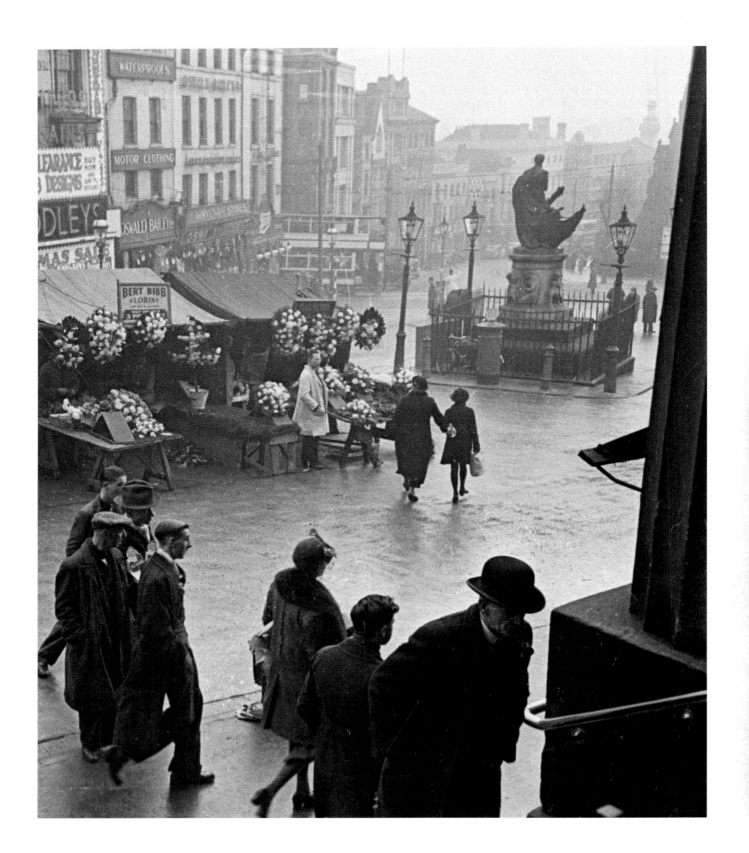

1939

The flower stall is open for business in Birmingham's Bullring, a long-established open-air market for street traders of all kinds.

TODAY

The architecturally impressive Grand Central shopping centre, which has now joined forces with the Bullring.

ARCHITECTURE & THE CITY

In the 1960s, Birmingham's Bullring became a prime example of what can go wrong when city planners decide to bulldoze the old centres of their cities and recreate them in 'modern' style.

Many British cities had huge problems of urban rebuilding and regeneration after World War II. But in too many of them, the arrival of the bulldozer meant the replacing of old city centres and domestic housing with concrete high-rise architecture so stark and so riddled with wind tunnels and exposed walkways that 'brutalism' seemed an apt name indeed.

In the 1990s, Birmingham, already brimming with the cultural self-confidence of a city possessing a major symphony orchestra, a leading ballet company and a superb exhibition centre, embarked on a modernization programme that restored it to its place as one of Britain's finest cities. The futuristic New Street train station and Grand Central shopping centre complex, which opened in 2015, has now joined forces with the Bullring shopping centre to offer the ultimate city shopping experience.

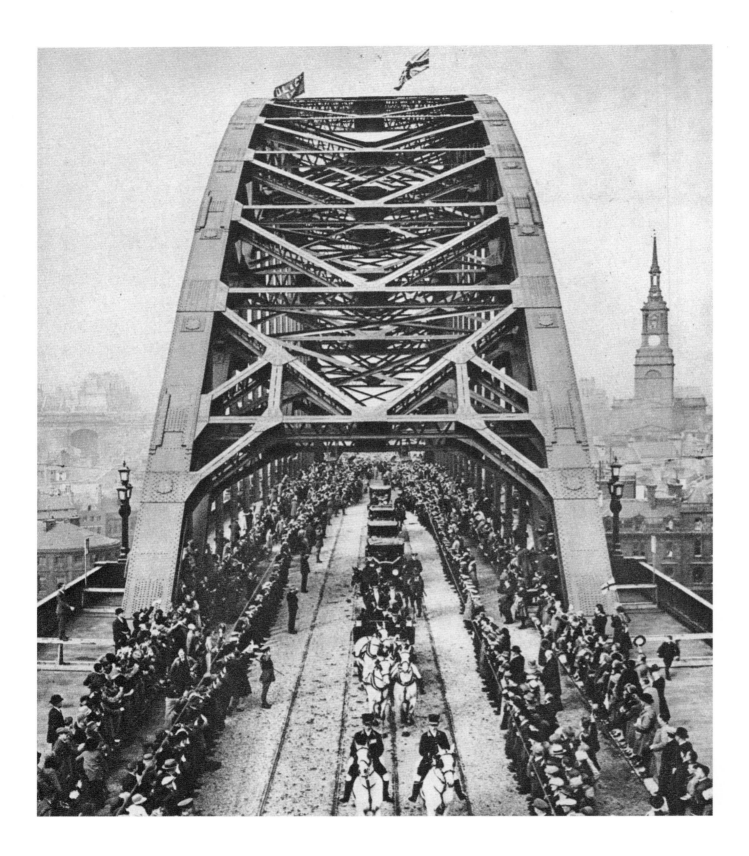

TYNESIDERS

The River Tyne in the north-east of England separates two great metropolitan areas. Newcastle upon Tyne, a cathedral and university city on the river's north bank, is a major ship-building and marine-engineering centre. Gateshead, on the south side of the river, is a rapidly growing cultural, sporting and shopping centre for the region.

The two are working together to spearhead the regeneration of the Tyneside region, with a large investment in culture. Although Newcastle-Gateshead did not succeed in its bid to be the British candidate for the title of European Capital of Culture in 2008, the attempt helped to revitalize the region. 'Newcastle-Gateshead Buzzin' was the image projected for the bid.

Today, there is plenty of buzz along the Tyne to support the image, from the BALTIC Centre for Contemporary Art on the Tyne in Gateshead to the Sage Gateshead cultural centre, to the amazing Millennium Bridge, assembled at a Tyneside shipyard and lifted into position over the river by one of the world's largest floating cranes.

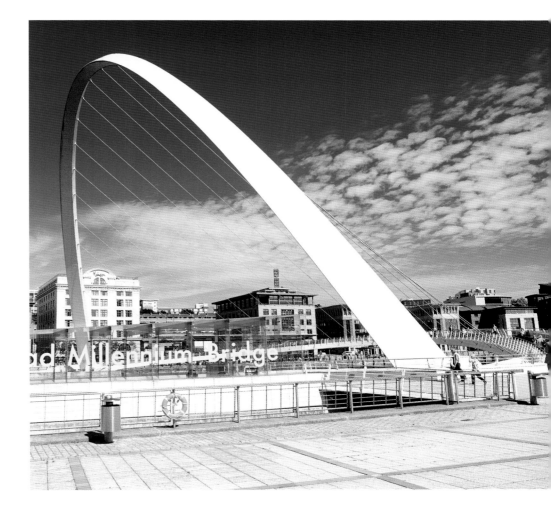

1928
George Stephenson designed Newcastle's great two-tier Tyne Bridge, which was opened in 1928. The bridge carries a railway line and a road over the River Tyne.

TODAY
The Gateshead Millennium Bridge, completed in 2001, is the world's first rotating bridge and opens in a 'blinking eye' movement.

GLASGOW

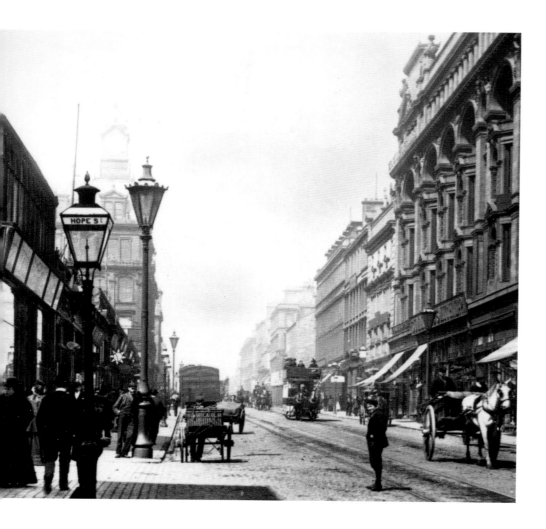

The great Scottish comedian Harry Lauder used to sing about Glasgow belonging to him, rather than he to the city, after a drink or two of a Saturday night. That was when Glasgow, Scotland's second city, still had a great ship-building industry along the River Clyde and the prosperity that went with it.

The destruction of large parts of the Clyde ship-building docks during World War II, followed by the collapse of the ship-building industry, meant that Glasgow had to pick itself up, dust itself down and start all over again.

Glasgow's appointment as European City of Culture in 1990 spurred the city on to greater efforts to revitalize its flagging economy. In the 1990s the city replaced its almost vanished imperial-age industries with something very different: culture and shopping. A centre for the arts since the inauguration of the Charles Rennie Mackintosh-designed Glasgow School of Art in 1845, Glasgow today has a vibrant theatre culture, a new Royal Concert Hall, superb art galleries and a new Museum of Education. These, and the fact that Glasgow is now Britain's fourth-biggest shopping city, attract thousands of visitors. Harry Lauder would be proud to belong to Glasgow today.

1895
Window-shoppers, autobuses, trams and horses and carts crowd Sauchiehall Street in Glasgow city centre.

TODAY
Outwardly not much changed, bar the odd skyscraper, Glasgow's Hope Street/Sauchiehall Street crossroads is as buzzing today as ever.

EVERYDAY

LIVING

OVER THE SEA TO SKYE

The beautiful, mountainous Isle of Skye, off the west coast of Scotland, is celebrated for its place in the story of Bonnie Prince Charlie's escape from the disaster of Culloden in 1746. He made the hazardous journey disguised as Flora Macdonald's maid 'over the sea to Skye' from Benbecula, in the Outer Hebrides.

Had he gone from the mainland, there would have been no story, for the crossing is little more than a stone's throw. The narrow crossing from the Kyle of Lochalsh to Kyleakin on Skye was made by motorboat or car ferry until 1995, when a road bridge was opened.

The new, costly bridge was a toll bridge – much to the rage of local people, forced to pay the toll to get themselves, their sheep and their cattle to and from the mainland because the car ferry was withdrawn and other island services were summer-only. A long anti-toll campaign bore fruit in 2004, when the Skye Bridge tolls were abolished.

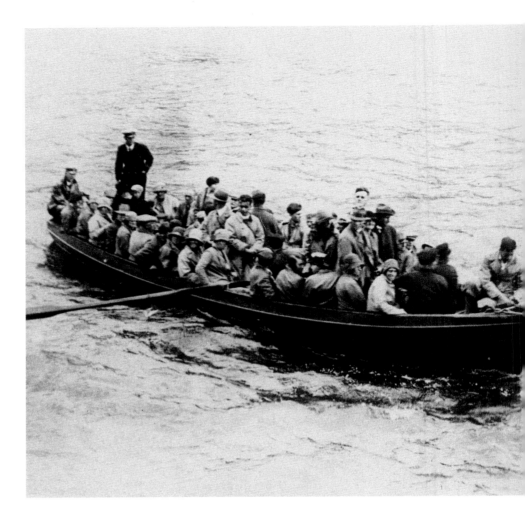

1920s
A boatload of men and women is rowed over the narrow stretch of water to Skye from the mainland at the Kyle of Lochalsh.

TODAY
The gracefully arched Skye Road Bridge, spanning the narrow sea crossing from the Scottish mainland to the Isle of Skye, opened in 1995.

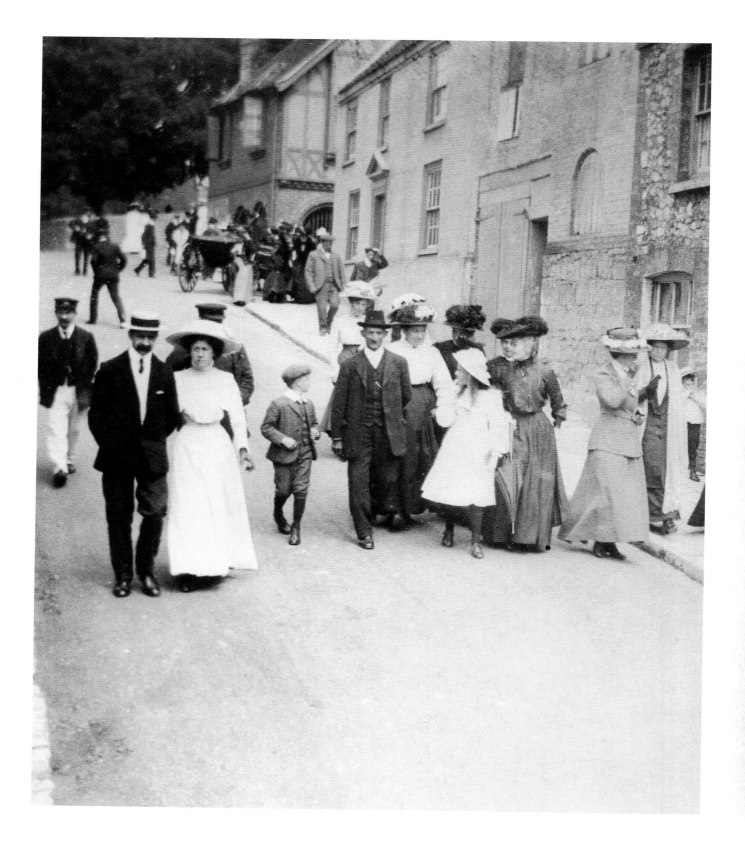

1890

Morning church service over, the congregation in their Sunday best walk home to lunch down Brading High Street, Isle of Wight.

TODAY

The Eternal Sacred Order of the Cherubim and Seraphim Church's choir in full song. The church was founded in Nigeria in 1925, and this branch is in London's Elephant and Castle.

FLOURISHING CHRISTIANITY

Christianity has been the most important religion in the UK for 15 centuries. It is the faith that the great majority of Britons – who may be Anglican, Catholic or nonconformist – put on passport and census forms, the latter for the first time in the 2001 Census. There is a distinction to be made, however, between 'community size' and 'active membership' figures, and the number of people who actively follow a Christian life has been falling.

Christianity in Britain remains richly varied and diverse. People from many different cultures have migrated to Britain since the Middle Ages, bringing their kind of Christianity with them. Communities of Greek and Coptic Orthodox churches, Armenian, Lutheran and Reformed churches from all over Europe can now be found in large cities such as London.

Outnumbering them are growing numbers of lively communities of charismatic and Pentecostal churches, boosted by African and Afro-Caribbean immigration since World War II.

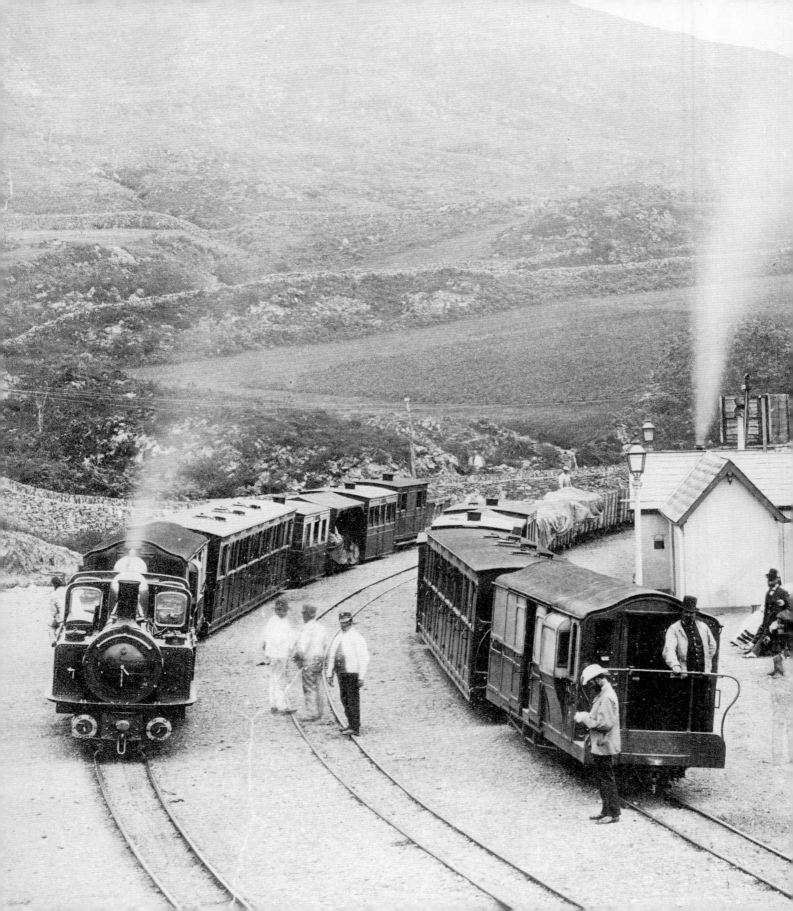

THE RAILWAY AGE

Railways were pioneered in Britain early in the nineteenth century. The 1830 opening of the Liverpool to Manchester Line, which carried both people and goods, triggered a massive railway boom during which, while fortunes were made and lost, a great railway network was built. By 1912 it covered over 11,160 kilometres (18,000 miles) and brought most people in Britain within reasonable reach of a train.

Despite a wide-ranging closure of unprofitable lines in the 1960s, Britain still has 32,000 kilometres (20,000 miles) of railway track and over 2,500 railway stations, even though many of the smaller ones were sold off, their tracks lifted and the station buildings converted to houses and offices.

Today, rail is more popular (and more expensive) way to travel in the UK, with services transformed by investment and upgrades. Local services have seen the introduction of light railways in and between cities. So far, there are five light railways in operation in England and more planned. Also planned to launch in 2026 is a national high-speed network, HS2, which will link London, Birmingham, the East Midlands, Leeds and Manchester.

1870s
Trains at Tan-y-Bwlch station on the Ffestiniog Railway in Snowdonia, North Wales, which was opened to passengers in January 1865.

TODAY
The light-rail service the Docklands Light Railway connects London's Docklands with surrounding areas and the City of London.

1926

Two begowned undergraduates of Cambridge University discuss life from the saddles of their 'sit-up-and-beg' bicycles.

TODAY

All that hard work at school has paid off for these young women, celebrating the A-level results that will get them into university.

UNIVERSITIES

Educating good numbers of the country's youngsters to a high standard became important when Britain became an industrialized society, which is why so many technical colleges and places offering practical advanced learning were founded in Britain during the course of the nineteenth century.

A university education remained something for a minority of young people until well after the Second World War, although the 1944 Education Act, which established secondary education for all, at least ensured plenty of potential students from among those who obtained good results in their final-school-year examinations.

University education began a great expansion in the 1960s, with the founding of new universities – including the Open University – and polytechnics and the conversion of many other higher-education foundations to full university status.

The State would like to see half the country's young people undertaking some form of higher education. This is an expensive ambition. The government-led swingeing increase in university fees from 2012, and the subsequent massive increase in student debt, caused a major outcry.

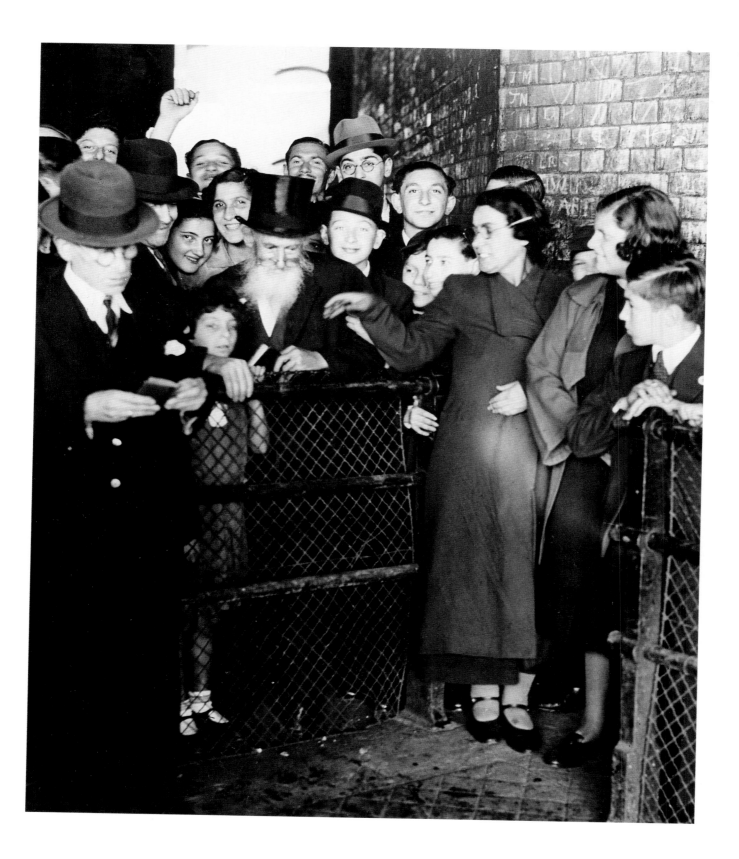

OBSERVING
THE SABBATH

The small Jewish community in England, well established by the eighteenth century and with its own synagogue in Aldgate, London, was greatly enlarged from the 1880s onwards by Jews fleeing persecution in Europe and Russia.

The largest communities of Jews in Britain were to be found in the East End of London, especially in Whitechapel; where their particular trade was tailoring. Jews were largely responsible for establishing the ready-made suits and clothing trade in Britain.

The Jewish community in Britain remains relatively small, coming fourth on the religion membership table, after Christians, Muslims and Hindus. Like other religions, Jews fall into separate groupings, Orthodox Jews being the strictest in their observance of religious laws. After many years' discussion, Orthodox Jews succeeded in 2003 in having an eruv marked out in Golders Green, north London, within which they may relax their observance of some of the very strict laws governing their behaviour on the Sabbath. There are now six eruvs in London and one in Manchester.

1937
It is the beginning of the Jewish New Year 5698, and Jews gather at Tower Bridge to carry out the ceremony of casting their sins upon the waters.

TODAY
An Orthodox Jewish father and his child admire the poles and fine wire that mark out the 18-kilometre (11-mile) eruv set up in Golders Green, London, in 2003.

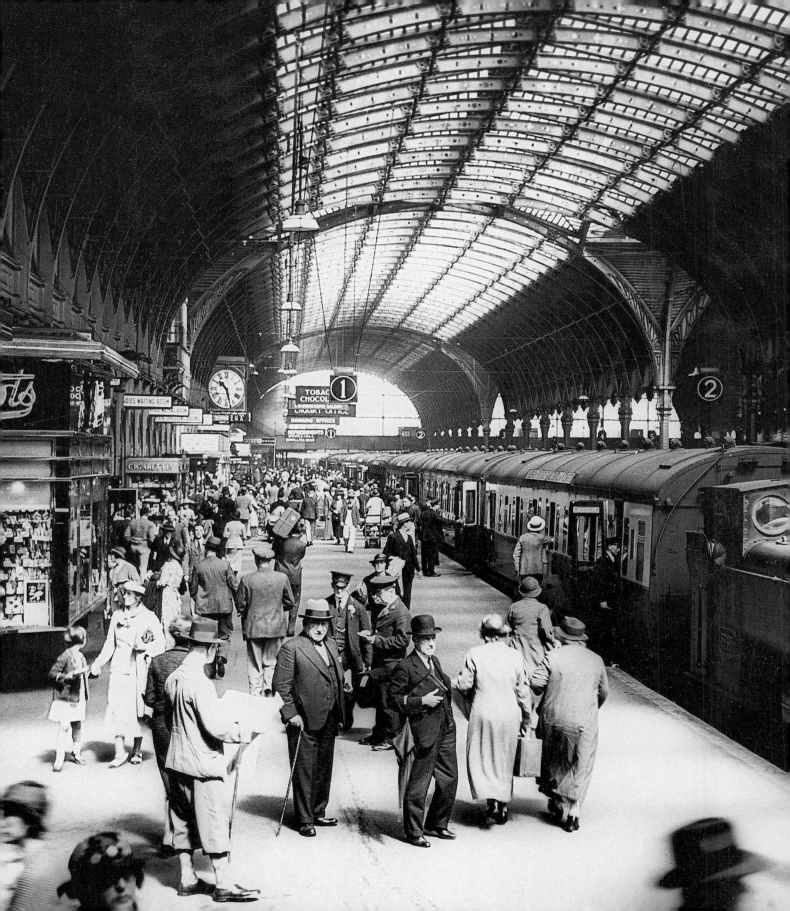

PADDINGTON & THE GWR

'God's Wonderful Railway' was how its employees once described the Great Western Railway. They probably meant not the deity but the builder of the line from London to Bristol – the great railway engineer, bridge builder and ship builder Isambard Kingdom Brunel.

Brunel was appointed engineer of the Great Western Railway in 1833, and between 1835 and 1841 built the GWR and all its tunnels, bridges and viaducts. He designed its stations, too, the most splendid of which was the London terminal, Paddington Station.

Today, Paddington is a spruced-up, modern railway terminus linked to Heathrow Airport by a fast electric train service and providing dozens of services a day to the west of England and South Wales. From 2018, it will also have a main central London station on the high-frequency, high-capacity Crossrail Elizabeth line service running from Maidenhead and Heathrow to the west of London to Shenfield and Abbey Wood in the south-east.

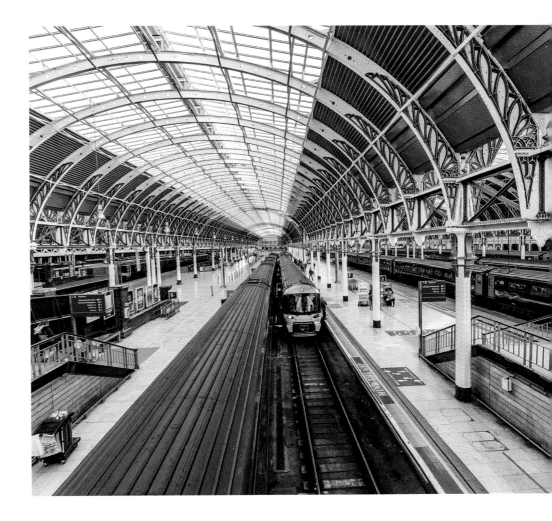

1935
Platform 1 at Paddington Station has not much changed over the years since the station opened in 1854, although the crowd, and the trains, have.

TODAY
A multi-million-pound refurbishment in the late 1990s revealed the glory of Brunel's great glass-and-iron roof at Paddington Station..

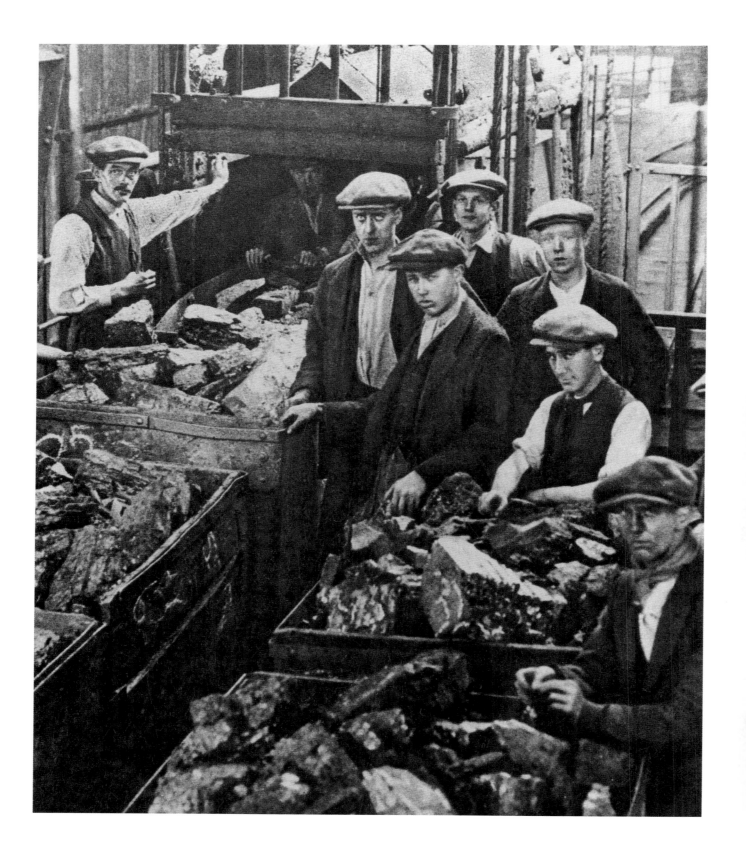

1926

Miners bringing up trucks of coal at the Cresswell Colliery, near Mansfield in Nottinghamshire, where coal mines were prosperous and modern.

TODAY

Workers make repairs on the *Armada* gas platform off the coast of Aberdeen.

FROM COAL TO OIL & GAS

From the reign of Elizabeth I to the reign of Elizabeth II, coal was a primary source of heat and power in Britain's homes, offices and factories. Today, it is not. It has been overtaken by other fossil fuels, oil and natural gas, much of which comes from the North Sea. Renewable energy, too, has gained in popularity.

The North Sea oil and gas industries got into gear in the 1970s, at much the same time as coal mines were becoming unproductive and expensive to operate. A series of bitter strikes in the 1980s sounded the death knell of an industry that had been part of the nation's culture for centuries.

The UK still uses a lot of coal, to make electricity and to have friendly open fires at home and in pubs and bars, but it no longer provides work and a way of life for whole communities.

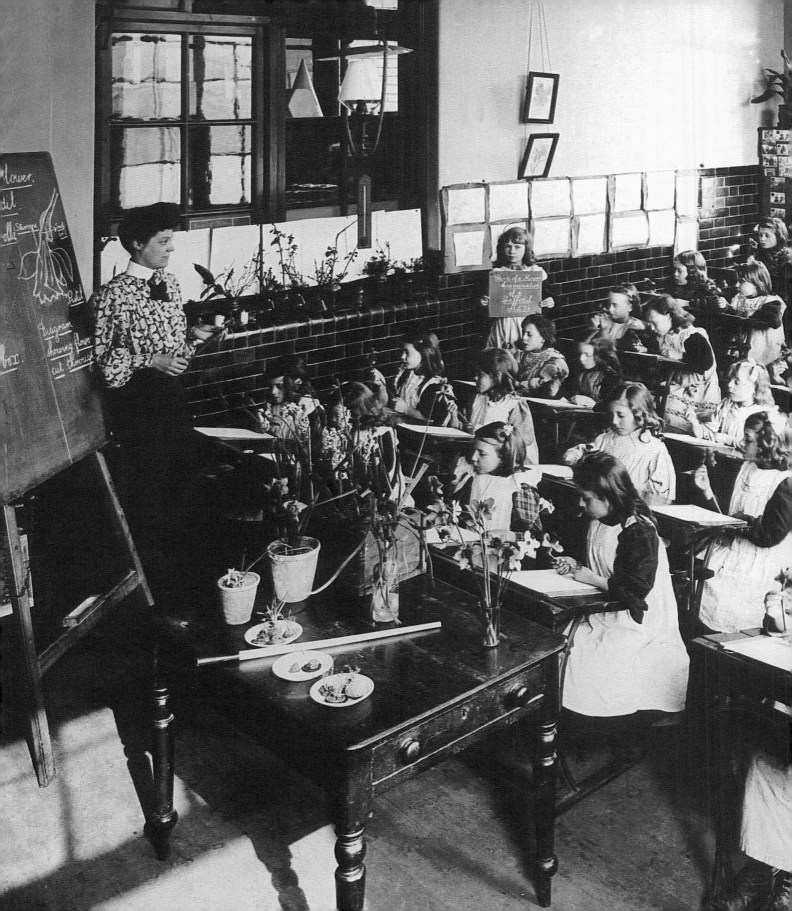

EDUCATION

Primary education for all children became compulsory in Britain in the 1870s. Every town and village in the land had a school, many of them run by the different churches, where children were taught to read, write and do sums. For many years, boys and girls were separated, both in class and in the playground. They sat in bench-like desks set in neat lines facing their teacher and the blackboard.

In the days before radio, television and other distractions, many children filled their time out of school with occupations complementary to their school work. Children might collect and press the flowers they studied in botany, or arrange plant and flower cards, taken from their father's cigarette packs, into albums.

Primary-school teaching has become child-centred. Children are encouraged to be individuals, while working in groups, and also embracing technology in the classroom. But some things do not change. The school playground is still a place where children can leap about and let off steam and many of the games they play were played by their grandparents at the turn of the century.

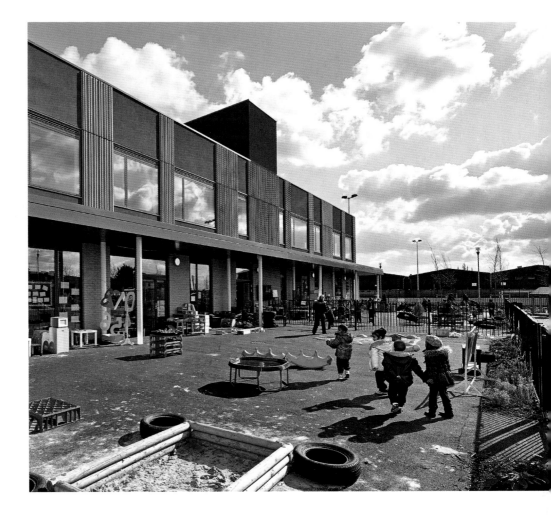

1908
A botany class in progress at a girls' school in London. The smock-clad girls are sitting at desks that would still be in use 50 years later.

TODAY
Children in the playground of the Oasis Academy Hadley, Enfield. Traditional playground pursuits combine with new, colourful plastic toys.

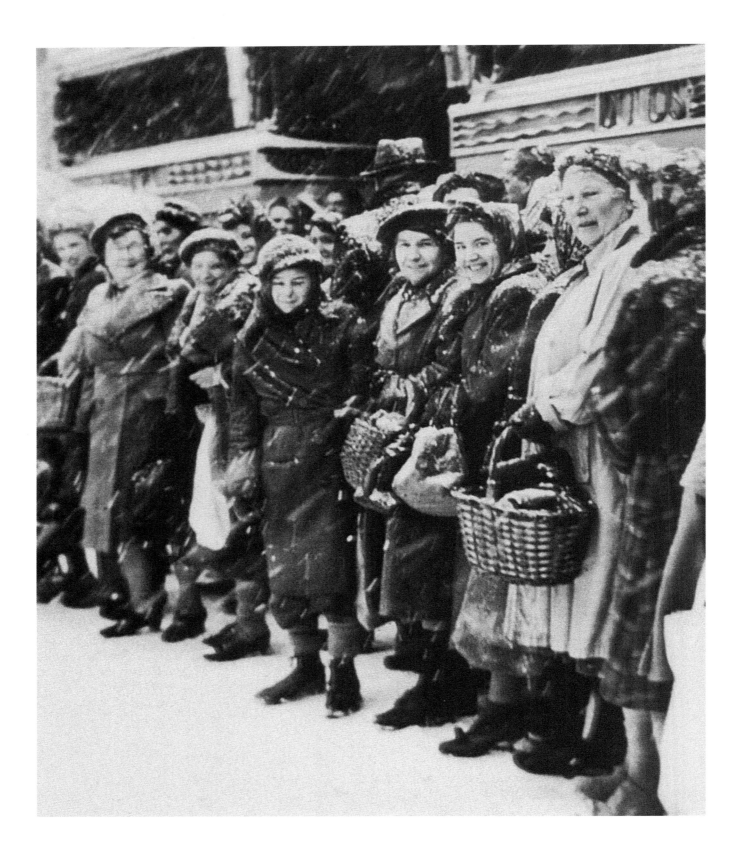

QUEUING: A VERY BRITISH HABIT

Forming orderly queues to obtain anything from stamps in the post office and tickets at the cinema to a seat on a bus has long been a sensible British habit. During the Second World War it became almost a way of life as shoppers queued in all weathers, ration books at the ready, to buy permitted quantities of many basic foods. Rationing, first imposed in 1940, did not end until 1953.

The careful decisions involved in deciding which queue to join used to be down to a fine art in the UK. Except in the supermarket, this is no longer necessary. Now, one queue usually snakes back and forth across the available space, people peeling off when a ticket window or counter becomes free. The high point of the queuing year comes with the January sales. Shoppers – Christmas dinner hardly digested – take folding stools and sleeping bags for an overnight wait, to be the first through the doors on the opening day of their favourite store's sale.

1940s
These shoppers queuing for rationed foods might not have smiled had they known that war-time rationing would last until 1953.

TODAY
Queuing, sometimes overnight, to be first through the door at the post-Christmas sales is a fine British custom. Here, London shoppers wait for Selfridges on Oxford Street, central London, to open their Boxing Day sale.

GETTING
ABOUT
BY AIR

When Britain's biggest 'aerodrome' fully opened near the small Middlesex village of Heath Row in 1948, tents and Nissen huts left over from the Second World War housed administration offices and passenger facilities.

The extraordinarily rapid growth in air travel within the UK and to destinations all round the world meant not only that Heathrow had to be enlarged again and again but also that many other airports had to be built – and enlarged – in all parts of the country.

Today, there are more than 40 UK certificated aerodromes, handling between them at the latest count over 240 million passengers a year and 2.3 million tonnes of freight. The tents and Nissen huts have long gone, of course, and today's big airports have shopping malls, cafés and restaurants offering every type of cuisine to ease the wait for flights.

1946
A view of the runway at 'Britain's £20,000 civilian aerodrome at Heath Row', nearing completion and intended to be the country's main air junction.

TODAY
Since Queen Elizabeth II officially opened Heathrow's spectacularly modern Terminal 5 in 2008, 277 million passengers have travelled through its doors.

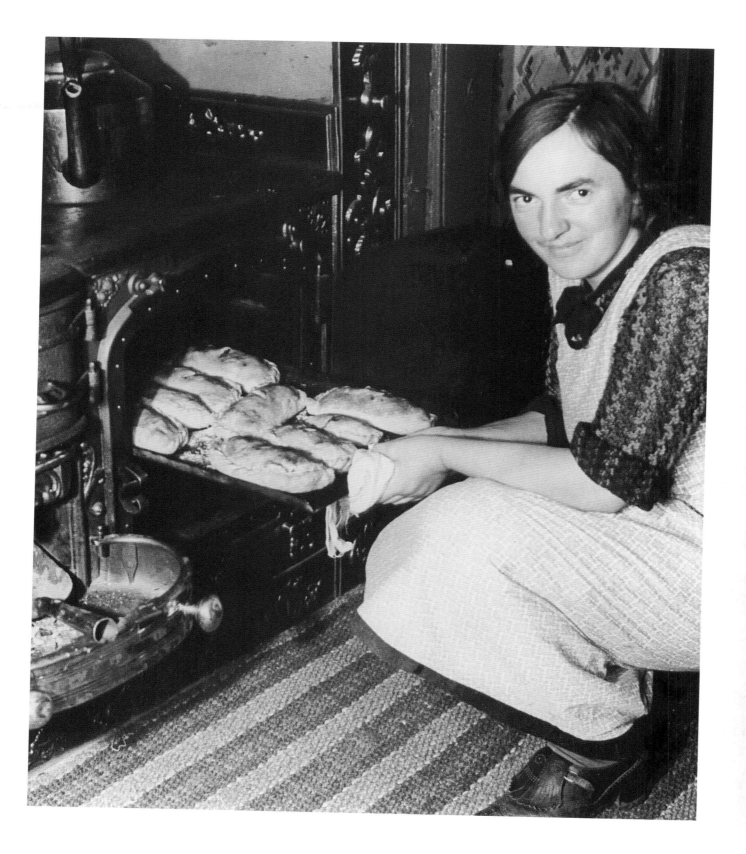

1936

A Cornish housewife checks how a tray of pasties are getting on in her beautifully black-leaded coal-fired kitchen range.

TODAY

The modern way to cook: following an online recipe on an iPad or other tablet makes it achievable to cook something new every night.

KITCHENS

A heavy closed range, made of cast-iron and fired by wood or coal, became the main feature of kitchens during the Victorian era. Food was cooked in it, water was heated on it, and clothes were dried round it. It also kept the kitchen – and the whole house, if small – warm and snug.

The harnessing of gas and electricity as a cooking fuel changed everything. Closed ranges, which had once seemed the ultimate in convenience compared with open fires, were now torn out of kitchens in town and country. They were replaced by gas and electric cookers or, especially in country kitchens, by efficient new ranges, fired by gas, oil or electricity and with electric thermostats.

The modern kitchen is seldom the heart of the household, that role having been taken by the living room and the television. However, the healthy eating trend and the increased availability of exciting, global produce in supermarkets is encouraging a generation of young cookery enthusiasts, as is the popularity of celebrity chefs and television cooking competitions such as *Masterchef* and *The Great British Bake Off*.

HINDUS IN BRITAIN

Most of the members of the Hindu community in Britain today originate from India, once the 'Jewel in the Crown' of the British Empire, though some Hindus have come from other former colonial territories, mostly in Africa, to which Indians migrated.

The first Indians to reach Britain came as servants of merchants returning home, having made their fortune in India. They were few in number and Indians, both Hindu and Muslim, were not seen in large numbers in Britain until they were encouraged to come to relieve the intense labour shortage after the Second World War.

Hindu communities are close-knit and their culture is important to them. London's Hindus demonstrated their devotion to Hindu culture and religion in the 1990s by raising within the community the money to build the magnificent Shri Swaminarayan Temple in Neasden, north-west London, the first purpose-built Hindu temple in Europe. Much of the marble for the temple was prepared and carved in India by master craftsmen and then transported to Britain.

1956
The first Hindu wedding to take place at India House, the office of the India High Commission in London, nears completion.

TODAY
The building of the Shri Swaminarayan Hindu Temple in Neasden, north-west London, was paid for by the Hindu community.

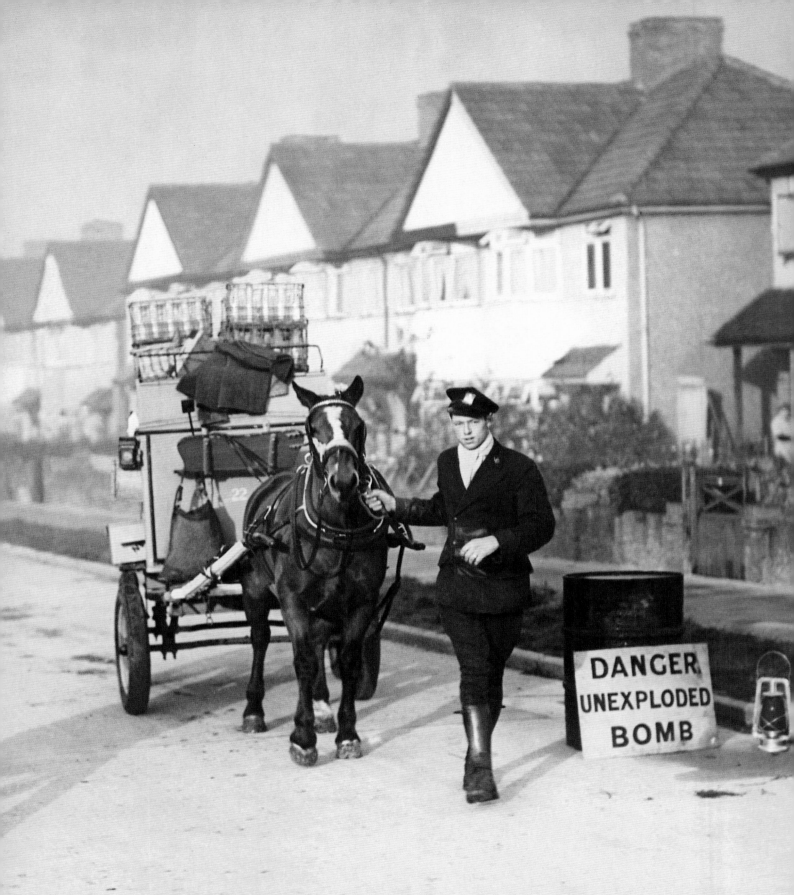

DELIVERING THE GOODS

The Victorians, with their railway lines reaching into all parts of the country, moved into the business of home deliveries with enthusiasm.

The post, milk, bread and newspapers were at the everyday end of a system that in time included huge mail-order catalogues from businesses such as the Army & Navy Stores, which offered to deliver everything from corsets to cricket pavilions to the ends of the Empire.

Even when war came to the Home Front in 1940, deliveries of essential goods still got through – both in town and country – however, hazardous unexploded bombs made the job more challenging.

The home-delivery business flourishes in Britain, given new impetus by the Internet. Today, people can sit at home and tick off on a screen the items on their weekly shopping list, sit back and wait to have them delivered to the front door, where the milkman, paper boy and postman will have already delivered their goods. Takeaway food has never been easier to order, with new apps and websites offering delivery from even the finest restaurants. You can also have seasonal, organic fruit and veg boxes delivered to your door.

1940
An unexploded bomb is no reason for not delivering the milk! To save precious fuel, the milkman uses horsepower to pull his milk float.

TODAY
Most supermarkets now have home delivery services – here, a household in Manchester receives a food delivery from Tesco.

CELEBRATIONS

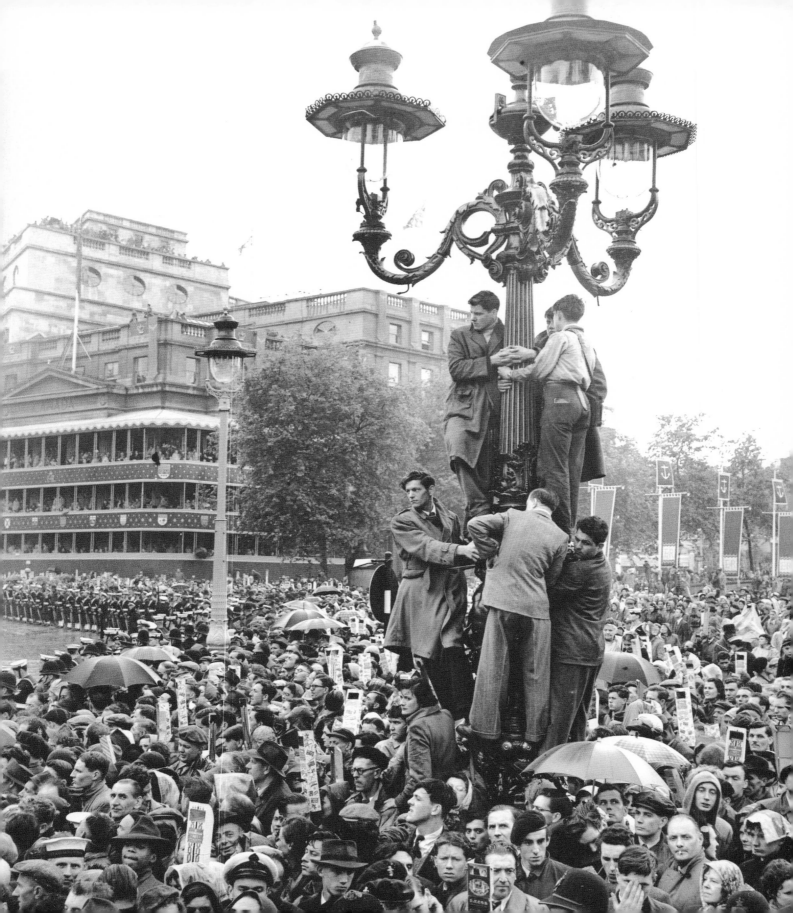

QUEEN ELIZABETH II

More than half a century ago, on 2 June 1953, the coronation of Elizabeth II brought crowds flocking into London from all over the country and the Commonwealth, eager for a glimpse of the young woman whose father's death a year earlier had made her queen. Many people had waited for days for the big event, and pouring rain did not dampen their enthusiasm.

Sixty years after that unexpected accession, London's streets were once again hung with banners and flags and were full of crowds, eager to celebrate Her Majesty the Queen's Diamond Jubilee.

10,000 guests were selected by national ballot to attend the Diamond Jubilee Concert in the Buckingham Palace Garden, with the unique concert stage built around the Queen Victoria Memorial. 1.2 million spectators were estimated to have watched the Royal Pageant from the banks of the Thames, as 1000 boats assembled from across the UK and Commonwealth made their way down the route. Many thousands lined the streets for the state procession too, and the atmosphere and excitement of the day showed patriotism is alive and well in an age of scepticism and doubt.

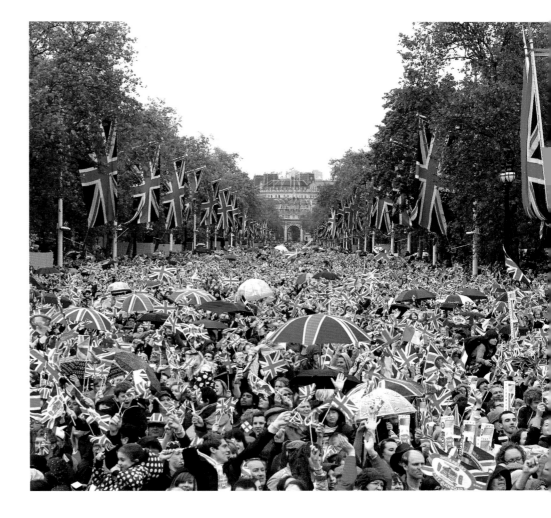

1953
Cardboard periscopes at the ready, huge crowds fill Trafalgar Square, ready to cheer Elizabeth II after her coronation on 2 June.

TODAY
Union Jack flags flutter as the large crowd in The Mall takes part in the Diamond Jubilee celebrations in 2012.

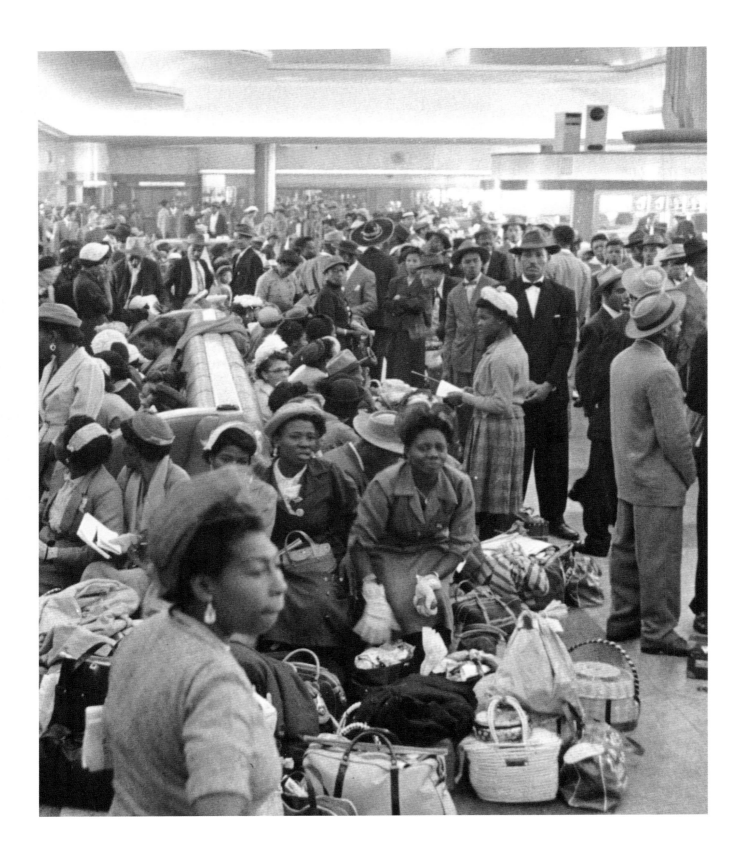

NOTTING HILL CARNIVAL

Although many Britons grew rich on the West Indian sugar and slave trade in the days of Empire, few Caribbean nationals came to Britain.

Things changed after World War II, when a severe labour shortage in Britain led the government to promote the idea of finding work in Britain to people in the West Indies, where there was high unemployment, and offer British citizenship to Commonwealth residents. One of the first large groups of Jamaicans reached Britain in 1948, sailing on MV *Empire Windrush*. Thousands more followed and the UK's West Indian communities grew rapidly, playing a vital role in the rebuilding of Britain's post-war economy.

London's Notting Hill became a hub for West Indian culture in the UK, and in the 1950s the area became notorious for its serious racial tensions. In 1966, local activists and community figures organized the first Notting Hill Festival, with the aim of mending the rift and making links between the multi-racial communities in the area. Today, the Notting Hill Carnival has evolved into an extravaganza of music, dance, food and fantastic costume that brings over a million people of all races and backgrounds to Notting Hill to take part in the fun.

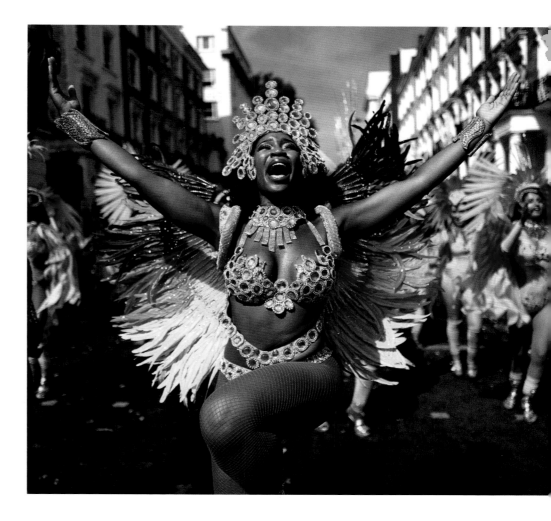

1956
The first stopping place for these new arrivals in England from the West Indies is the Customs Hall at Southampton docks.

TODAY
The Notting Hill Carnival, an exuberant showcase of Caribbean culture, is the largest street carnival in Europe.

SCOTLAND CELEBRATES

The two greatest nights of celebration in Scotland's year come within weeks of each other in the depths of winter, when the glowing warmth provided by whisky, the Scots' national spirit, is very welcome.

Hogmanay, or New Year's Eve, is celebrated by many Scots at home, with visitors offered black bun and copious amounts of whisky. The ideal first visitor, or First Foot, of Hogmanay is dark-haired or carries a lump of coal to signify the wish that the home fire will burn brightly throughout the coming year. In Scotland's cities Hogmanay is an excuse for all-night revelry among the crowds filling the streets.

On 25 January, Scots and non-Scots all over the world celebrate the birth of Robert Burns, the country's greatest poet. As well as reciting Robert Burns' poetry, the ceremony of Burns Night is centred on the haggis, a surprisingly tasty mixture of offal and oats, served with potatoes, swede and plenty of whisky. Vegan and vegetarian versions of this classic Scottish dish are now available too.

1950s

It is Burns Night: the haggis has been piped in and is about to be stabbed, doused in whisky and served with champit tatties and bashed neeps (swede).

TODAY

Hogmanay revellers enjoy the spectacular firework display above Stirling Castle, a highlight of the New Year festivities in Scotland.

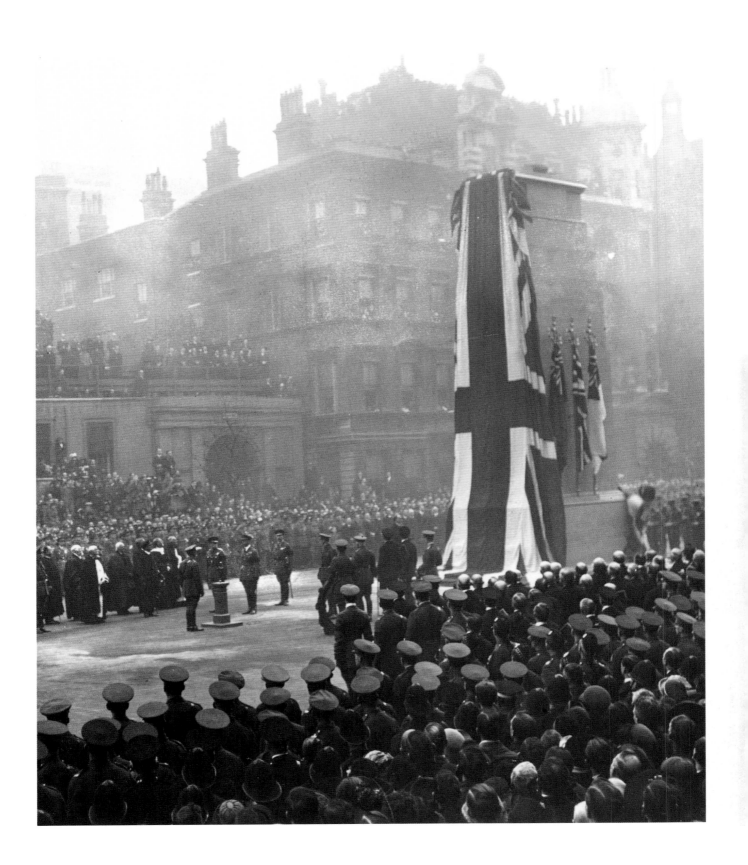

1920

The Cenotaph in London's Whitehall is surrounded by a silent crowd, many in uniform, marking the minute's silence at 11 am on 11 November.

TODAY

The Queen has seldom missed leading the nation in homage to its war dead, and she is the first to lay a wreath on the Cenotaph's steps.

REMEMBRANCE SUNDAY

The guns of the First World War fell silent at 11 am on 11 November 1918. Ever since, 11 November has been Armistice Day in Britain. For a week or so before, many people wear poppy symbols in memory of the men who lost their lives in the poppy fields of Flanders and for those from the British Empire and Commonwealth who lost their lives in the many conflicts, large and small, that followed the Great War.

The anniversary of Armistice Day is marked in London by a wreath-laying service in Whitehall, around the Cenotaph designed by the architect Edwin Lutyens, which was unveiled on Armistice Day in 1920.

Some years ago, to avoid bringing London to a standstill on a weekday, the wreath-laying ceremony was moved to the Sunday nearest 11 November. Every year, on a Sunday morning in November, central London falls silent as the Queen leads the nation in remembering the men and women who died for their country.

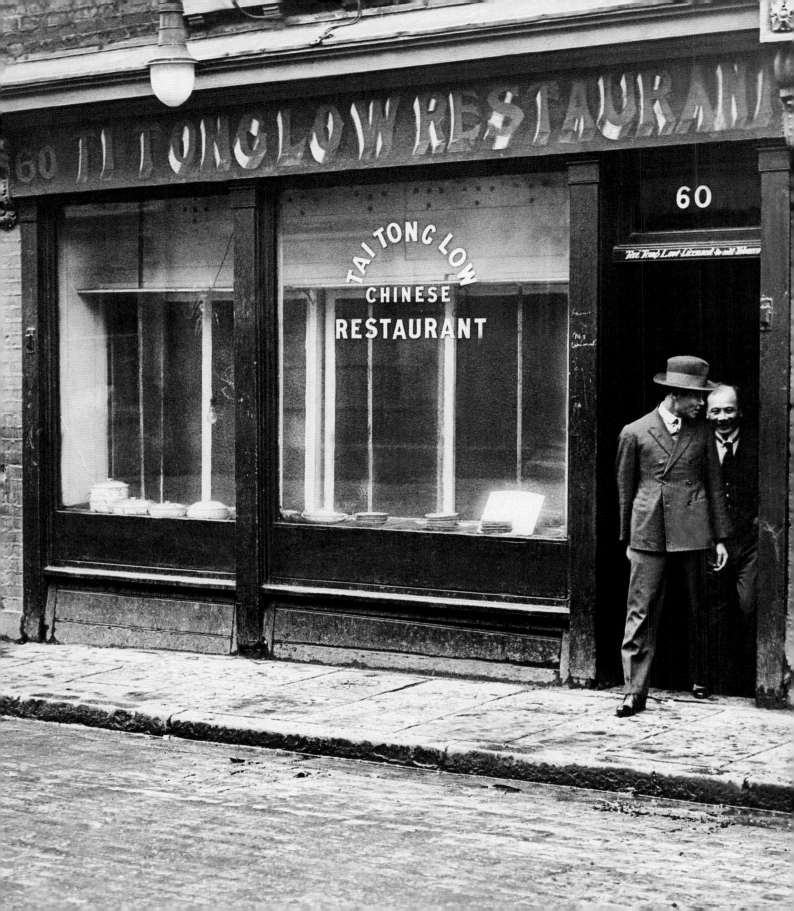

CHINESE NEW YEAR

It is the tradition in China to visit relatives and distribute presents, symbols of goodwill and good fortune, at the start of the New Year, which is given a new animal name according to a long-established 12-year cycle. These New Year traditions are celebrated in great style by Britain's Chinese population.

Communities of Chinese people developed in several of Britain's big cities in the twentieth century. Some set up restaurants or shops selling oriental foods and other goods that were becoming fashionable here in Britain. Others came to work in the sweatshops of the clothing industry in the East End of London.

Chinese New Year is now celebrated every year, especially in London, and is enjoyed as much by British people and foreign visitors as by the Chinese themselves. London's Chinatown holds a huge and colourful parade, featuring beautiful models of dragons and performances of the lion dance, to enliven the wintry streets of Soho every January.

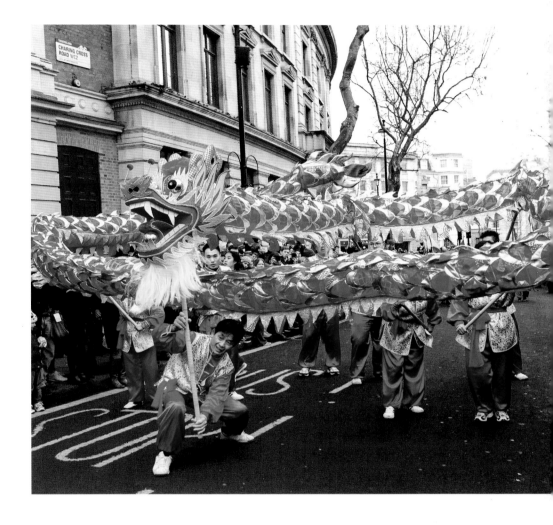

c.1950s
London's Chinatown was located in the East End until the 1950s, when Soho became the city's hub of Chinese food and culture.

TODAY
On Charing Cross Road in London's Chinatown, dragon dancers entertain the crowds to celebrate the 2016 Chinese New Year.

1927

A handsome shawl wrapped round her shoulders, this centenarian in Yeovil, Somerset, holds a hand-written congratulatory telegram.

TODAY

Chelsea Pensioner and WWII Royal Fusilier Joe Britton celebrates his 100th birthday in 2011 by reading his telegram from Her Majesty the Queen.

GREAT LIFE EXPECTATIONS

In the early years of her reign, it was not an arduous task for Elizabeth II to send the by-now-traditional congratulatory telegram to those of her subjects in Britain and the Commonwealth who had reached the notable age of 100. There were not too many of them. Today, there are a great many more, including, in 2000, the Queen's own mother.

Life expectancy rose greatly for men and women in the twentieth century. In 1901, the average life expectancy at birth for men was 48 years; by 2016 it had risen to 79.2. For women, the figures rose from 51.6 to 82.9 years.

Britons are living longer for many reasons. Rising standards of living, healthier eating habits and enormous advances in medicine and medical technology have helped adults survive much longer. Perhaps 100 will become so commonplace a birthday that Elizabeth II's successors will stop sending telegrams to those subjects who reach it.

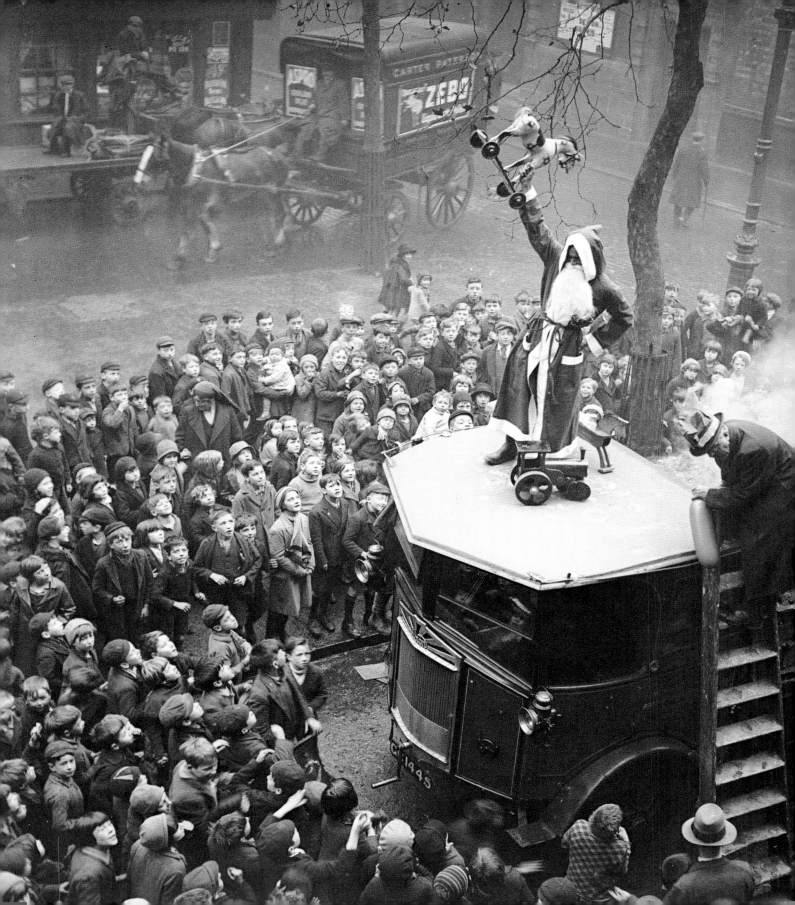

CHRISTMAS

The Victorians added the Christmas card, the Christmas tree and the idea of giving everyone presents (rather than just the servants on Boxing Day) to the way we celebrate the birth of Christ. All too soon, it was no longer enough for the village choir to rehearse a special Christmas anthem for everyone to listen to in church and then go home to a more special dinner than usual.

While the real meaning of Christmas has become submerged in modern Britain's consumer culture, it is by no means lost. Christmas remains for most people a time for making a special effort to bring families together. Churches are much fuller at Christmas for a range of special services than at any other time of the year except Easter.

For many children, their first introduction to the magic and mystery of the Christmas message comes at school. The infant class's annual performance of the nativity play, in which as many children as possible get a part, remains for many of the children and their parents a lifelong memory.

1933
A Christmas party at the Hoxton Mission, east London. Children crowd around as Santa begins to distribute toys.

TODAY
London's Regent Street is lavishly decorated with lights and figures of angels to celebrate Christmas, and to draw in Christmas shoppers.

1957

A druidical ceremony at the National Eisteddfod. During the Proclamation Ceremony the Hirlas Horn is carried to the Logan Stone.

TODAY

Sikh dancers and musicians take part in the International Music Eisteddfod in Llangollen, Wales, 2015.

EISTEDDFODAU IN WALES

The festivals called eisteddfodau have long held a special place in Welsh cultural life. They celebrate and encourage literature and music, both of which have very long traditions in Wales. Welsh literature, which many believe can be traced back to the Druids, is one of the oldest literatures in Europe.

The first recorded eisteddfod in Wales was in 1176. It was not until the early nineteenth century that the tradition of crowning the best bard of the year began. From this time, too, many rituals purporting to date back to the times of the Druids began to be introduced into the ceremonial of the eisteddfod.

Two particularly important eisteddfodau are held in Wales every year. The Royal National Eisteddfod, held in a different town each year, has competitions in music, singing, prose and poetry in Welsh. The Llangollen International Music Eisteddfod, ttracts performers from all over the world.

ROYAL JUBILEES

Only two British monarchs have reigned long enough to celebrate Golden and Diamond Jubilees marking 50 and 60 years on the throne: Queen Victoria in 1887 and 1897 and Queen Elizabeth II in 2002 and 2012. For both, their Golden Jubilee had seen renewed popularity after periods of questioning and growth in republican sentiment.

Queen Victoria's Diamond Jubilee was a time for Imperial pageantry, with leaders of the countries of the Empire invited to the celebrations and a splendid 9.6 kilometre (6-mile) carriage procession to St Paul's Cathedral. Victoria, by now quite lame, remained in her carriage for the brief thanksgiving service, held at the steps to the Cathedral's west door.

Queen Elizabeth II celebrated her Golden Jubilee in 2002 by circumnavigating the globe, for the sixth time in her reign. She also visited 70 cities and towns in 50 counties in the UK over 38 days. She travelled to St Paul's Cathedral in the Gold State Coach, which she had used twice before – on her Coronation and on her Silver Jubilee.

1897

Queen Victoria's Diamond Jubilee celebrations took her on a splendidly escorted procession through the streets of London, vast crowds cheering her all the way.

TODAY

In contrast to Queen Victoria's open landau, Queen Elizabeth rode along the Mall in the Golden State Carriage during her Golden Jubilee celebrations.

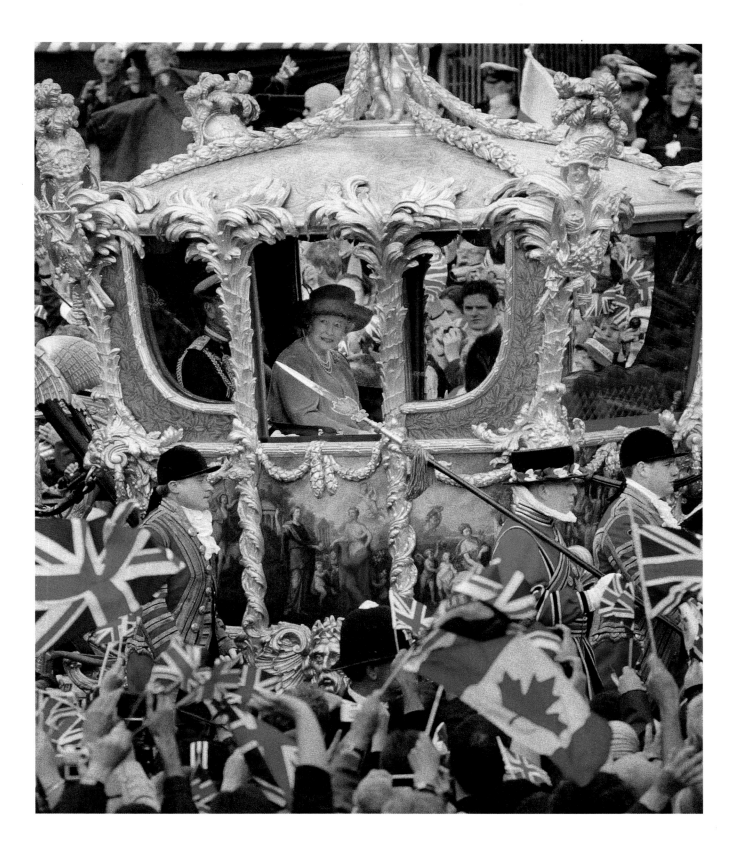

INDEX

CREDITS

The publishers would like to thank the following sources for their kind permission to reproduce the pictures in this book.

AKG-Images: 76

Alamy: Cultura Creative: 29; /Julian Eales: 55; /PjrStatues: 57; /Grant Rooney: 115; /Anna Stowe: 23; /E.Westmacott: 15

Billie Love Historical Collection: 52, 114, 146, 148

Photo by Jamie Davies on Unsplash: 187

Ffotograff: 131

Getty Images: Tolga Akmen/AFP: 177; /Shaun Botterill: 69, 87; /Matt Cardy: 85; /Corbis: 104; /Central Press: 20; /Richard Cummins: 123; /Simon Dawson/Bloomberg: 53, 159 ; /Adrian Dennis/AFP: 75; /Herbert Felton: 116; /English Heritage/Heritage Images: 8-9; /Otto Herschan: 136; /Fox Photos: 130, 186; /General Photographic Agency: 42; /Rune Hellestad/Corbis: 6; /Hulton Archive: 18, 44, 90, 124, 142, 190; /Hulton-Deutsch Collection/Corbis: 34, 84, 168; /Samir Hussein/WireImage: 181; /Will Ireland/Future Publishing: 167; /Keystone-France/Gamma-Keystone: 94, 182; /FLPA/REX: 105; /Dan Kitwood: 59, 149; /Raymond Kleboe: 24; /London Express: 30; /London Stereoscopic Company: 134; /Lucentius: 143; /Haywood Magee/Picture Post/Hulton Archive: 176; /Clive Mason: 67; /National Motor Museum/Heritage Images: 66; /Keystone: 128; /Daniel Leal-Olivas/AFP: 89; /Dominic Lipinski - WPA Pool: 121; /Leon Neal/AFP: 49, 51; /Moment: 25; / David Pearson/REX: 171; /PNA Rota: 92; /Popperfoto: 64; /The Print Collector: 140; /Chris Ratcliffe/Bloomberg: 13; /Rischgitz: 12; /Quinn Rooney: 65; /Clive Rose: 83; /Oli Scarff: 93; /Justin Setterfield: 81; /E. Sevent/Otto Herschan: 150; /Humphrey Spender/Picture Post: 138; /SSPL: 38; /Michael Steele: 45; /Jack Taylor: 27, 73; /Sion Touhig: 191; /

Topical Press Agency: 2, 106, 120, 122, 184; /James Valentine/Hulton Archive: 132; /Margaret Bourke-White/March of Time/The LIFE Picture Collection: 48

Mary Evans Picture Library: 96

Shutterstock: 1000 Words: 19; /Asiastock: 157; /Duncan Andison: 35, 141; /AP/REX: 79; /Ian Barnes: 147; /Jason Batterham: 97; /Philip Bird LRPS CPAGB: 43; /Chas Breton/REX: 109; /Ms Jane Campbell: 183; /Ben Cawthra/REX: 41; /Cultura/REX: 113; /Martin Dalton/REX: 111; /DrimaFilm: 21; /Elena Dijour: 127; / Huw Evans/REX: 153; /Scott Heppell/AP/REX: 91; /FrontlitPhotography: 135; /Brendan Howard: 107; /I Wei Huang: 39, 169; /Hufton+Crow/VIEW/REX: 161; /Inacioluc: 17; /Vicky Jirayu: 151; /Peter Jolly/REX: 101; /Oscar Johns: 95; /Jasperimage: 77; /Marso: 139; /R.Nagy: 129; /Paolo Paradiso: 103; /PK Perspective: 179; /Howard Pimborough: 189; /PomInOz: 133; /Rachelc: 117; /Hugh Routledge/REX: 71; /Mark Schiefelbein/AP/REX: 61; /Photocritical: 165; /Pxl.Store: 47; /Carl Sims/REX: 175; /Ray Tang/REX: 31, 163; /Topical Press Agency: 86; /John Williams: 125; /Kev Williams: 33; /Chris Winter/REX: 185; /Serg Zastavkin: 137

Royal Botanic Gardens, Kew: 32

© Nigel Sutton: 155

Topfoto.co.uk: 4, 14, 16, 22, 26, 28, 40, 46, 50, 54, 58, 60, 68, 70, 72, 74, 78, 82, 88, 100, 102, 108, 113, 126, 152, 155, 156, 159, 160, 162, 164, 166, 170, 174, 178, 180, 188; /Museum of London/HIP: 56; /National Motor Museum/HIP: 80; /John Topham: 110

Every effort has been made to acknowledge correctly and contact the source and/or copyright holder of each picture and Carlton Publishing Group apologises for any unintentional errors or omissions that will be corrected in future editions of this book.